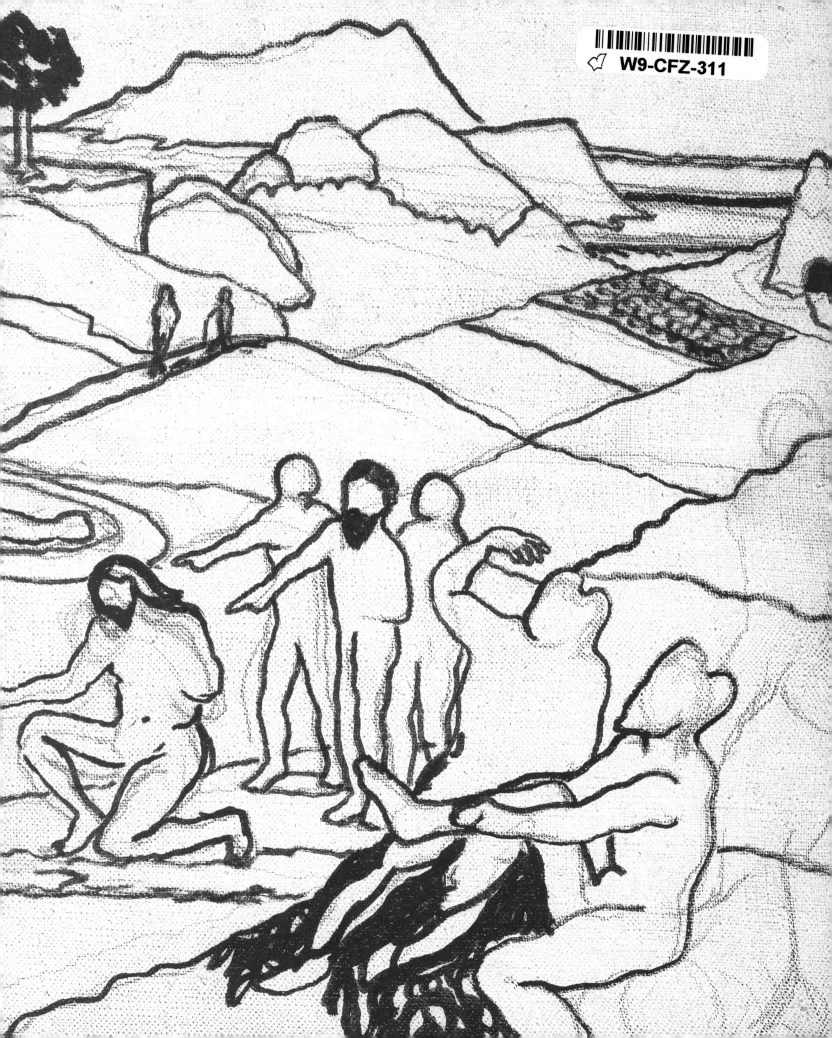

BOB THOMPSON

BOB THOMPSON

THELMA GOLDEN

WITH AN ESSAY BY JUDITH WILSON

AND COMMENTARIES BY SHAMIM MOMIN

WHITNEY MUSEUM OF AMERICAN ART, NEW YORK

IN ASSOCIATION WITH

UNIVERSITY OF CALIFORNIA PRESS

BERKELEY · LOS ANGELES · LONDON

This book was published on the occasion of the exhibition
"Bob Thompson" at the Whitney Museum of American Art,
September 25, 1998 – January 3, 1999.

AT&T and the National Committee of the Whitney Museum of
American Art are pleased to partially sponsor this exhibition,
with additional support from Fletcher Asset Management, Inc.
and TLC Beatrice International.

Research for the exhibition and publication was supported by
income from an endowment established by Henry and Elaine
Kaufman, The Lauder Foundation, Mrs. William A. Marsteller,
The Andrew W. Mellon Foundation, Mrs. Donald A. Petrie,
Primerica Foundation, Samuel and May Rudin Foundation,
Inc., The Simon Foundation, and Nancy Brown Wellin.

Front and back covers: Bob Thompson, *Untitled*, 1963 (details)
Paper edition inside covers: Bob Thompson, *Saving of Pyrrhus
(Poussin)*, 1964 (details)
Cloth edition endpapers: front, Bob Thompson, *Sacrament of
Baptism (Poussin)*, 1964 (detail); back, Bob Thompson,
Saving of Pyrrhus (Poussin), 1964 (detail)
Frontispiece: Thompson in his studio on Rivington Street,
New York, c. 1964. Photo © Charles Rotmil

Library of Congress Cataloging-in-Publication Data
Golden, Thelma.
 Bob Thompson / Thelma Golden : with an essay by
 Judith Wilson and commentaries by Shamim Momin.
 p. cm.
 Exhibition held at the Whitney Museum of
 American Art.
 Includes bibliographical references.
 ISBN 0-87427-115-0 (Whitney Museum of American
 Art : alk. paper). — ISBN 0-520-21259-2 (University of
 California : alk. cloth). — ISBN 0-520-21260-6
 (University of California : alk. pbk.)
 I. Thompson, Bob, 1937-1966—Exhibitions. 2.
 Afro-American painting—Exhibitions. I. Wilson, Judith.
 II. Whitney Museum of American Art. III. Title.
 ND237.T5519A4 1997
 759.13—DC21

 97-9499

 CIP

Printed in Hong Kong
9 8 7 6 5 4 3 2 I

CONTENTS

9 DAVID A. ROSS

FOREWORD

12 THELMA GOLDEN

ACKNOWLEDGMENTS

15 THELMA GOLDEN

INTRODUCTION

27 JUDITH WILSON

GARDEN OF MUSIC

 THE ART AND LIFE OF BOB THOMPSON

81 **PLATES**

173 SHAMIM MOMIN

COMMENTARIES

189 **SELECTED EXHIBITION HISTORY**

191 **SELECTED BIBLIOGRAPHY**

195 **WORKS IN THE EXHIBITION**

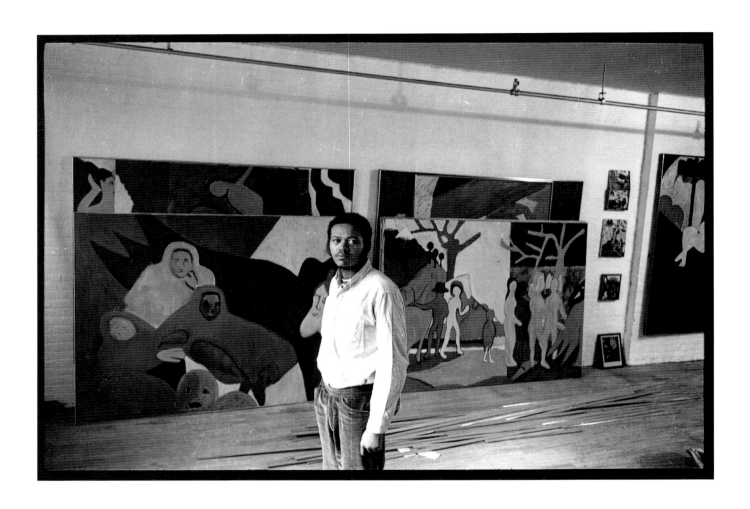

Thompson in his studio, 1963.
Photo copyright © by Fred W. McDarrah

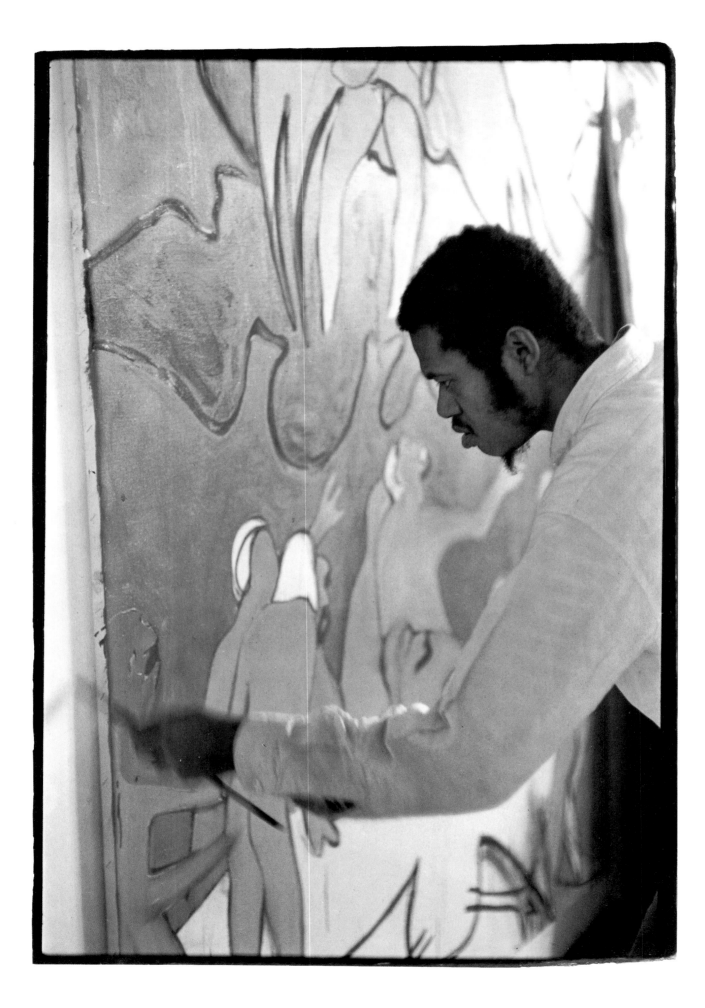

FOREWORD

The issues confronting all young artists, musicians, poets, and dancers throughout the century have been the same: you've got to determine how to stand out, to find your own voice, to be heard above the noise. In decade after decade, American artists from across the United States joined with artists arriving in New York from all corners of the globe to participate in the richest and most tangled cultural experiment in history. In the period directly after World War II, when the mix was particularly complex, what took place was in fact nothing short of revolutionary. Never before had America been the site of this kind of cultural explosion, and the exhilarating struggle it produced deeply shook this nation and the world.

The painter Bob Thompson was a vital part of it all. He lived through the struggle, fought to develop his own vision, made some extraordinarily beautiful work, and died far too young—years ahead of the recognition appropriate to his talent and his contribution. Like many other artists and musicians of his time, he found his voice in the novel hybrid forms that emerged from the global consciousness informing American postwar culture. Jazz and R & B, Abstract Expressionism, and powerfully expressive abstract figuration all danced in the politics of ecstasy and the ecstasy of the everyday.

This retrospective, the first major survey of Thompson's work in twenty years, provides an opportunity to celebrate the brief but intense career of an artist who managed to create over a thousand works in the short span of seven years. In the hundred paintings and drawings selected by curator Thelma Golden—among them a 1964 canvas acquired by the Whitney twenty-five years ago—we see an artist who quickly matures in the hothouse that was Greenwich Village in the late 1950s and early 1960s. As both Golden and art historian Judith Wilson make clear in this catalogue, we are confronted with the powerful imagery of an African-American artist whose work seeks not peace and harmony, but rather evokes in narrative the pain borne by the angry demons of modern life. The result is puissant painting of transcendent beauty. And like other tragic artists who lived brief lives at full speed, he remains, through his work, forever young. Yet this is a moment of

1. Thompson painting in his studio, 1963.
Photo copyright © by Fred W. McDarrah

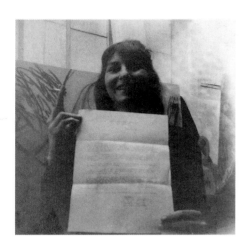

2. Carol Thompson holding the Whitney
Opportunity Fellowship letter, Paris, August 1962.

celebration: a time to enjoy Thompson's unique vision, and to recognize that this man who lived so briefly among us made a great contribution to twentieth-century American art.

Carol Plenda Thompson has been dedicated to preserving her husband's work since his death in 1966. For almost thirty years, she has been an indefatigable advocate, cataloguer, and archivist. This exhibition could not have been realized—or even conceived—without her; in one sense, it is as much a tribute to her dedication as to her husband's art.

We owe a great debt to Judith Wilson, whose original research and profound understanding of Thompson has helped rekindle worldwide interest in the artist and his work. Thelma Golden, the Whitney Museum curator who has guided this intricate project from inception through its installation, has once again shown herself to be resourceful, dogged, perceptive, and brilliant.

Graphic designer Bethany Johns has worked magic with the catalogue, as has the Whitney Museum's superb Publications Department. This inspired team has once again produced a book worthy of the artist's own high standards of graphic power.

This foreword would not be complete without expressing deep gratitude to those who have provided financial support for this exhibition: AT&T, Fletcher Asset Management, Inc., TLC Beatrice International, and the National Committee of the Whitney Museum of American Art. Their support has made the organization and presentation of this exhibition possible.

David A. Ross
Director, 1991–98

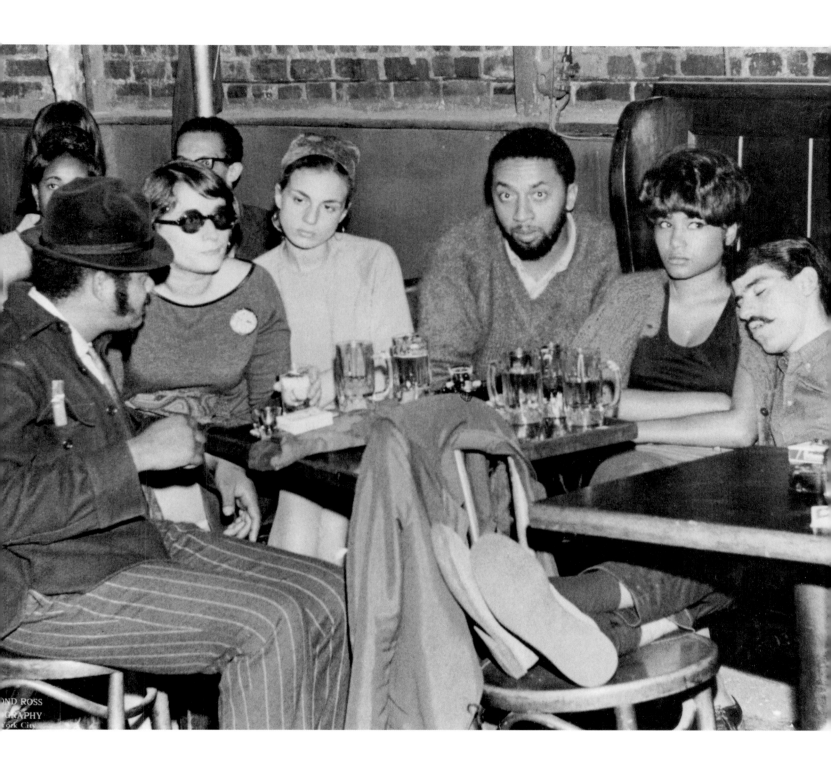

3. Jazz at Slug's, New York, 1964.
Left to right: Thompson, Nancy
Dannenberg, Danielle and A.B. Spellman.

ACKNOWLEDGMENTS

This ambitious exhibition would never have been possible without the immeasurable contributions of a great many people. At the Whitney Museum, I would like to thank David A. Ross, former director, who encouraged and supported this project from its inception. Shamim Momin, curatorial research assistant, and Erika Muhammad, curatorial assistant, have admirably overseen the complex tasks of coordinating research, planning, photography, and loans for the exhibition and the publication. In addition, Shamim Momin's commentaries offer an insightful perspective on Thompson's work. Mary DelMonico, head, Publications, along with Nerissa Dominguez Vales, production manager, Sheila Schwartz, editor, Dale Tucker, copy editor, and Christina Grillo, assistant, edited and directed the publication of this volume, with additional copy editorial assistance from Alexandra Bonfonte-Warren and Cheryl Wolf. Anita Duquette, manager, Rights and Reproductions, provided valuable advice and assistance. I am extremely grateful to Bethany Johns, designer, for her constant grace under pressure and for the fabulous design of this catalogue. I am indebted to Lana Hum, manager of exhibition design and construction, for her assistance with the gallery construction. Debra Singer provided vital preliminary research, and intern Huey Copeland enthusiastically undertook essential research that yielded much valuable information at several stages of the project. Interns Teka Selman and Carol Johnson also deserve thanks for their efforts.

I came to know and appreciate Bob Thompson's art through art historian Judith Wilson, assistant professor, University of California at Irvine, whose seminal work has been critical in establishing Thompson's place in the narrative of American art. Not only has Wilson provided the central text of this volume, but her vital research and curatorial assistance has added immeasurably to the success of both the catalogue and the exhibition. The gracious assistance and unparalleled encouragement of Carol Plenda Thompson, the artist's widow, gave me a wonderful insight into the world she and Bob shared. I am also indebted to Hilton Als, whose support and perceptive editorial insight helped make this publication possible.

I would like to express my appreciation to the many lenders who have generously allowed me to borrow from their collections: David Anderson and the Anderson Gallery, The Art Institute of Chicago, Elizabeth and Eliot Bank, Miki Benoff, Dr. Donald and Marcia Boxman, Jacqueline Bradley and Clarence Otis, Brooklyn Museum of Art, Janice and Mickey Cartin, Maurice

Cohen, Paula Cooper and the Paula Cooper Gallery, Curtis Galleries, Mr. and Mrs. Robert C. Davidson, Jr., The Denver Art Museum, The Detroit Institute of Arts, Dorsky Gallery, Nancy Ellison, The Walter O. Evans Collection of African-American Art, Mr. and Mrs. Stanley M. Freehling, Sally Gross, Solomon R. Guggenheim Museum, halley k. harrisburg and Michael Rosenfeld of Michael Rosenfeld Gallery, Martha Henry, Maren and Günter Hensler, Hirshhorn Museum and Sculpture Garden, the Hudgins Family, Katherine Kahan, Harmon and Harriet Kelley, June Kelly, Emily Fisher Landau, Elisabeth and William M. Landes, Ed and Diane Levine, Richard and Camila Lippe, Dr. and Mrs. Paul Todd Makler, Cornelia McDougald, Raymond J. McGuire, The Metropolitan Museum of Art, Robert Miller Gallery, Minneapolis Institute of Arts, Rachelle and Steven Morris, Donald and Florence Morris, The Museum of Modern Art, Munson Williams Proctor Institute, George R. N'Namdi Gallery, National Museum of American Art, The Newark Museum, The Oakleigh Collection, Ellen Phelan and Joel Shapiro, George Nelson Preston, Sheldon Ross Gallery, John Sacchi, Mickey Shapiro, Robert L. Shapiro, Edward Shulak, Meredith and Gail Wright Sirmans, Jim and Danielle Sotet, Carol Plenda Thompson, University Art Museum, University of California, Santa Barbara, Vanderwoude Tananbaum Gallery, Wadsworth Atheneum, George and Joyce Wein, and Andy Williams. Finally, I would like to thank the lenders to the exhibition who wish to remain anonymous.

Numerous other individuals have given their time, knowledge, expertise, and shared insights about many aspects of this project and I gratefully acknowledge them: Dr. Mary Schmidt Campbell, Gylbert Coker, Paula Cooper, Stanley Crouch, David Driskell, Gail R. Gilbert at the University of Louisville Library, Richard Gray, halley k. harrisburg and Michael Rosenfeld, Andrea Miller Keller, Klaus Kertess, Tommy LiPuma, Donald and Florence Morris, Elizabeth Murray, Edie Newhall, Lisa Phillips, Daniel Shulman at The Art Institute of Chicago, Elisabeth Sussman, Dorothy Tananbaum, Jack Tilton, Mary Ann Wilkinson at The Detroit Institute of Arts, Constance Wolf, and Virginia Zabriskie. Photographers Dirk Bakker, Paula Goldman, and Jerry Thompson provided a substantial amount of new photography that greatly enhanced the beauty of the book. I would especially like to thank Dorothy Beskind for her wonderful portraits and film, and Fred W. McDarrah for his amazing photographs of Bob Thompson. I wish I could thank Bob Thompson and that he could witness this deserved honor.

Thelma Golden
Curator

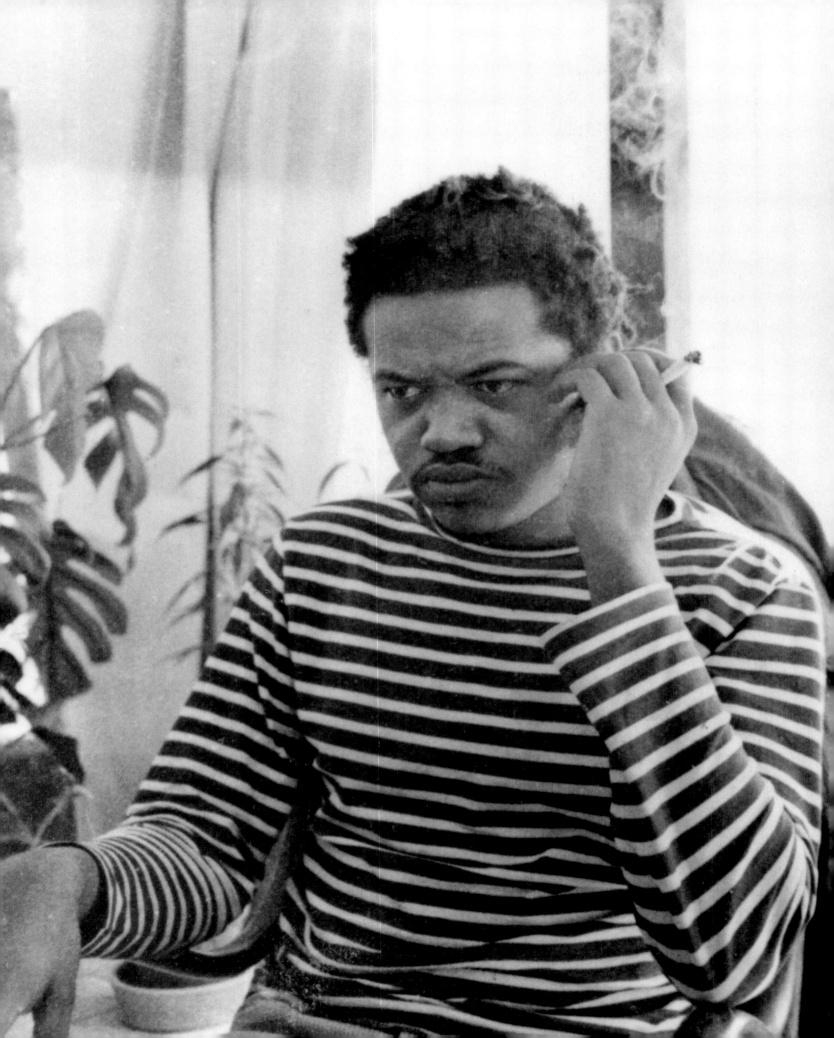

INTRODUCTION

...in a twisted sort of way I am doomed to be buried alive in cadmium orange, red, yellow light with flowers on my grave of magenta violet, and my casket being the canvas for forcefully having to wrap, walk, and slide into it everyday like the wan [P]russian blue shore and the shore the tree the leaf the wind the end.

— BOB THOMPSON [1]

Ten years ago, Judith Wilson described Bob Thompson as "the man in the middle." This exhibition seeks to insert Bob Thompson in the middle of a number of discourses, above all, in the discourses he established himself. Thompson's fame (and infamy) during his lifetime, combined with his early death, have created a mythology distinct from the discussion of his artistic achievements. But it is the work itself which must be seen in the context of a newly formed understanding of certain parallel aesthetic histories of the 1950s and 1960s. Thompson was a "black" painter in a time still dominated by the "Negro" artist. In other ways, too, he defied expectations: he was an appropriator before this term would be used positively to describe an aesthetic impulse, and he was a figurative painter working in the midst of Abstract Expressionism. Perhaps it is only in our present day of cultural and aesthetic diversity that an individualist like Thompson can finally be understood.

Like many who die young, Thompson remains fixed in a moment of youthful exuberance. His death at twenty-nine seemed to many untimely, although, given his fast-paced lifestyle and heroin addiction, ultimately unavoidable. Thompson's fame evolved from his art and his persona; both can be described as ardent, irrepressible, larger-than-life. He was like a force of nature—sweeping in, then sweeping out, leaving an indelible memory on all who encountered him. Thompson's art, too, was intense and emotional—figurative expressionism is the term often used (inadequately) to classify it. He was a narrative painter, enamored of images, real and imagined, but equally enthralled by the freedom, the painterliness, and the aesthetic bravado of Abstract Expressionism, not to mention the unfettered palette of the German Expressionists. At his most developed, Thompson melded abstraction into his figuration. It was an inspired synthesis, the creation of a style to serve his unique vision of a new contemporary art.

Robert Louis Thompson was born in Louisville, Kentucky, in 1937. His father owned the state's only black-run dry-cleaning plant and his mother held a degree from Kentucky State Normal School. Bob and his sisters were encouraged and expected to attend college and train for professional careers. Thompson graduated from high school and entered Boston University with the intention of pursuing premedical studies, but his grades and lack of interest brought this venture to a halt after a year.

Returning to Kentucky, Thompson entered the University of Louisville in the fall of 1957 to study art and to immerse himself in the city's active literary, theater, music, and art scenes. In the summer of 1958, he traveled to Provincetown, Massachusetts, where he met many of the artists who would become his peers in New York. After a solo exhibition at the Arts in Louisville Gallery in the winter of 1959, Thompson moved to Manhattan's Lower East Side. In 1960 he had his first show in New York at the Delancey Street Museum and married Carol Plenda.

4. Thompson in Ibiza, Fall 1962.

That spring, after receiving a grant, the Thompsons left for Paris. The effect of this first European trip and the others that followed was profound. After studying European painting in books, Thompson, visiting the museums every day, was now able to experience the works firsthand. The Thompsons stayed in Paris for two years, then went to the Spanish island of Ibiza; they remained in Europe until 1963 with the help of a Whitney Opportunity Fellowship (Fig. 4).

Back in New York, Thompson embarked on an impressive exhibition career. He had a one-artist exhibition at the Martha Jackson Gallery in 1963. In 1964 he showed with the Paula Johnson (now Paula Cooper) Gallery in New York and the Richard Gray Gallery in Chicago. The following year he again exhibited with Martha Jackson and Richard Gray and had his first exhibition in Detroit with the Donald Morris Gallery. He was also included in several group exhibitions and his work was being actively acquired by public and private collections.

After his 1965 Martha Jackson exhibition, the Thompsons returned to Europe. In Rome, Thompson continued to paint while studying the Renaissance masterworks all around him. Up to this point, his victories and his vices had been intertwined. But now hard living, heroin addiction, and a voracious appetite for excitement began to take a physical toll on the twenty-eight-year-old. Ignoring doctors and friends, who advised rest and moderation after a gall bladder operation in March 1966, Thompson remained immoderate in every way. Two months later, on May 30, 1966, he died in Rome of a drug overdose.

The story could have ended there. Though Thompson had achieved some degree of renown during his life, the American art world that he would have returned to was growing indifferent to figurative painting. After his death and a few memorial exhibitions, most notably the exhibitions organized by The New School in 1969 and in his hometown at the J.B. Speed Art Museum in 1971,[2] only a few true believers

5. Thompson and a friend at a café in Rome, Easter, 1966.

kept his memory alive. His biography became the stuff of legend: the young artist who lived hard and played hard; the black man in the center of a newly formed interracial Beat scene; the artist-expatriate who returned home triumphantly. Nevertheless, it was a decade before Thompson's art came up for reconsideration. In recent years, he has been labeled "ripe for rediscovery."[3] He is not simply in need of rediscovery, however, but of serious evaluation, one that will finally establish his place with his contemporaries and in the larger story of American art.

This task was begun valiantly by several institutions. An important exhibition was mounted by the National Collection of Fine Arts in 1975.[4] In 1978, Gylbert Coker organized an impressive retrospective of Thompson's work at The Studio Museum in Harlem, then under the direction of Mary Schmidt Campbell.[5] In the heady days of the late 1960s, when many museums of African-American art were formed, reclamation was the primary focus: the research, presentation, and preservation of African-

American art in order to expand the discourse around American art in general. Given the exhibition programs of most museums during this era, which in the best cases were simply oblivious and in the worst willfully exclusionary, institutions like The Studio Museum had a vast gap to fill. Like many retrospectives mounted at that time at The Studio Museum, this one was based on a few critical facts and more than a few unstated ideals.

Thompson was a perfect candidate for such a retrospective because he had pioneered a new identity for the African-American artist: he espoused neither the philosophy of the earlier figurative African-American artists who depicted the black experience nor that of the later abstract painters whose desires encompassed universality. He was a figurative painter who referenced the Western tradition, creating appropriations that were multicolored, but not entirely or essentially racialized—the ironies and horrors of racism are apparent in Thompson's work only if read through his biography and the burgeoning civil rights movement. Coker's catalogue essay not only provided data about Thompson's life, but also began to create an inspired framework through which the work could be understood.

In 1987, Thompson's art was again brought to public attention in the one-artist show organized by Kellie Jones and Judith Wilson at the Jamaica Arts Center. The following year, one section of "The Figurative Fifties" exhibition at the Newport Harbor Art Museum was devoted to Thompson's painting, and in 1990 he had a joint exhibition with William H. Johnson in Los Angeles. These three exhibitions created the crucial foundation for the present project. [6]

Two other enterprises are significant in the evolution of Thompson's critical fortunes. The first is the steady movement of his works into private and, more important, public collections. Since 1966, the Thompson estate has been represented by a number of galleries, all of which have sought to place his art in the public domain. [7] Their efforts and the burgeoning appreciation for Thompson have made him well represented in the nation's major museums and, if not immediately recognizable, at least somewhat familiar to museum audiences.

Most important, however, is Judith Wilson's research on Thompson, which resulted in a Ph.D. dissertation and the text in this volume. Wilson's work, her many lectures, shorter essays, and talks, laid the groundwork for the current reinvestigation of Thompson. Her approach is to contextualize Thompson within an art historical, cultural, and biographical matrix. The present exhibition, inspired and focused by Wilson's studies, is designed to provide a variety of experiences for different viewers. For those familiar with Thompson's work, it will serve as an occasion for reacquaintance. There will be some surprises even for the most ardent Thompson supporter, because a number of the exhibited works have not been seen publicly in more than thirty years. For those unfamiliar with the artist but knowledgeable about the era, the show illuminates 1950s figurative art. For those with an interest in African-American art, this project further expands the efforts to define the field. Whatever the viewer's vantage, it will emerge that Thompson's vision, though in some ways analogous to that of his peers and mentors— including artists Jan Müller, Christopher Lane, Jay Milder, Emilio Cruz, and Red Grooms, to name a few—was ultimately unique.

This exhibition also seeks to establish not only the artists who inspired Thompson—Poussin, Piero della Francesca, Bosch, Goya, etc.—but those whom he inspired. In the latter case, it is hard not to think about the painter Jean-Michel Basquiat (1960–1988) when considering Bob Thompson. It cannot be documented that Basquiat knew of Thompson, but such acquaintance is not impossible. On the day Basquiat died in August 1988, many, like myself, were stunned. Not only for the loss of Basquiat, but for the earlier

loss it recalled. Those a bit older, wiser, and/or wearier understood that history always repeats itself and the signs are usually clear. The similarities in the two lives are eerie: practices, personas, victories, and vices.

For viewers new to Thompson's work, the exhibition offers an intensive introduction to a highly talented mid-century artist who reads as clearly today as he did in his time. What makes this work seem fresh is Thompson's prescient concern for what we now refer to as issues. His interest in the past, his appropriative tendencies, and insistence on narrative all have analogues in contemporary practice.

This exhibition methodically presents Thompson's engaging career. Between 1959, the year of his first one-artist show, until his death in 1966, Thompson worked prodigiously, rushing, it would seem, to get it all down. He made many, many works; most very good, many truly great.[8] The more than one hundred works presented provide a visual parallel to Wilson's art historical and biographical narrative. Thompson's seven-year career falls into three phases that correspond not only to his natural growth as a young artist, but also to the expanding vision he gained during his travels. The pictures range in size from the truly miniature to the monumental. The exhibition focuses primarily on painting, with manifestations that lean toward drawings, other types of work on paper, and even a two-sided work which is slightly sculptural. There is a comprehensive selection of small paintings, many of them studies for the larger paintings on view. These smaller paintings almost form an exhibition within the exhibition.

The retrospective is organized chronologically, which allows an examination of the three phases in Thompson's development. The first phase is the formative period of 1959–62, a moment that coincides with Thompson's moves from Louisville to Provincetown to New York and then to Paris. This journey marks the metaphoric transition in Thompson's life away from his ancestral home to his life as an artist. These early canvases are unruly and full of raw emotion. The compositions are slightly distorted, the rendering of forms cryptic, and the depictions of the body and nature abbreviated. In all, the works of this period attest to Thompson's early attempts at a personal approach to figuration in relation to other artists of the day. These works rely on geometry and color to make their point; they rush, fast and hard, and set out a large terrain that Thompson would revisit for the rest of his career.

Thompson's first sojourn in Europe began in 1961, and his unbridled enthusiasm for the European paintings he encountered produced not only obvious references to these works, but also a painterliness indebted to the influence of his mentor, Jan Müller. Müller represented a group of artists that Thompson encountered in Provincetown who were committed to the idea that there were possibilities for innovation in figurative painting. The dissonant color and distorted drawing which characterize Müller's paintings had a profound effect on Thompson and inform his early paintings. *Le Poignarder (The Stab)* of 1959 (Fig. 47) centers around three frontal, flat figures, the most prominent being the pink, nude female torso and legs in the foreground. On the opposite side is another, less decipherable figure marked by a prominent yellow patch that reads as hair. The scene takes place outdoors, the background of the canvas filled with a blue patch of sky, a white patch of clouds, three stiff trees, and an expanse of green ground. The space is compressed, the perspective illogical. The title is ambiguous. Does it refer to some impending violence or perhaps a sly, crude sexual innuendo? In the middle of the picture is a black-hatted figure, an apparition that will appear and reappear throughout Thompson's career. The figure represents Thompson himself—not a self-portrait but a coded mark of his presence in and on the periphery of his pictures.

Le Poignarder also begins to exhibit a composi-

tional depth. The picture is divided between the fore-ground action and the background, which stretches into an undefinable region—a "someplace else" that is often signaled in Thompson's work by an unending path, a far-off mountain range or, as in this case, the hint of a distant forest.

An untitled painting from the next year exhibits a more sophisticated approach and exemplifies Thompson's increasing use of direct appropriation as a pictoral device (Fig. 61). The two seated nude women at center are lifted directly from Manet's *Déjeuner sur l'herbe*. Again with a broad hand, Thompson depicts these two and other nude females, along with fully clothed men, in a forestlike setting made psychedelic by his use of color. As in *Le Poignarder*, he begins with naturalistic definitions of color—the bodies approximate white flesh, the grass is green—but at the same time he veers into the unnatural. Distinct to this picture is the inclusion of a figure at the center who appears neither human nor animal. In a photograph of Thompson published in The Studio Museum catalogue,[9] he appears in front of a shelf featuring a wooden African sculpture that was clearly the source for the depicted figure (Fig. 6). Its presence in the painting suggests an ironic com-ment on the historic relationship between the primi-tive and the West, and on the appropriation of African art by modern artists, a dialectic which inevitably informs Thompson's work. Thompson's interest in African art was not widely documented or remem-bered, but he, like many African-American artists of his time, must have been curious about the burgeon-ing black nationalist advocacy of Africa and things African. He was aware of the attempts to characterize him as a primitive, a naïf, and he was also aware of those aspects of primitivism which critically informed modern art. Thus any reference to primitivism by Thompson carries a two-tiered meaning: it is both ancestral and aesthetic, with an edge of complicity and critique.

6. Thompson and Ornette Coleman in Thompson's studio on Rivington Street, New York, 1965. On the shelf behind them is the African sculpture that was the source for the central figure in *Untitled*, 1960 (Fig. 61).

Along with visiting museums and voraciously reading art books, Thompson was a regular and enthusiastic patron of jazz clubs and a fan and friend of many of the major players of the day. The connec-tion between his Abstract Expressionist peers and jazz musicians has been well documented. Abstract Expressionists found the freedom of jazz liberating and instructive and created its corollary in visual form. As Wilson discusses below, Thompson was equally, although differently, affected by the music. In the ability of these musicians to take a standard song and make it their own, he saw a direct relation to his working process of appropriation or interpreta-tion. He embodied the "hot" and the "cool" of the music of this era. And just as jazz musicians strove to find their own voice, their "sound," Thompson sought self-expression through the visual vocabulary he was developing.

Ornette of 1960–61 (Fig. 69) is a portrait of the jazz musician and composer Ornette Coleman. Coleman was a friend of Thompson's, and they admired each other's work. Thompson here depicts Coleman in the center of the canvas from four vantage points—one frontal view, two in profile, left and right,

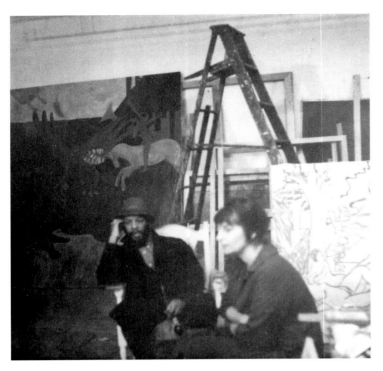

7. Ornette Coleman and Carol Thompson in Thompson's studio on Rivington Street, 1965.

and one in bird's-eye perspective. Ringing the canvas are vignettes depicting female figures in a variety of poses—reclining, sitting, in groups and alone, perhaps copied from images in books. The picture, with its peculiar circular sequencing, suggests that Thompson wanted to create a visual form analogous to the complex, nonlinear music Coleman was creating. Thompson uses this same compositional device in a later painting, *Cathedral* (1963; Fig. 92), where he recreates the vertiginous effect of viewing stained-glass windows by placing the figures in a circular fashion around a brilliant sunburst in the middle of the canvas.

Christ and *L'Exécution*, both of 1961 (Figs. 73, 74), are loaded images of death and martyrdom. *L'Exécution* shows a black, blindfolded body hanging from a tree while a group of people look on. Though the title is general, the image itself recalls a lynching, an act which still consumed the thoughts of many African-Americans. *Christ* appropriates the classic Christian composition of the *Lamentation* and is one of the many works in Thompson's oeuvre that features traditional Christian iconography. The idea of redemption, as expounded in Christian dogma, seemed to fascinate

Thompson. At a moment when many of his contemporaries were rejecting conventional religious beliefs, he seemed to exploit them—not so much as an act of faith but for the narrative potential he saw in sacred art.

The 1962 canvas *Tree* (Fig. 83) exemplifies the second phase of Thompson's career (1962–64), which is marked by a formal evolution and intensification of thematic concerns. Thompson now typically established the composition with large, flat areas of color that delineate figures or abstract shapes. In *Tree*, a monumental 9-foot-wide canvas, a red-haired, winged woman grasps the trunk of a tree; a red humanoid creature to the right struggles with a white animal who is being attacked by a brown creature emerging from the bottom of the canvas. The painting is full of psychosexual drama. The bestial couplings can be read as carnal as well as brutal. Thompson, whose depictions of sex are always coupled with violence, is obsessed with the struggle between the conscious and the unconscious. The paintings are the realization of the hallucinations and emotions that consumed him. In his work, passion and fear are corollary emotions.

The paintings of 1963, made toward the end of the second phase, represent a decisive shift in Thompson's vocabulary. At this point, he and his wife, Carol, had returned to New York, and he had again set up a studio on the Lower East Side. The compositions of this year became more abbreviated and focused on a single central action or idea. As Thompson's narrative sensibility developed, he gave the faces clearer suggestions of emotional expressiveness, perhaps as a nod to portraiture, but certainly in order to intensify the narrative. The action in *Descent from the Cross* (Fig. 93) takes place in an indeterminate space. The cross is a gnarled, treelike form surrounded by bird and female creatures. Elsewhere in this volume, Shamim Momin reads the omission of the male mourners traditionally included in the *Descent* scene and the dominant presence of three

female figures as a reflection of Thompson's complicated relationship with women.

Among the other figures in *Descent from the Cross* is a blue-bodied, green-winged Christ who has just been taken down from the cross. The added wings help transform the familiar iconographic moment of descent into a proleptic ascent: Thompson was always attracted to stories that implied the possibility of physical and psychological freedom. The visual emphasis on wings throughout the canvas also reminds us that flight—undertaken to escape fear or seek freedom—is a constant theme in Thompson's art.

The setting of *The Spinning, Spinning, Turning, Directing* (Fig. 108), also of 1963, is spatially ambiguous: the tree seen through an archway reads as background, but the space in front of it cannot be logically calibrated. The figures are taken from three different plates in Goya's *Los Caprichos*, a pessimistic series of etchings published in 1799 that presents a turbulent world of debased, barely human creatures. Thompson's interest in the fantastical component of Goya's work is evident. The flying bird and the tumbling woman inhabit a nightmarish nether region. Here also we can see that Thompson was obsessed with making sense of all he saw in Europe, working feverishly to capture as much of it as possible on canvas. In his energetic mind, the processes of looking, thinking, and making collided as he synthesized older imagery with his own thoughts and fears.

From 1964 on, in what we can consider the final phase of Thompson's work, the artist thoroughly combines the appropriated and the imagined. These paintings, even more intensely hued than before, show a more complex, definitive figurative thrust and a new coherence of Thompson's Old Master sources and thematic concerns: mythology and religion, death, and sex and passion.

Massacre of the Innocents (Fig. 122) is thematically inspired by the standard Old Master image depicting Herod's slaughter of the male infants of Bethlehem after Christ's birth. Thompson's version insinuates the narrative's sense of violence and horror through garish reds, yellows, and oranges and the frenzied brushstrokes of the sky. In the *Adoration of the Magi (After Poussin)*, Thompson punctuates the canvas with the same intensely warm hues (Fig. 99). The figures, assembled in procession across the canvas, adore not a traditional Christ Child, but a blue bird perched on the lap of a yellow woman. It is a striking substitution which demands to be read as an indication of the deeply personal (though sometimes inexplicable) narrative currents which drift through Thompson's work.

Two images of this period testify to Thompson's working process. *Sacrament of Baptism (Poussin)* and the *Saving of Pyrrhus (Poussin)* are both drawings on canvas (Figs. 127, 129). Using felt-tip pen, ink, and pencil, Thompson traced out the original compositions and then placed them in an imagined landscape of his own design. Seen in black-and-white reproduction, they merely seem to document Thompson's close study of compositional conventions of European art. When viewed in relation to the larger body of Thompson's work, as they are in this exhibition, they make clear how reliant Thompson was on color. It is with color that Thompson made his most critical interventions, using it to introduce his personal mark, to make the real dreamlike, the pious perverse. In *Mars and Venus* (Fig. 121), the mythological lovers lie in sensual repose. Venus is blue, Mars a brilliant red. They sit against multicolored trees in a multicolored sky. Even Thompson's treatment of the sky includes colors from the composition below mixed in with the white clouds.

Much has been made of Thompson's multicolored people. They are often read, perhaps misguidedly, as a purely nonracial statement. But it is more

complex than that. Thompson was working in the years when civil rights leaders were advocating the use of the word "black" instead of "colored" to describe African-Americans. Another artist might have substituted black figures for the white Europeans of his sources as an expression of racial politics (as Robert Colescott did two decades later). Thompson, however, through his wild chromatics, rejected such racial coding, choosing instead to play on the very word "color."

Personal symbolism, which had been developed in Thompson's earlier work, also informs these late paintings. The ever-present bird imagery now becomes a dominant motif. If the hatted man is Thompson "in the flesh," the birds represent him in spirit. Birds abound in most of these paintings, and they are crazed, caught creatures. *Bird Party* (Fig. 75) features them in a sensual dance with the female figures. In a small untitled painting of 1963, the bird is an attacker, slaying the human figure on the ground. In both versions of *The Death of Camilla* (Figs. 116, 117), birds are held aloft in the solemn procession, denied the freedom to fly. (The pictorial source of Thompson's paintings is unknown. The reference in the title is to Camilla, a maiden in pre-Roman Italy whose story is told in Virgil's *Aeneid*.) In the *Saving of Pyrrhus (Poussin)*, birds hover in the foreground, their spread wings echoed in the spanned arms of the procession of people at center. Thompson uses birds to personify human emotions and act out the emotional content of the paintings. It is easy to read Thompson in these dynamic birds, in their violence, their captivity, their beauty, their menace.

Although Thompson was consumed by the Old Master art through which he expressed his inner life, he was no less engaged in the world beyond his studio. In New York and in Europe, he and his wife were part of the wide-ranging Beat community. *LeRoi Jones and His Family* and *Portrait of Allen* (Figs. 151, 152) document two of Thompson's Beat friends.

Thompson himself was in many ways a quintessential Beat. When Lisa Phillips described the Beat experience as "the ecstatic, the horrific, the beatific and the beaten,"[10] she could also have been describing Thompson's work and life. *LeRoi Jones and His Family* portrays Jones and his wife, Hettie, also a writer, as serious and direct. The subdued tones and unfettered brushstrokes represent a style that Thompson reserved for these portraits. The Jones' young daughters, Kellie and Lisa, are portrayed less precisely, with Kellie as a small figure, similar to some of the angels in earlier pictures, and Lisa as a green-swaddled creature at lower right. Allen Ginsberg was painted when he was visiting Thompson's studio. The background is akin to the more calculated abstraction that Thompson was incorporating into the backgrounds of the late landscapes. Ginsberg, a Buddhist, is portrayed sitting on a chair in the lotus position with a sheaf of papers (perhaps something he brought to read to Thompson) scattered on the floor in front of him. These two paintings, in which Thompson leaves the imaginary to document those in the intensely creative world around him, mark a small, but important part of his oeuvre.

Two last works speak directly to Thompson's mental state at the end of his life. *Untitled (The Operation)*, a small crayon-on-paper drawing of 1966 that appropriates classic *Creation of Eve* iconography, depicts an attenuated, anguished body (Fig. 156). The picture testifies to Thompson's use of Old Master themes to document his own experiences and emotions. The abdomen is sliced open, the gash bloodied—an obvious reference to Thompson's gall bladder operation, which, according to Carol Thompson, he had postponed for a long time. The picture insinuates that Thompson was overwhelmed by his physical deterioration as well as his fear of death. *View from Hospital* (Fig. 157) is a careful line drawing of the view outside his Italian hospital window. Inside the window frame, in the hospital room, there was a small

arrangement of flowers which Thompson depicts in color. The rest of the scene—the window and the outside view—is drawn in black-and-white.

Thompson's time in the hospital undoubtedly made him reckon with his own mortality. Contemporary accounts from friends suggest that, while sobered by his condition, Thompson was eager to get back to working and living at his former frenetic pace. The barely begun canvas which Carol Thompson identifies as her husband's last work shows him returning to art in his typical style and scale (Fig. 158). It is a large composition that only went as far as the colored outline underdrawing, leaving us to imagine what would have been.

A chronological view of Thompson's work, such as that just presented, tells only one story—and it is a flawed one. Thompson's peripatetic movement and far-ranging mind indicate that he did not work in a linear fashion. Like the jazz musicians he admired, he seemed to be constantly improvising on himself—moving around similar compositions, emphasizing a different aspect in each new statement. Stylistic devices and scale keep shifting and the themes appear and reappear.

There is also the issue of appropriation, which, when considered outside the iconographic readings of the paintings, is vexing. In current parlance, Thompson would be considered an appropriator. But that definition narrowly and perhaps inaccurately describes the more complex thrust of this act in his working method. Appropriation now often implies a critique which was not a part of Thompson's project. And there are many in the field who belittle Thompson as simply a copyist. And still others say that these adaptations of Western art were an assimilationist tactic. In a bizarre, minority approach, some observers divide the works into two categories: those in which Thompson was trying to paint like an acceptable "white" painter and those in which he was painting

as his true, authentic "black" self. This division, however, denies that Thompson was in fact a curious mix of both.

Perhaps Thompson can be best understood in the present—but from a vantage that turns to the past. Henry Louis Gates, Jr., has brilliantly defined the concept of "signifyin'" as a cultural construction, which perhaps begins to describe the aesthetic attitude that Thompson worked in or around. Signifyin' is a black vernacular language structure in which meaning is inscribed through revision, repetition, and conscious misappropriation. The first chapter of Gates' book *The Signifying Monkey* begins with an epigraph quoting Frederick Douglass. Gates uses the Douglass quote to speak to the political, cultural, and ideological tradition of copying in African-American culture.

> *I then commenced and continued copying the Italics in Webster's Spelling Book, until I could make them all without looking on the book. By this time, my little Master Thomas had gone to school, and learned how to write, and had written over a number of copy-books. These had been brought home, and shown to some of our near neighbors, and then laid aside. My mistress used to go to class meeting at the Wilk Street meetinghouse every Monday afternoon, and leave me to take care of the house. When left thus, I used to spend the time in writing in the spaces left in Master Thomas's copy-book, copying what he had written. I continued to do this until I could write a hand very similar to that of Master Thomas. Thus, after a long, tedious effort for years, I finally succeeded in learning how to write.*[11]

So the act of copying, in this context, becomes a surreptitious claim to power and equality, or rather to the power that can be gained through equality. It is about what is given and what must be taken or claimed. This is Douglass' implication. Like Douglass, Thompson understood the power of the works he used and their place in the history of art. Western art

offered him something which he assumed was his right to use freely. He also was clear about his desire to make these works his own: inflect their vocabulary with his grammar; infuse the agreed-upon meanings with his intention. To claim them. To signify. He says: "Why are all these people running around trying to be original when they should go ahead and be themselves and that's the originality of it all just to be yourself."[12] Thompson's art lay not simply in the restatement, but in the revision and replacement of these familiar passages—a philosophy that brings him into a direct affinity with his jazz musician contemporaries as well as with an entire generation of African-American artists who followed his strategy.

Today, Thompson's most direct and frequently cited heir is the painter Robert Colescott. For over twenty years, Colescott has been creating a body of work that comments on and critiques art history while exploring attitudes about race and gender. His restatements are biting and funny in their unrelenting honesty. Thompson's influence can also be seen in the works of other artists who take on art historical traditions and the idea of ownership, for example, Fred Wilson's methodological investigations into culture and art. Thompson's approach to narrative has a contemporary peer in Kara Walker's silhouettes, which reimagine American history, and in Glenn Ligon's text paintings, where narrative is literally reduced to text, and process to the copying of that text.

Thompson worked fast and furious in his short eight years, and it is clear that he was trying to create something new. Given his early demise, and the iconographic approach other historians have taken toward his life and work, conjecture about where Thompson would have ended up artistically had he lived seems like a huge leap—a leap one shouldn't make, given his formidable achievement staring us right in the eye. That he lived and changed the ways in which we look at figuration, Abstract Expressionism, bebop, the whole cool world through vibrant, violent, yet considered images is enough.

1. Bob Thompson, undated letter to his family, quoted in Michael Rosenfeld, *Bob Thompson: Heroes, Martyrs and Spectres*, exh. cat. (New York: Michael Rosenfeld Gallery, 1997), p. 3.

2. New School for Social Research, New School Art Center, Wollman Hall, "Bob Thompson (1937-1966)," 1969, and J.B. Speed Art Museum, Louisville, "Bob Thompson 1937-1966: Memorial Exhibit," 1971.

3. Ann Landi, "Ripe for Discovery," *Art News*, 95 (November 1996), p. 118.

4. National Collection of Fine Arts, Smithsonian Institution, Washington D.C., "Bob Thompson: 1937-1966," 1975.

5. The Studio Museum in Harlem, New York, "The World of Bob Thompson," 1978.

6. Jamaica Arts Center, New York, "Bob Thompson," 1987; Newport Harbor Art Museum, Newport Beach, California, "The Figurative Fifties: New York Figurative Expressionism," 1988; and California Afro-American Museum, Los Angeles, "Novae: William H. Johnson and Bob Thompson," 1990.

7. In addition to Martha Jackson and Donald Morris, Thompson was represented during his life by Richard Gray and then posthumously by Vanderwoude Tananbaum. The estate is now represented by the Michael Rosenfeld Gallery.

8. Some estimate that Thompson created more than a thousand works in various media during his career.

9. *The World of Bob Thompson*, exh. cat. (New York: The Studio Museum in Harlem, 1978), p. 2.

10. Lisa Phillips, "Beat Culture: America Revisioned," in *Beat Culture and the New America 1950-1965*, exh. cat. (New York: Whitney Museum of American Art, 1995), p. 33.

11. Henry Louis Gates, Jr., *The Signifying Monkey: A Theory of African-American Literary Criticism* (New York: Oxford University Press, 1988), p. 1.

12. *The World of Bob Thompson*, p. 19.

GARDEN OF MUSIC

THE ART AND LIFE OF BOB THOMPSON

INTRODUCTION

A lone dark star in the artistic firmament of the first half of the 1960s, Bob Thompson achieved early on an unusual degree of success, based in part on his unconquerable ambition: he was only twenty-one and still a student at the University of Louisville when he made his first sale to a major collector, Walter P. Chrysler, during a summer 1958 stay in Provincetown, Massachusetts. And although he has been described as "soft-spoken," "laid back," and "an introvert,"[1] Bob Thompson was a man in a hurry. Writing to his mother while still in his early twenties, he described himself as "a man who changes constantly," adding, "which means progression in my book as long as one progresses there is no stopping."[2]

For the next seven years, there seemed to be no stopping Robert Louis Thompson as he raced from his native Kentucky, first to Provincetown and New York—crucial sites for American artists of his time—then to Paris and eventually Rome—creative meccas for American artists of the past. Along the way, he instinctively gravitated toward aesthetic vanguards, taking part in several of the earliest Happenings;[3] exhibiting at Lower Manhattan's first artist-run alternative space;[4] "studying" performances by musicians who reinvented jazz nightly at such downtown venues as the Five Spot, the Jazz Gallery,

and Slug's;[5] and appearing silhouetted in profile in an unidentified photograph on the cover of *Kulchur*, a seminal journal of sixties literature and nascent countercultural thought.[6] Through it all, Thompson painted feverishly, sometimes working on "three or four pictures at the same time," painting while friends drifted in and out of his studio, and music—ranging from the Beatles to James Brown or Bob Dylan to Thelonious Monk—blasted.[7]

The results were rapidly rewarded. Less than a year after his arrival in Manhattan, Thompson had his first New York one-artist exhibition, at the Delancey Street Museum.[8] Two months later came a two-artist show at the gallery of Virginia Zabriskie, a highly regarded uptown dealer.[9] Married by the end of 1960 and equipped with a Walter Gutman Foundation grant,[10] Thompson, with his bride and a collector friend, departed for Europe on the *Queen Elizabeth*, a mere two years after the young painter had set out from Louisville with a load of canvases tied to the roof of his decrepit black Oldsmobile coupe.[11]

"Bob had a gigantic jet engine driving him," is the way poet Amiri Baraka put it. "He took everything to extremes. He had a passion for life."[12] While this voracious appetite for life accounts for Thompson's meteoric rise to art stardom at a time when that phenomenon was just beginning in the US, the artist's passionate excesses would also lead to his early death.

8. Thompson painting in his studio, 1959.
Photo copyright © by Fred W. McDarrah

Indeed, his biography contains a seed of tragedy planted at a crucial juncture—the loss of his father at the onset of puberty.

To fellow painter Emilio Cruz, Thompson's "vision...was [fixed] on death," and he had "a method of carrying [it] out." Cruz thinks Thompson was not yet "into" drugs when they met in Provincetown during the summer of 1958. But he recalls Thompson's claim to have been previously initiated into heroin use by a prominent musician who had visited Louisville while on tour. The painter's subsequent addiction coincided with a "plan" to die young, Cruz feels.[13] At a twenty-ninth birthday celebration for a mutual friend, Thompson had prophetically declared, "I'll be dead by the time I'm twenty-nine."[14]

Dorothy White, the widow of William White, another black painter whose early death stemmed from heroin addiction, owns a small gouache that Thompson painted over a reproduction of the central group in Théodore Géricault's *Raft of the Medusa*. In this updated version, Géricault's figures are covered head-to-toe with lemon yellow pigment, the sky is royal blue, and the sea has turned inky black. Only the red cloth—with which the central figure attempts to hail a distant vessel—retains its original hue, here given an acid orange tinge consistent with the overall temperature of the transformed work. "That's the Bob I knew—waving that red flag...for help," White comments.[15] Yet, if his frantic work pace, chronic substance abuse, and sexual voracity struck some as signs of acute distress or willful self-annihilation, to others his private excesses merely seemed consistent with his enormous charisma and outsized talent.[16]

Since Bob Thompson's death, his art has been the subject of a retrospective at the New School for Social Research (1969) and a memorial exhibition at the J.B. Speed Art Museum in Louisville (1971); there have been surveys at the University of Massachusetts at Amherst (1974), the National Collection of Fine Arts (1975), and the Studio Museum in Harlem

(1978). Today, the list of institutions that possess examples of his work includes The Art Institute of Chicago, The Detroit Institute of Arts, the Hirshhorn Museum and Sculpture Garden, The Metropolitan Museum of Art, the Minneapolis Institute of Arts, The Museum of Modern Art, the National Museum of American Art, the New Orleans Museum, the Solomon R. Guggenheim Museum, the Wadsworth Atheneum, and the Whitney Museum of American Art.

Yet Bob Thompson's posthumous reputation has been obscured for several reasons. Having exhibited professionally for only eight years, three of which he spent abroad, Thompson died before the critics of his time could absorb his distinctive vision. His work remained peripheral during the next two decades because its stylistic language—figurative expressionism—confounded formalist accounts of recent art history, in which sixties Op, Pop, and Minimalism became the unchallenged successors to fifties Abstract Expressionism. And finally, because his career ended just as a new era in African-American art was beginning—an era marked by the emergence of the black consciousness movement during the second half of the 1960s—Thompson's preoccupation with the European tradition now seems anomalous.[17]

Paradoxically, however, it is precisely this engagement with tradition that points beyond Bob Thompson's brief stardom to his lasting importance. For that importance hinges upon what Michael Brenson has described as the artist's attempt "to paint all the history of art into one whole."[18]

Behind each artist there stands a traditional sense of style....It is something which the artist shares with the group, and part of our boyish activity expressed a yearning to make any- and everything of quality *Negro American*; to appropriate it, possess it, re-create it in our own group and individual images.

— RALPH ELLISON [20]

Bob Thompson's parents were part of a black elite. His mother, Bessie S. Thompson, had earned a degree from Kentucky State Normal School and his father, Cecil Dewitt Thompson, was a graduate of a Paducah, Kentucky, vocational school. Theoretically, the social aspirations of Thompson's parents placed their son in the period's black middle class. But within a year of his birth in Louisville, where his parents had owned a small restaurant, or "chicken shack," the family relocated to the small town of Elizabethtown, Kentucky, [21] about forty miles south of Louisville, which removed Thompson from the close-knit social matrices of the urban black bourgeoisie. His father's tendency to discourage associations with the area's other blacks further isolated the boy. The younger of Bob Thompson's two sisters, Cecile Thompson Holmes, remembers that her brother had no close friends during his childhood in Elizabethtown, and adds that the same was true for her and her sister. Their father wanted them "to be different" and feared they would be contaminated by contact with youngsters from less fortunate backgrounds.

For Thompson's parents, Elizabethtown signaled a return to familiar ground and a chance to continue improving their family's fortunes. Bessie Thompson had taught previously in Elizabethtown and Cecil had worked there in a dry-cleaning establishment. In 1938, he went into business for himself as a dry cleaner. Eventually he would own two outlets at nearby Fort Knox and a plant in Elizabethtown, the first such operation in the state to be owned by a black.

For a period, he and his wife also managed a country club. [22] By the time Bob Thompson was three or four, his mother had also resumed teaching, this time at a one-room school in Glendale, Kentucky. The school year started in August and ended in April, when every hand was needed to bring in the local harvest of string beans, corn, and other produce. While Bessie Thompson taught, her preschool-age son stayed with a childless woman, Mrs. Murrell, who lived "down the lane" and owned "a couple of nags, a cow and a pig." A true country woman, whom one of the artist's two sisters describes as "witchy-looking," Mrs. Murrell chewed tobacco, dipped snuff, and made quilts. Both of Thompson's sisters recall that their younger brother's only contact with farm life took place during his stays at Mrs. Murrell's, where he learned to ride a horse bareback and was taught to milk a cow. [23]

"My man" was what Cecil Thompson always called his son, to whom he spoke almost as if he were an adult and with whom he frequently traveled. Virtually inseparable, they were known as "Bigshot" and "Shot." Thompson came to share many of his father's personality traits, ranging from his keen sense of personal style to his insistence on being a

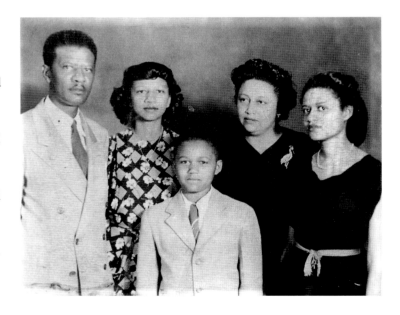

9. Bob Thompson as a boy with his parents and sisters, c. 1945. Left to right: Cecil Thompson, Cecile, Bob, Bessie Thompson, Phyllis. Margaret M. Bridwell Art Library, University of Louisville.

friend of the underdog. Bob Thompson was a man who did everything intensely.

On the evening of November 30, 1950, when Thompson was thirteen, his father's delivery truck was forced off the road and overturned; Cecil Thompson was fatally injured. For the extremely sensitive boy, Cecil Thompson's sudden demise was devastating. "His whole world fell apart," his sister Phyllis said.[24] Phyllis Cooper never saw her brother cry over their father's death, but she recalls that when Cecil Thompson's clothes were brought home from the mortuary in a box, the boy asked for the box, which he took to his room, then closed the door.

Soon after her husband's death, Bessie Thompson was diagnosed as suffering from diabetes—a condition that Phyllis, her nurse-daughter, attributes chiefly to "stress."[25] After the loss of her spouse, she turned increasingly to her son, doting on him and spoiling him to an extent that he would eventually find stifling.[26]

Thompson succumbed to a series of illnesses shortly after his father's death. First he developed hearing problems. Next, a case of mumps triggered encephalitis, sending him into a coma for three days. Shortly afterward, he began complaining about headaches—headaches that would continue to plague him for years. Hoping that a new environment would ease some of the pain, his sister Cecile and her husband, Robert Holmes, a cartographer at Fort Knox, took the distraught teenager to live in their Louisville home. Once there, Thompson drew even closer to his brother-in-law, to whom he was already attached. The one artist in Thompson's family, Holmes would eventually play a crucial role in the youth's break with his parents' bourgeois aspirations. By his own account, Holmes had exerted a significant influence on the youth. He had first met Thompson when the boy

> *...was nine or ten years old. I was stationed at Fort Knox as an artist in the Army, and was courting his*

sister, Cecile. When he found out that I was an artist...he would make drawings that he frequently showed me....[27]

Prior to his father's death, Thompson had attended Elizabethtown's "colored school," Bond-Washington.[28] After his move to the Holmes house in Louisville, he attended Madison Junior High School—another black institution—then went on to Central High School. "[M]ore than any other institution or activity," historian George C. Wright has noted, Central High School "united black Louisville."

> *Practically every black (or so it seemed) had an affiliation with the school, either as graduates, as parents of students, or as employees. Identity in the black community was in part derived from being a Central graduate, and each graduating class was associated with a certain event....Louisville blacks attended different churches, maintained loyalty to numerous fraternities, sororities, social clubs, and cliques. But they had only one high school.*[29]

African-Americans "equated Central with academic excellence, discipline, and fine teaching," although its "buildings and facilities were...inferior to [local] white high schools"—a disparity that reflected the artificial ceiling placed on black aspirations, since many of the group's "best and brightest" were limited to teaching careers in segregated schools. In addition to a "top-quality" general education, Central students received a "heavy dose of Afro-American history and culture...dished out in classes and assemblies [that] helped blacks gain an important measure of self-respect."[30]

Raised within the central African-American institutions of family, the black Baptist church, and black schools, Bob Thompson was at home in the black world; nevertheless, he was also too restless and too proud to yield to externally imposed boundaries. Despite an increasing need for freedom, Thompson

remained emotionally attached to his mother. In 1955, after graduating from Central High, he turned down a scholarship offer from a small college in California because it was opposed by his mother, who did not want him to go that far away. During an August visit to his sister Phyllis, now married and living in Cambridge, Massachusetts, he applied for and was awarded a full scholarship to Boston University, through the Reserve Officers Training Corps.[31] He moved in with his sister, her husband, and their first child. However, Thompson's grades were so dismal that in 1956 he decided to withdraw from the premed program at the university at the end of his freshman year. At Robert Holmes' suggestion, Thompson returned home and enrolled in the Art Center Association and, in the fall of 1957, at the University of Louisville. He now began to focus on an art-related career.

THE ARTS IN LOUISVILLE

In September 1957, Americans stationed in front of TV screens across the nation watched in stunned silence as armored tanks and helmeted battalions of the 101st Airborne Division of the US Army moved through the streets of Little Rock, Arkansas, where they had been sent by President Eisenhower to enforce the Supreme Court's historic 1954 school desegregation ruling. By contrast, in neighboring Kentucky, Bob Thompson's hometown had implemented the nation's "first successful school integration plan" a year earlier with little fuss.[32]

Race relations in Louisville mirrored the city's ambiguous location. Neither typically Southern nor truly Northern, it had been a bastion of antebellum slavery, yet stayed loyal to the Union during the Civil War.[33] After the war, Louisville remained free of the anti-black riots and lynchings that were widespread elsewhere. "Unlike their counterparts in [other parts of] the urban South," African-Americans in Louisville had voted from the 1870s on; throughout the twentieth century, they sat wherever they pleased on local buses and the city voluntarily began admitting them to its university in 1951.[34] Thus Bob Thompson's shift from the all-black schools of his childhood to the predominantly white University of Louisville took place in an oasis of civility in the midst of growing strife over civil rights in the South. However, even in Louisville—where it remained legal for private establishments to refuse service to blacks until the early 1960s—African-Americans faced deeply entrenched racial barriers.[35]

Louisville in the late 1950s was nevertheless a surprisingly cosmopolitan place. Cool jazz was big there, and during the years that Thompson lived with Robert and Cecile Holmes, he heard recordings of Charlie Parker, Thelonious Monk, Miles Davis, and Stan Getz.[36] Hailed in a *Life* magazine article as a manufacturer of "bourbon, burley tobacco, baseball bats," and as the home of the Kentucky Derby, Bob Thompson's hometown was touted as the site of a "cultural explosion."[37] Unidentified, but clearly recognizable, Thompson appears in an Alfred Eisenstaedt photograph that illustrates the article. He is shown seated in the front row at a lecture on Elizabethan theater at the Shakespeare Society, an organization affiliated with adult education at the University of Louisville.[38]

A "closet artist" at Central High School, Thompson had claimed to be too shy and insufficiently talented when a classmate at the University of Louisville, Robert Carter, urged him to apply for one of the Allen R. Hite Art Scholarships—which Thompson was awarded during his second semester at the university in 1957. He would continue to be awarded this grant each semester he remained on campus, relinquishing it only in January 1959, when he withdrew from the university.[39]

Along with the acclaimed African-American painter Sam Gilliam, who was also a student at the

Art Center Association during the fifties, Thompson studied with a number of German refugees whose Fauve and German Expressionist traits directly influenced his work. The faculty's most remarkable German member was Ulfert Wilke. Born in Munich in 1907, he was the son of a prominent Jugendstil cartoonist, Rudolf Wilke, a celebrated early illustrator for the famed satirical journal *Simplicissimus*.[40] Ulfert Wilke continued his training in Paris during the late 1920s, then traveled widely in Europe before emigrating to the United States in 1938. In the US, he was an arts administrator or teacher at various locations before moving to the University of Louisville in 1948.[41]

By the fifties, Wilke was making large-scale canvases. Unlike Mark Rothko and other leaders of the New York School, he wove a mesh of calligraphic marks across the picture plane in a manner reminiscent of Mark Tobey's art. Although Wilke played a crucial role in popularizing German Expressionism among his colleagues and students and Louisville collectors, he was also thoroughly versed in the rest of European modernism and in contemporary American art, and had a keen eye for objects from non-Western cultures. This extraordinary range of knowledge, taste, and social references was irresistibly attractive to Bob Thompson.

Yet evidence provided by Wilke's diary and by Sam Gilliam suggests that the peripatetic German's relationship with Thompson was ambivalent. Two of the three brief entries in which Wilke mentions Thompson concern the instructor's jealousy of his former student, with whom the older man was competing for the attentions of a flirtatious model.[42] The third entry describes a visit Wilke paid to Thompson's studio in January 1959, not long before Thompson withdrew from the University of Louisville. At the time, the young painter either was currently or had been recently Wilke's studio assistant. Wilke's assessment of Thompson's art was unenthusiastic. Of the "many...large paintings" that were "all over" the studio,

Wilke writes, "[t]he best he did in our studio; alone only little things developed."[43]

In Gilliam's view, Wilke's love for African art "led him to have empathy for his black students," but he "wanted to remain the Great White Father." The effects of this racial double standard were not all bad, though, "because they made you stronger."[44] Or, as Bob Thompson once quipped, "There's no way you can *not* like Wilke—because he brings out the worst in you!"[45]

While Wilke and other European artists on the faculty gave Thompson's Louisville training a decidedly international flavor, two American painters, Mary Spencer Nay and Eugene Leake, also substantially influenced his development. As an artist and educator, Kentucky native Mary Spencer Nay was deeply entwined with the history of art instruction at the University of Louisville. Her own training had begun in 1925, at age twelve, as a member of the Children's Free Art Classes, a program initiated that year by Miss Fayette Barnum, as she was always called, a future founder of the Louisville Art Center and first director of its institutional successor, the Art Center Association. After graduating from Louisville Girls High School in 1931, Nay studied at the recently opened Art Center.[46]

In 1935, and from 1944 to 1949, Nay served as the director of the Art Center Association. In 1950, she resigned her administrative post in order to devote more time to painting.[47] During Bob Thompson's years at the university, Nay taught painting, lithography, and art education at the Art Center Association's school.[48]

In contrast to the Fauve-Expressionist-Abstract Expressionist tendencies to which Thompson was exposed by Wilke, Nay's art exhibited a moody, quasi-abstract Surrealist orientation; she had arrived at this mode through a series of shifts from a Bentonesque, expressionistic Social Realism to an increasingly fluid, spatially ambiguous, biomorphic abstraction.[49]

Eugene Leake contributed to Thompson's creative evolution in a different way. A 1934 graduate of the Yale School of Fine Arts, during the late thirties he had his first one-artist show at a New York gallery and assisted in the creation of a mural for the 1939 New York World's Fair. Like Nay, he participated in the 1942 "Artists for Victory" exhibition at The Metropolitan Museum of Art.[50]

Louisville was Leake's wife's hometown, and after the war the couple moved there. In 1949, when Mary Spencer Nay stepped down, Leake became the Art Center Association's new director, a position he would hold for the next decade.[51] More than any of Thompson's other painting instructors, Leake was a "realist"—a painter of meteorologically precise, Impressionist-inspired landscapes and intimate, domestic portraits.[52] According to painter and faculty member Frederic Thursz, Leake's watercolors and oils were "very French," firmly anchored by a Cubist-derived infrastructure that would influence Bob Thompson.[53] In addition to classes in painting and composition, landscape and portraiture, Leake taught life drawing at the Art Center Association school.[54]

Bob Thompson probably began fulfilling the Hite Institute's art history requirements by taking "Introduction to Sculpture" with Justus Bier, the chairman of the department, in the spring of 1957. He took two courses with Dario Covi, "Introduction to Painting" in the fall of 1957 and "Renaissance Art" in the fall of 1958. Interviewed almost thirty years later, Covi retained a vivid impression of Thompson, whom he described as "lively, enthusiastic" and "full of ambition," but "not well-directed." Although his academic performance was better in the introductory course, Thompson's subsequent career would reveal the continuing impact of Covi's Renaissance art class—for which he may have written a paper on Piero della Francesca.[55] By his fourth semester at the Institute, however, Thompson was "already losing interest in academics," according to Covi. Indeed,

approval of his 1958–59 Hite Scholarship was delayed pending successful completion of Walter Creese's history of architecture course. At the end of the spring 1958 semester, however, Thompson had earned an exam score of 90 and written a term paper that led Creese to "highly" recommend renewal of his scholarship.[56]

It is less clear which studio courses Thompson took and in what order he took them. At some time during his first three semesters at the Institute (spring 1957 through spring 1958), he seems to have taken life drawing with Eugene Leake, a painting course, and a course in lithography with Mary Spencer Nay. During the spring of 1958, he apparently served as studio assistant to sculptor Daniel Boles, with whom he lived at the time, and he was a member of Frederic Thursz's painting class.[57] He probably took painting with Wilke (who taught only advanced undergraduates and graduate students) the following fall. At some point, he also studied painting with Charles Crödel.[58]

Eugene Leake recalls that Thompson was making "good Abstract Expressionist paintings" when the youth entered his figure-drawing class. Leake was especially impressed by a red and black canvas that resembled work then being produced by Franz Kline.[59] Thompson's familiarity with New York School painting derived from a variety of direct and indirect sources. The characteristic features of gestural Abstract Expressionism were so well known and widely disseminated that, in a fall 1958 diary entry, Wilke would lament the prevalence of large-scale, "decorative" abstraction even in Louisville, announcing his wish to eschew attention-getting tactics and create what he termed "paintings without lipstick."[60]

Leake thinks that Thompson's enrollment in his figure-drawing class sparked an interest in figurative painting. But Thompson doesn't seem to have made the switch to figuration immediately. Instead, Leake dates Thompson's commitment to figurative painting

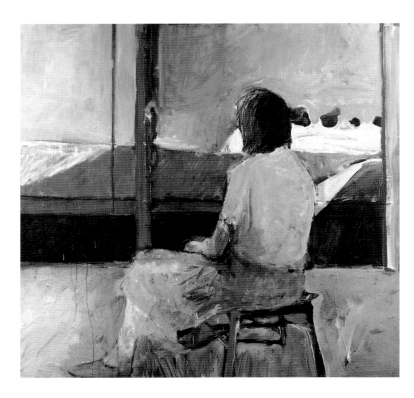

10. LARRY RIVERS (b. 1923)
Portrait of Frank O'Hara, 1952
Oil on canvas, 30 1/2 x 26 (77.5 x 66.0)
Whitney Museum of American Art, New York;
Bequest of Mrs. Percy Uris 23.77

11. RICHARD DIEBENKORN (1922–1993)
Girl Looking at Landscape, 1957
Oil on canvas, 59 x 60 3/8 (149.9 x 153.4)
Whitney Museum of American Art, New York;
Gift of Mr. and Mrs. Alan H. Temple 61.49

to his 1958 summer stay in Provincetown. [61] Fellow student Kenneth Young remembers Thompson drawing from the figure, but does not recall him painting figuratively while he was a student. Figurative painting was "kind of a no-no" at the time, according to Young. [62] In contrast, another Hite colleague, Robert Douglas, maintains that Thompson's student work consisted of "large, figurative—but abstracted" canvases that, while expressionistic, employed a relatively subdued palette and simple one- or two-figure compositions, as opposed to the brilliant color and busier designs for which he would later become known. [63]

The existence of an oil-on-masonite still life, signed and dated 1957, indicates that, in his migration from abstract to figurative expressionism, Thompson did not follow a smooth, unswerving path. [64] Similarly, an untitled, undated Thompson canvas that was probably painted in the summer of 1958 suggests that the artist did not suddenly abandon nonrepresentational painting the moment he set foot on Cape Cod.

If Thompson vacillated at this stage, it was per-

haps for two reasons: on one hand, the late fifties were a time of relative stylistic uncertainty. Pollock was dead, and Allan Kaprow would soon announce painting's imminent demise. [65] Having erased a Willem de Kooning drawing in 1953, Robert Rauschenberg spent the remainder of the decade replacing the "sincere brushstroke"—a category that now included the Abstract Expressionist "mark" itself—with the recycled object. [66] Meanwhile, de Kooning and Hofmann had simultaneously spawned acolytes who were as apt to be "gestural realists" (Larry Rivers, Grace Hartigan, Jan Müller) as "gestural abstractionists" (Joan Mitchell, Michael Goldberg, Alfred Leslie). [67] On the other hand, how to paint in 1958 was not simply a question of mode or manner. It had become a set of issues ranging from the need to expand painting's horizons, by incorporating nontraditional materials, mixing media, or crossing disciplinary boundaries, to the urge to abandon the production of discrete objects altogether.

While he studied at the University of Louisville,

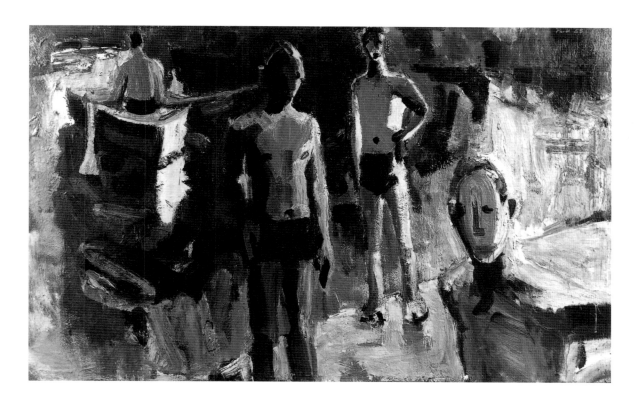

12. DAVID PARK (1911–1960)
Four Men, 1958
Oil on canvas, 57 x 92 (144.8 x 233.7)
Whitney Museum of American Art, New York;
Purchase, with funds from an anonymous donor 59.27

Bob Thompson was exposed to many of these shifting currents. Both New York School abstraction and its figurative offshoots were widely publicized and well represented in exhibitions circulated by the American Federation of Arts that came to Louisville's J.B. Speed Art Museum. "Gestural realist" canvases by Robert Goodnough, Grace Hartigan, and Larry Rivers, for example, were included in the 1957 Corcoran Biennial and that year's Whitney Annual, both of which came to the Speed while Thompson was a Hite Institute student. [68] Work by the Bay Area figurative painters David Park and Richard Diebenkorn was also seen. [69]

Thompson's literary tastes were fairly eclectic. He admired T.S. Eliot, e.e. cummings, Langston Hughes, and Dylan Thomas, in addition to Richard Wright and Jack Kerouac. [70] Given this multicultural literary bent, it is not surprising that Thompson was also friends with a number of faculty and students in the University of Louisville's English Department.

Don Fiene—a writer of short fiction and editor of a literary magazine, as well as an instructor of

English, Russian language and literature, and comparative literature at the university—was one of them. Fiene got to know Thompson when the painter lived and worked in a studio on St. James Court during his first year as a Hite Institute student. [71] Moreover, following in his brother-in-law's footsteps, by the time he got to college Bob Thompson had built an "unlimited" record collection. [72] "He might not have heat, he might not have food, but he *would* have a new album!" [73]

Despite Louisville's relatively enlightened atmosphere, it was unusual for local blacks to assert themselves in traditionally white cultural domains as readily as Bob Thompson did. In the fall of 1958, the need for an alternative to creative circles they found alien or hostile led graduate student Sam Gilliam and newly arrived undergraduate Robert Douglas to form a black artists' group. Bob Carter, Ken Young, and Bob Thompson, fellow Hite Institute students, were invited to join. Eugenia Dunn, a local painter who had taught briefly at Spelman College in Atlanta,

and Fred Bond completed the membership roster.[74] The group's first project was to hold a competition for designs for a mural to decorate the Brown Derby, a local bar situated in the heart of Louisville's black community and legendary since the 1920s for its jam sessions. Eventually, they decided to redesign the whole place and request a meeting space for themselves. There they held poetry readings and gave "live" painting performances.[75] At some point, they acquired the name Gallery Enterprises.

A deeply influential model for Gallery Enterprises was black Beat poet/painter/world citizen Ted Joans. From about 1947 to 1951, Joans had lived in Louisville, where, with Horace and Fred Bond, he founded the International Bebop Society, a group that met each week at a local YMCA to dissect and savor the latest jazz recordings.[76] For a while, Joans managed one of Louisville's black movie theaters, the Palace, where on Saturdays he staged events Sam Gilliam labels "Happenings."[77] But it was Joans' transformation of Joe's Palm Room, a community bar whose walls he adorned with improvisational painting, that prompted the young artists of Gallery Enterprises to wed art-making and interior decoration at the Brown Derby.[78]

Despite its distance from New York—then the unrivaled center of North American cultural life—Louisville was fertile ground for Bob Thompson's budding artistic identity. There he not only began learning the craft of painting, but was also exposed to some of the chief literary and musical currents that intersected contemporary trends in visual art. And Louisville gave Thompson his first taste of professional life as an artist.

In April 1958, during his second year at the Hite Institute, Thompson was one of the participants in the Louisville Art Center Annual, a juried exhibition that drew entries from artists throughout Kentucky and nearby Indiana, including several of his instructors. Thompson's offerings consisted of two oils—one titled *A Stranger in New York*, the other *East*

Shore—and a pair of monoprints—*Conflict at Issues* and *The Family*. The first canvas was priced at $200, while the second went for a mere $75. The two prints were listed at $10 each. Because dimensions for the works are not given, it is impossible to make anything but the most tentative comparisons with prices seen on the exhibition checklist for other artists' paintings and works on paper. By and large though, Thompson's prices seem consistent with those of the other participants.[79]

While it is not known if any of Thompson's works sold, at least one of them—the monoprint entitled *The Family*—may have survived.[80] Anomalous in several respects, the 1958 monoprint of that name in the collection of Robert and Cecile Holmes is the only print by the artist I have seen and one of only five works I have viewed (either directly or in reproduction) that can be securely assigned a date to this early period of Thompson's career.[81] Vertically elongated in format, the brown monochrome image shows a full-length standing figure, probably female, holding two children. A biomorphic Surrealist composition, rendered in a continuous flow of undulant Beardsleyesque line, the print both departs from and displays an obvious kinship to the ropy, attenuated forms seen in Mary Spencer Nay's biomorphic abstract paintings of the period.

The Family also exemplifies Thompson's penchant for lifting motifs from art historical sources. Indeed, Frederic Thursz remembers that he and Thompson frequently discussed Masaccio, especially the way "the space between the figures was alive" in the Quattrocento artist's work. According to Kenneth Young, Thompson "looked at art history books a lot" and was especially taken with Piero della Francesca and Giotto.[82]

In November 1958, Thompson was one of twenty-two local artists featured in a show at the Arts in Louisville House Gallery. Entitled "Wet Paint," this display included work by Mary Spencer Nay and

Ulfert Wilke, as well as by Arts in Louisville founder-director Leo Zimmerman, a painter of hard-edge abstractions. [83]

According to Sam Gilliam, Thompson was Louisville's first black artist to exhibit "downtown." And while Arts in Louisville shows usually went unnoted by the local press, Thompson's 1959 solo exhibition there garnered a brief, three-paragraph item in Senta Beier's *Courier-Journal* art column, saying the artist had "an original feeling for color combinations." [84] Leo Zimmerman's *Gazette* also gave the show unusual coverage, publishing a long statement by the artist. Thompson's manifesto is a jejune document. "[D]isdaining the gallery going public's notions of what a painting should be," he claims:

> *...it is necessary for me to utterly repudiate so-called good painting in order to be free to express that which is visually true to me....My aim is to project images that seem vital to me....images...that seem to have meaning in terms of feeling....* [85]

Thompson goes on to declare that his art "has no style—it constantly changes." But the two works from the exhibition that I have been able to locate show little stylistic difference. They are moderately large paintings—roughly 4 by 5 feet each—in oil on canvas. The earlier of the two was painted during Thompson's first trip to Provincetown during the summer of 1958. [86] Entitled *Differences*, it is a vertical composition; the left half seems especially successful in its juxtaposition of the warm, light golden tones filling the window; the cool darkness of the gray walls, and the even darker mass of the standing woman's auburn hair. The acid warmth of these red-brown tones, in turn, complements the emerald green wedge of shirt visible beneath her dark navy double-breasted jacket. And, rather than the expected contrast of pale hands against her dark blue trousers and jacket, Thompson risks making hands and garments remarkably close in value—forcing him to

leave the book white, the one chromatic infelicity in his treatment of the painting's left side, which makes the book seem to pop out of the picture plane.

Thompson's handling of color relations in the painting's right half looks less assured. In order to avoid completely silhouetting the standing woman's upper body against the radiant white mirror that frames the seated woman's head and bust, for example, he has added green highlights to the seated figure's left shoulder and upper arm in a conspicuous and rather clumsy fashion. Nonetheless, the tawny shades of the nude's flesh effectively anchor the mirror's large square of white; at the same time, they echo—in a lighter tone—the red-brown hues of the opposite woman's hair and contrast with the inky blue of her clothing.

The second painting, *The Wilting Flower*, was executed in 1959 in Kentucky. [87] Horizontal in format, its organization involves a play of curves against straight edges and rectilinear forms that produces a less static composition than that of *Differences*. The painting shows a woman seated at a table fingering a dying flower. She is flanked by two empty high-backed chairs. A lamp and an unopened book can be seen on the table. More dynamic in design, the painting also has a more subtle palette, which demonstrates the young artist's increasing grasp of his medium.

As Thompson began to mature, he sought out other artists in communities different from those he had known in Kentucky. Thompson was a young man in a hurry, eager to learn about himself in the larger world.

THE "ECSTASY OF INFLUENCE"
PROVINCETOWN, 1958

[F]reedom is not something that anybody can be given; freedom is something people take. . . .

— JAMES BALDWIN (1960)[88]

In 1958, after completing his sophomore year at the University of Louisville, Bob Thompson spent the summer in Provincetown. Initially, Thompson's teachers, family, and friends were under the impression that he had gone to Provincetown under the auspices of Mary Spencer Nay, his former teacher at the Art Center Association in Louisville, and that he would somehow be under her direction there.[89] But in Provincetown, where he quickly gained a collection of new friends among artists his own age, Thompson linked himself with Nay's colleague, John Frank, which suggests the youth's uncanny intuition about artistic trends, for Frank had recently completed a master's degree at Hunter College under the tutelage of Robert Motherwell, the renowned Abstract Expressionist. Frank had also served as Ulfert Wilke's sabbatical replacement at the University of Louisville, and, before Thompson's arrival, spent several summers in Provincetown, where he taught at Seong Moy's School of Painting and Graphic Arts. Frank also seems to have been instrumental in helping Thompson obtain a scholarship to attend the Seong Moy School that summer.[90] Located at 7 Brewster Street, the school was sufficiently well attended to occupy its own studio building and offer "a full program of classes in painting and graphic arts, as well as evening life sketching sessions."[91]

Painter Emilio Cruz, who met Thompson that summer, also credits Frank with removing other obstacles from Thompson's path. "It was difficult then to rent a place in Provincetown," Cruz explains. "Only rare individuals would rent to you if you were black."[92] Through his numerous local contacts, Frank was able to put Thompson in touch with one of the few local black property owners, an elderly blind man named Nathan, who rented out a small "cabin."[93]

Like Thompson, Cruz was a prodigiously gifted black youth who had been lured to Provincetown by an urge to paint and an appetite for the latest artistic developments. Raised on slender means in a relatively large family in the Bronx, he was blessed with parents who instilled in him a love of poetry and of painting. Despite substantial differences in their backgrounds, Cruz and Thompson had a great deal in common, including the loss of a father—one to divorce, the other to death.

Cruz and Thompson had been introduced by the painter Gandy Brodie, for whom Cruz occasionally babysat, and whose paintings were a strong influence on Thompson during this time. Cruz asserts that Thompson painted his "first figurative pictures" in Provincetown in response to the influence of Gandy Brodie.[94] The gray-brown palettes, division of the canvas into large rectangles of contrasting light and dark tones, and the masklike treatment of faces, as in Brodie's *The Penetration of a Thought* and Thompson's summer 1958 *Differences*, seem to bear this out.

Cruz recalls that his first encounter with Thompson consisted of downing a few beers at a local fish house frequented by Franz Kline and several of the Black Mountain poets. Cruz was deeply impressed by Thompson, remembering him as "a man of unique, contagious character....The moment you met him, you understood his sense of self-possession....Everything about him said, 'I am myself and no other shall I be.'"[95]

Invited to dine with Thompson in his small home a few days later, Cruz was startled "to find... [Thompson] had really cooked dinner: ham and sweet potatoes and a large, inexpensive bottle of wine served in a glass."[96] Cruz continues:

I knew then that there was something different about myself and Bob....[H]e asked me why I washed dishes for a living. "To eat," I answered. He never asked me that question again. I don't think he was fond of the

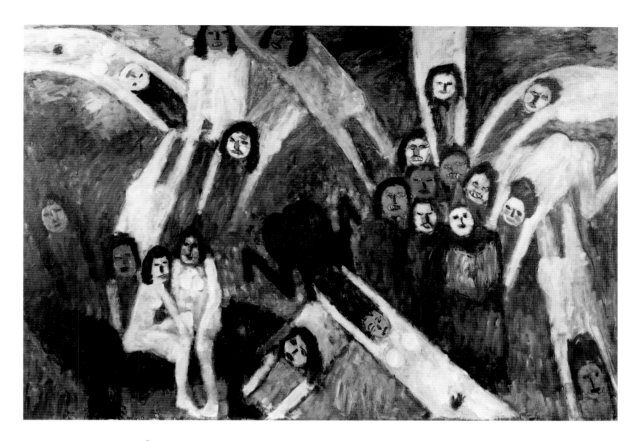

13. JAN MÜLLER (1922–1958)
The Temptation of St. Anthony, 1957
Oil on canvas, 79 x 120 3/4 (200.7 x 306.7)
Whitney Museum of American Art, New York; Purchase 72.30

idea; for him, the proposition was much too humiliating....Bob was perhaps the only black man I ever met who was totally intolerant of the notion of inferiority. [97]

At "parties in this little shack," Thompson played host to a circle of figurative painters that included Lester Johnson, Red Grooms, Christopher Lane, Mimi Gross, Anne Tabachnick, and Bill Barrell. Barrell, one of several young Britons on the Provincetown scene, got to know Thompson as a result of "a show in a fish and chips shop" that included work by Thompson, Cruz, and Barrell.

We were all young painters...looking for places to show. I remember Bob's painting—just oranges, reds, blues and yellows—it was pretty abstract. [In Provincetown] I met Emilio and Bob, and ran into people like Jan Müller, who had generated a lot of interest in figurative painting at that time. [98]

With Barrell's remarks on the Fish Inn show, the question of Thompson's stylistic development surfaces. In a 1965 interview with Jeanne Siegel, Thompson discussed a canvas entitled *Girl in Yellow Raincoat*, from his 1958 Provincetown summer: "At that time [my] color was very subdued," he stated, going on to attribute the confinement of his palette to largely muted gray tones to the "Provincetown atmosphere." [99]

The figurative expressionist painter Dody Müller, who belonged to a circle of artists roughly ten to fifteen years older than Bob Thompson, considered Thompson's work "very good student work—quasi-Cubist landscapes, seascapes, etc." A piece of advice that Thompson capitalized on was Müller's "Don't ever look for your solutions from contemporaries—look at Old Masters." [100] In reproductions found in books and on postcards, Thompson studied the work

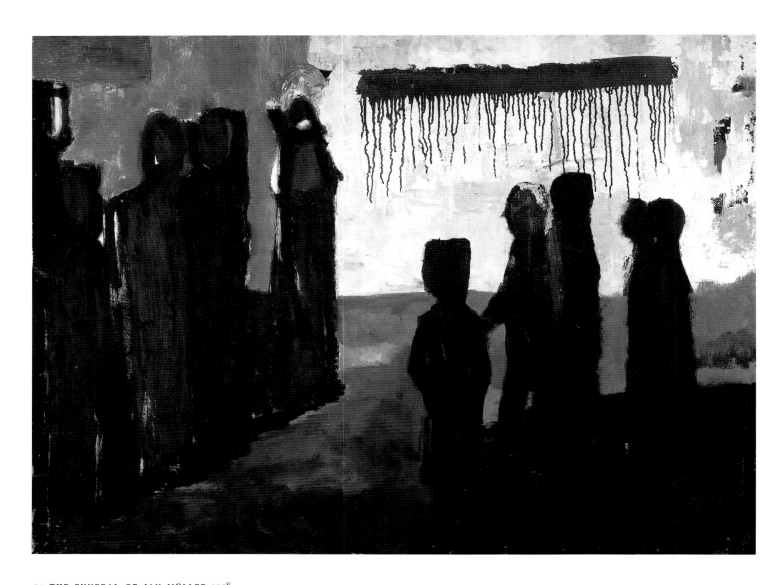

14. *THE FUNERAL OF JAN MÜLLER*, 1958
Oil on masonite, 36 x 42 (91.4 x 106.7)
Collection of Martha Henry

of Piero della Francesca, Titian, Caravaggio, and Bruegel, among other artists, whom he would continue to study until his death in 1966.

But the most overt homage to another artist that Thompson made during this time was not to an Old Master but a near contemporary, Dody Müller's husband, Jan Müller, who died in Provincetown in January 1958. The style of Thompson's tribute was antithetical to that of the deceased painter. Painted in oil on a 3 x 4-foot masonite panel, *The Funeral of Jan Müller* (Fig. 14) depicts a scene Thompson could only have known secondhand.[101] The canvas, in an array of lugubrious blacks, browns, steel gray, and a chill white, shows two rows of mourners facing each other across a band of earth, presumably the site of Jan Müller's burial in the North Truro Cemetery the winter before Bob Thompson arrived at the Cape.[102] Dody Müller remembers "thinking [at the time] how odd it was that Thompson had produced this painting" in which an actual event was recreated "from imagination and hearsay."[103]

With its blatant geometries, clumsy drawing, and messy paint handling, *Funeral* is an obviously immature work. Nevertheless, the canvas is remarkable in at least two respects: on the one hand, the painting reflects Müller's centrality to the Sun Gallery's circle of young figurative expressionists; on the other, in its lack of stylistic affinity with Müller's work, Thompson's tribute to his influential predecessor shows a precocious independence.

Jan Müller had attended the Hofmann School, founded in 1934 by the painter Hans Hofmann, in New York and Provincetown from 1945 to 1950. The school in the 1940s was at the height of its fame, due to the presence of students and working artists like Arshile Gorky, Willem de Kooning, and Jackson Pollock. Credited with having wedded Cubist infrastructure with Fauve color dynamics, Expressionist facture, and Kandinsky's improvisational procedures,

Hans Hofmann probably arrived at the freewheeling, anti-illusionistic mode known today as Abstract Expressionism before Jackson Pollock.[104] Müller, a German refugee like Hofmann, but considerably younger, would enjoy an "almost father-and-son relationship" with the great teacher.[105] Yet a description of one of Müller's earliest known paintings, *Cyclops* (1943), suggests the inevitability of an Oedipal clash between the two artists and Müller's mutinous return to a figurative mode and literary content that Hofmann's pedagogy had repressed. Müller's profound indebtedness to Hofmann and an equally intense need to rebel against his mentor's abstract creed epitomized the relationship between an emergent school of figurative painters and their Abstract Expressionist predecessors. Unthinkable without Abstract Expressionism's raw emotion and rough-hewn facture, yet boldly defiant of the earlier movement's central tenets, the art that Bob Thompson would eventually produce fit squarely into this mold.

Again like Thompson after him, Müller was actively involved in the cooperative gallery scene. In fact, Müller played a central role in one of Greenwich Village's earliest and most esteemed Tenth Street cooperative galleries, the Hansa. Despite its distance from the period's established galleries, which were strung along 57th Street and upper Madison Avenue, the Hansa quickly gained the attention of such influential critics as Thomas Hess and Meyer Schapiro, as well as such leading members of the first generation of New York School painters as Franz Kline and Willem de Kooning.

Jan Müller's first one-artist exhibition took place in the spring of 1953, the Hansa Gallery's second season in operation. He would continue to show each spring at the Hansa, where his final exhibition closed less than a week before his death in January 1958. His 1953 show featured what has been described as his "'mosaic' paintings,"

...made up of small squares of color, irregular in size and spacing and based always on landscape or figure compositions. The touches of color, sometimes elongated into strokes, run in lines which converge and swirl together, activating the large canvases with dynamic patterns of motion and light...in which the small, roughly blocked in figures emerge from the formless universe as frail substances which challenge the engulfing chaos.[106]

Frequently, these brilliantly tessellated compositions were painted on wood or burlap, rather than canvas—a matter of economic necessity that, as Martica Sawin points out, also certified one's bohemian credentials.[107] During this period "Müller lived and worked...in a bleak, unheated loft on Bond Street which seemed to be entirely given over to painting, with only the most rudimentary provisions for living."[108] A similar description could be made of Bob Thompson's living conditions in lower Manhattan in the late fifties, the years of his most intense struggle for recognition.

In 1954, Müller underwent coronary surgery. His heart had been severely damaged by rheumatic fever, contracted during his family's stays in Switzerland and Paris.[109] Now, a damaged heart valve was replaced by a plastic version that produced an audible ticking sound and brought on "painful seizures."[110] Several authors seem to imply that this doubly traumatic event—in which a major operation saved the artist from imminent death, but left him with a constant, noisy reminder that his time was running out—is what triggered the crucial shift in his style.[111]

Müller had summered in Provincetown during the early 1950s and resumed the practice in 1955.[112] His timing was propitious. In July, a new gallery opened in a tiny storefront on Commercial Street, Provincetown's main drag. Called the Sun Gallery, it was the brainchild of a disaffected ex-Hofmann student named Yvonne Andersen and her partner,

poet Dominic Falcone. Like their Manhattan counterparts who founded the Hansa and Tenth Street's other cooperative galleries, Andersen and Falcone sought an alternative to the aesthetic gridlock of Provincetown's existing gallery scene. Thus, the Sun Gallery stood apart from the old-guard Provincetown Art Association, the prestigious Kootz-HCE Gallery (summer outlet of Samuel Kootz's midtown-Manhattan establishment), and Gallery 256, a cooperative in which free-form abstractionists predominated.

The Sun Gallery chose the work of Jan Müller for its first one-artist exhibition. Enormously influential while he lived, Müller's art remained a center of gravity for artists drawn to the Sun after his death. Ironically, however, Bob Thompson's painted tribute to him, *The Funeral of Jan Müller*, displays a greater stylistic affinity to the work of Lester Johnson—the painter whose art stood as the other pole of Sun Gallery exhibitions.

At the time, Johnson's work was considered "more acceptable" than Müller's because of its "more mainstream look."[113] In a 1963 review, Dore Ashton declared:

Stylistically Johnson belongs to the younger abstract expressionist generation. His first exhibition that I saw in 1951 comprised thickly painted abstractions intended to startle in their harsh juxtapositions of orange and black form, their heavy-handed palette knife technique. In keeping with a moment...when paint itself appeared independently efficacious, and the hand of the artist, as it groped and grappled with tacky matter, was considered invaluable for its idiosyncrasy alone, Johnson's style was rooted in expressionism.[114]

Johnson's work of the late fifties combined a remarkable surface density with unorthodox means of drawing to produce imagery that simultaneously displayed an iconic terseness and heroic engagement

with the medium of paint. His canvases typically were "so intensely worked that the few human profiles, potted plants and outlines of tables and room interiors" they reveal seem "not so much figurative as poetically abstract."[115]

In *The Funeral of Jan Müller*, Bob Thompson seems to have adopted several of Johnson's stylistic traits: his dark palette, thick paint, and reduction of human figures to silhouetted monoliths. But Thompson seems more akin to Müller in the way he positions his figures in a space that reads as landscape rather than as a field of lavishly applied paint. And *Funeral*'s dramatic tableau, as opposed to the emblematic character of Johnson's figures from this period, is Mülleresque, too. It is as if, at this stage, Thompson feels compelled to simultaneously adopt Johnson's and Müller's competing modes of figurative expressionism—one cognate with the candid materiality of Abstract Expressionism, the other with the idealistic themes of earlier, European expressionisms—not in order to reconcile them, but to seek his own artistic identity through a dialectical interrogation of both.

And in the paintings Thompson began to conceive and execute the following year, in New York, after his first Provincetown summer—paintings with equestrian figures; schematic, candy-colored landscapes; and anonymous nude women—Thompson's debt to Jan Müller becomes clear. At the same time, Thompson's relationship to these motifs conveys a distinct personality. His palette tends to be hotter than Müller's; his use of color generally violates the Hofmannesque balance of chromatic tensions that Müller's art displays. While his early work is less marked by the sensuous contours that would subsequently characterize Thompson's figures, even at this stage his nudes have greater muscular definition than the blocky ciphers who staff Müller's late canvases. And, although Thompson's brushwork tends to be more blunt and bristly than it would be later, he never addresses the canvas in as controlled or constructive a manner as Müller characteristically had.

Asked about literary critic Harold Bloom's view of artistic production as a process of reinvention fueled by an Oedipal "anxiety of influence," Meyer Schapiro is said to have replied, "It just isn't true! We feel an ecstasy of influence."[116] In Provincetown, Bob Thompson began experimenting with a heady mix of imagery, techniques, and themes borrowed from contemporary artists. It was the start of his self-insertion into art history through the appropriation and reworking of choice bits of his predecessors' styles. The irreverent eclecticism of this Provincetown novice suggests remarkable self-confidence and an extraordinary capacity for creatively savvy play.

Overleaf:
15. Thompson's studio, 1963.
Photo copyright © by Fred W. McDarrah

"YOU CALL THIS LIVING?"

BOB THOMPSON AND THE AVANT-GARDE
CRITIQUE OF CONTEMPORARY CULTURE

A successful revolution establishes a new community.

— PAUL GOODMAN (1960)[117]

The new cultural wave that had crested in San Francisco was rolling full force into Manhattan.... Young and broke, they converged upon the eastern-most edges of the Village, peeling off into the nondescript district of warehouses and factory lofts, and...the broken-wine-bottle streets of the Bowery. An area with an industrial rawness about it, proletarian, unpretty—quite illegal to live in, but landlords were prepared to look the other way.

— JOYCE JOHNSON[118]

[O]ne time, a[n] inspector walked in on Bob in his loft as he was waking up. The guy looked down and said, "Do you live here?" And Bob says, "You call this living?"

— SHEILA MILDER[119]

Bob Thompson's first summer in Provincetown acted as a bridge from a relatively brief period of study at the University of Louisville to a short-lived, but stellar career in New York and Europe. There is some uncertainty about when Thompson took up permanent residence in New York. A few friends date his permanent departure from Kentucky some time after his February 12–March 5, 1959, "Arts in Louisville" show, but his New York comrades Jay Milder and Christopher Lane both give the fall of 1958 as his official arrival date in Manhattan. At first, Thompson resided with Milder on Horatio and Washington Streets, in Greenwich Village's western fringe. Then, for a period, he shared a loft with Milder, Lane, and,

briefly, Red Grooms on Monroe Street, at the southern end of the Lower East Side.[120]

Like many young artists who arrived in New York in the late fifties, Bob Thompson's social identity was that of a "Beat," for "Beatnik," a term invented by *San Francisco Chronicle* columnist Herb Caen and used as shorthand to describe the apotheosis of a whole slew of youthful antiheroes, depicted by Norman Mailer and J.D. Salinger; impersonated by Marlon Brando, Montgomery Clift, James Dean, and Sal Mineo; given swivel hips and mean guitar licks by Elvis Presley and Chuck Berry; and, in such cases as Lenny Bruce and Mort Sahl, even "[d]isguised as stand up comics."[121]

Bob Thompson's renunciation of middle-class goals by withdrawing from the premed program at Boston University and then from the Hite Art Institute, followed by his plunge into Lower Manhattan's bohemia firmly aligned him with Beat culture. He was a participant in two of the earliest Happenings staged in the United States: Allan Kaprow's *18 Happenings in 6 Parts* and Red Grooms' *The Burning Building*, both of which took place in 1959. In 1958, shortly after his return from Europe, poet Allen Ginsberg, whose long 1956 poem *Howl* was a touchstone for the Beat sensibility, "met Bob Thompson through LeRoi Jones." Spurred by Jones' excitement about Thompson's work, Ginsberg went to see the work and was particularly impressed with Thompson's "giant *Homage to Ornette* filled with raspberry trees."[122] Today, it is called *Garden of Music* (Fig. 51).[123]

Of heroic size—roughly 6 1/2 feet tall by 12 feet wide—Bob Thompson's *Garden of Music* automatically valorizes its subject: a dream band consisting of saxophonists John Coltrane, Sonny Rollins, and Ornette Coleman, trumpeter Don Cherry, bassist Charlie Haden, and drummer Ed Blackwell.[124] These giants of post-bop jazz perform *alfresco* in the buff for an equally unclad assortment of men and women, said to include several of the artist's associates.[125]

Bob Thompson was one of the many painters who regularly "went to study" the music of various jazz artists at the Five Spot.[126] Located at Fifth Street and Cooper Square, the club sat opposite the residence of his friend and fellow jazz maven LeRoi Jones (later Amiri Baraka).[127] Originally a neighborhood bar owned by an Italian family, it underwent a drastic shift of clientele during the 1950s, when "the neighborhood changed...musicians and artists started moving into" former sweatshops that now became illegal live-in lofts.[128] Philip Guston, Mark Rothko, Robert Motherwell, Franz Kline, and Willem de Kooning could frequently be found there.

Having met Bob Thompson one night at the Five Spot, Ornette Coleman's bassist, Charlie Haden, began frequenting the painter's loft on Clinton Street, where Thompson had moved in 1959. Thompson, Haden recalls, occupied the third or fourth floor of a building so dilapidated that, if it wasn't already condemned, it should have been. The building's unlit stairwell led the musician to ask, "Aren't you scared to live here?" Thompson's response: "Nobody knows I live here, so there's no rent."

There was also no heat or hot water. The artist slept on a mattress on the floor. A portable heater, a chest of drawers, and a couple of chairs completed the furnishings. Otherwise, Haden recalls, there were only the artist's paints, canvas, a record player, and the records he played all day long.

While the bass player sat watching Thompson paint, the two men would discuss their respective arts. The painter talked about the colors he used and the various painters "he was always reading about." He was also curious about what Haden experienced while playing his music. "Do you see anything when you're playing?" he would ask. "Do you relate improvisation to any visual process?"

Both men were strung out on heroin at the time and Haden thinks the urge to live in the moment may have contributed to their mutual attraction to drugs.

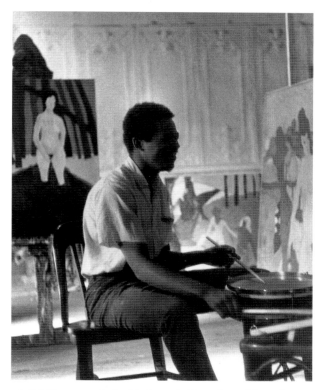

16. Bob Thompson playing his drums in his studio on Clinton Street.

The artificial stimulation of narcotics can seem like a shortcut to what he feels "every creative person tries to do"—that is, "develop the rest of your life to the level of your art form." Thompson struck him as vital, full of life. The painter seemed to have "endless energy" and "would not sleep for days. He'd just paint, rest for a couple of hours, and get up again."[129]

Haden's impressions of the artist's vigor are widely shared. Jay Milder, for example, has written:

I have never met anyone so intensely into all the emotions of life at his pace of living. [O]ne time I brought my students from the Dayton Art Institute to New York for a field trip. Bob gave them a four hour lecture in his studio starting at three A.M., after we had been at the Five Spot listening to Thelonius [sic] Monk. After the lecture, Bob and I drove to Staten Island just to ride over the new Verazzano [sic] Bridge....Bob painted the whole next day and well into the night. No sleep for about 36 hours....[130]

While Thompson possessed enormous energy, his chronic alcohol and drug use suggests this vigor was not matched by sturdy psychological defenses or high tolerance for pain.[131] "The dope made him

17. Red Grooms in Marcia Marcus' *A Garden*, at the Delancey Street Museum, February 6, 1960. Thompson is playing the bongo drums.
Photo copyright © by Fred W. McDarrah

impervious to a lot of painful experience," Emilio Cruz declares. The same mix of exquisite sensitivity and profound vulnerability that gave their art such power also made musicians like Charlie Parker, Lester Young, and Billie Holiday crave escape from a wounding world. Like them, according to Cruz, Bob Thompson "used dope as a screen," a way to "keep the world at a distance." "[Narcotics can] help you survive and do what you have to do quickly. [They] took Bob past some inhibitions." [132]

One day, while Charlie Haden sat watching him work, Thompson announced, "I'm painting my favorite musicians, the ones who inspired me!" A few days later, he phoned and told Haden, "I'm putting you in the painting." Haden went to the artist's loft and spent an afternoon watching his portrait emerge. (He did not "model" for it, however.) The painting shows the figure representing Haden staring at a giant bass fiddle that he holds aloft by its stem. When he asked why Thompson showed him addressing his instrument in this impossible way, Thompson said that that was how he played. Recognizing the accuracy of the painter's insight, Haden explains that he was extremely dissatisfied with his playing at the time.

Further evidence of the specificity of Thompson's images is furnished by Haden's remarks about the brown figure directly beneath his own portrait. Seated behind a set of drums, he is the Coleman Quartet's drummer, Ed Blackwell, whom Haden immediately identifies by the knife he clasps in one hand. Bob Thompson, he explains, was fascinated with the way Blackwell, who had studied the drum making of traditional craftsmen in New Orleans, whittled his own drumsticks. [133]

"There are certain people in different art forms you feel more akin to than other people," Haden observes. "Bob felt a closeness to the way we felt about what we were expressing about life. He really painted sound....A lot of people felt very excited about what we were playing at the Five Spot, but not to the

extent that Bob did—in terms of a realization of it in his work. It struck something in him where he felt 'Yeah, I'm not alone!'" [134]

In April 1959, a bearded trio of downtown Manhattanites consisting of Grooms, Milder, and Thompson piled into Thompson's decrepit black Oldsmobile coupe and headed for Mexico via Milder's hometown of Omaha, Nebraska. Because of their beards, which marked them as "weird" in the staid Midwest, Thompson and Grooms were twice "picked up by cops" for vagrancy in Omaha, Milder recalls. Ultimately, the trio failed to venture beyond Nebraska, where Milder got engaged and stayed behind, immersed in prenuptial activities. His buddies "were a little miffed....They drove back to New York...." [135]

Thompson's experience of the trip is cryptically recorded in several documents: a letter to his mother, a postcard to Cecile and Robert Holmes, and three entries in a makeshift sketchbook/diary. A heady blend of youthful *joie de vivre*, restlessness, and investment in the Beat generation romance of the road is conveyed by the message scrawled on the back of a postcard reproduction of Édouard Manet's *Le journal illustré*:

> *I'm on my way to Mexico. Will detail later. Am happy moving to nowhere up on an idea satisfied beyond control. I'm going somewhere.* [136]

In contrast, Thompson's letter to his mother implicates her in a fierce psychic tug-of-war pertaining to his career goals, lifestyle, and emotional independence. He begins by describing the Milder family ("very Jewish and wonderful") and their "beautiful house...in the Ritziest section of town," but quickly betrays his underlying agenda by adding they "are very much like our family used to be—all for one and one for all. They don't agree completely with what Jay is doing but back him all the way because they love him and this is what he loves (his art)." Following a reference to an upcoming exhibition "sometimes [*sic*] in May" and plans for the threesome to subsequently

"continue to Mexico for new experiences," he vents his frustration and issues a plea:

> I realize mother that you have somewhat of a problem of believing in me but I ask of you to bear and not so much understand but be with me—I can never fail if you are with me.

Finally, having boastfully resumed a pose of self-sufficiency ("Do not worry because I am a man who changes constantly which means progression in my book...."), he reveals the immediate source of conflict by requesting that his mother "write, and tell me why school is so important to you for me." The letter ends with an obvious bid for parental approval: "I love you very much Mother, Your son, Always." Like the postcard to his sister and brother-in-law, the letter closes with a thumbnail self-portrait sketch in place of a written signature. [137]

Thompson's Omaha diary reveals that the contest of wills between him and his mother was but one of several emotional disturbances at this juncture in his life. What he calls his "existential journal" begins on May 1 and ends two days later. The first day's account is written in a Joycean manner that he subsequently drops. A prematurely nostalgic reminiscence on his "beginning as [a] painter"—an event he apparently dates to his "arriv[al] in the nucleus N.Y." less than a year earlier—is followed by a list of New York and Louisville girlfriends he misses. Then he reports:

> I've been drawing, drawing, and the show possibly here in Slomaha is so undeveloped and indicatively futile. I also miss the Metropolitan and the beautiful Picasso with the figure standing alone—I believe a circus performer also the Modiglianis, the Roualt [sic], the Brueghel, Vermeers, Raphael, on on on & continuous.... [138]

On May 2, he is still out of sorts, but able to end by grudgingly admitting, "I guess it was an enjoyable day...." Apparently, his spirits have improved as he has begun to "concentrat[e] on the coming show this Sunday at the park here in Omaha." Art—making it, viewing it—seems to be the only thing about which his feelings are not ambivalent:

> The woodcuts were made for posters, the printing done—drawings thrown together, a final meeting with the caretaker and everything in part unperparatorily [sic] prepared. I think Masaccio is one [of] the greatest painters who ever....I'm getting [a lot of work] done, like tonight I have I think two sketches for fine paintings.... [139]

By May 3, the exhibition has been hung and Thompson's assessment is favorable: "[T]he show at the pavillion [sic] is up and I say it is moving. Only few will grasp the meaning...." Yet he also reports, "I am hazy and feel uncomfortable as far as my immediate existence is concerned." At least part of this discomfort seems to stem from his impatience with intellectualizing:

> I wish people would stop talking so much—always criticizing this, that....Tonight it consisted of putting down Balthus, science fiction or other far-fetched things—Why do we often...speak of things that would...take a grand amount of knowledge to discuss with any depth? Terms thrown about like clothes of an untidy boy.

At the diary's close, Thompson's craving for unmediated sensation ultimately fuses with his drive to paint: "I must get on with myself settled where I can paint until my brow flood[s] my cheeks with perspiration, until I go mad." [140] One envisions him jettisoning his writing pen at this point to seize art-making tools instead.

"The Three Musketeers" (as Marcia Marcus dubbed Milder, Grooms, and Thompson) were late arrivals in Provincetown that summer and Thompson did not participate in either of that year's Provincetown Art Association summer shows. [141]

18. Thompson and Jay Milder in an Alan Kaprow Happening, October 2, 1959.
Photo copyright © by Fred W. McDarrah

He did, however, manage to take part in a three-man show, along with Grooms and Milder, at the Sun Gallery.[142] And he and a "tall, statuesque" woman named Carol Plenda, whom Thompson had met at the Cedar Bar earlier that year, began "going together."[143] She recalls that he painted what has come to be known as *Beauty and the Beast* that summer.[144]

The painting was exhibited in 1960 in Thompson's first one-artist show in New York, at the Delancey Street Museum. The announcement for the show consisted of a black-and-white reproduction of *Beauty and the Beast* framed by two thin borders containing the show's title, location, and dates.[145] The painting's future owner, Reginald Cabral, proprietor of Provincetown's Atlantic House and an avid collector of contemporary art, attended Thompson's opening. According to Cabral, *Beauty and the Beast* "was the centerpiece of the show."[146]

Beauty and the Beast provides an early and unalloyed example of the artist's highly charged female imagery. A key trait of Thompson's oeuvre is its frequent use of imagery that, in its frank display of violent, conflict-laden, or indecorous sexual interactions, is deeply disturbing. Throughout his adult life, Thompson was a man who frequently found himself surrounded by women. Painter Anne Tabachnick has described the scene at the opening of one of Thompson's early New York shows:

I remember his mother and aunt at that opening. They didn't take their eyes off him all evening. I never saw such naked joy and pride in two faces. Thompson was spending his time being kissed and congratulated by a long line of girls, mostly two at a time.[147]

But if women were in some sense a "natural" preoccupation for Thompson, his art nevertheless depicted them in ways that were far from symbolically neutral. In his signature work, women are either madonnas, nymphs, and goddesses, or sirens, witches, and harpies.[148] As the artist explained in a 1965 interview, his "true" artistic identity began to emerge in New York in 1959:

I got into a groove...where the subject matter was monsters. The whole thing was involved in a sort of poetry and the relationship was like man and woman to nature and beasts.[149]

Unlike some of his previous work and much of his later output, his monster paintings featured "totally original" compositions. Describing his source of inspiration for these images, he explained, "I had many dreams then....I think it had to do with my relationship with girls, that sort of thing."[150] In *Beauty and the Beast*, the nude female at the center of the canvas—in comparison with the fantastic characters that populate the rest of the work—is rendered in anatomical detail, given naturalistic flesh tones and, in an uncharacteristic allusion to contemporary fashions, wears a Brigitte Bardot hairdo.[151] She is flanked on the right by a black creature, whose grotesquely enlarged head, sprouting horns, and bristling fangs shout his aggressive sexuality. A glance at a brush-and-ink version of the composition makes this doubly clear, exposing details that are less legible in the large oil, for example, the claws with which the creature gores or grasps the woman's side and his oversized, erect penis. Left of the woman is a brown silhouetted figure—again male, judging by its hat. Viewed in conventional psychoanalytic terms, *Beauty and the Beast* can be read as symbolic of male vulnerability in the face of the powerful, self-destructive forces unleashed by unfettered desire. But given the artist's identity as a young black male, newly arrived from Kentucky, Thompson's imagery suggests an awareness of the highly charged psychosocial dynamics of interracial sex in the late 1950s.[152]

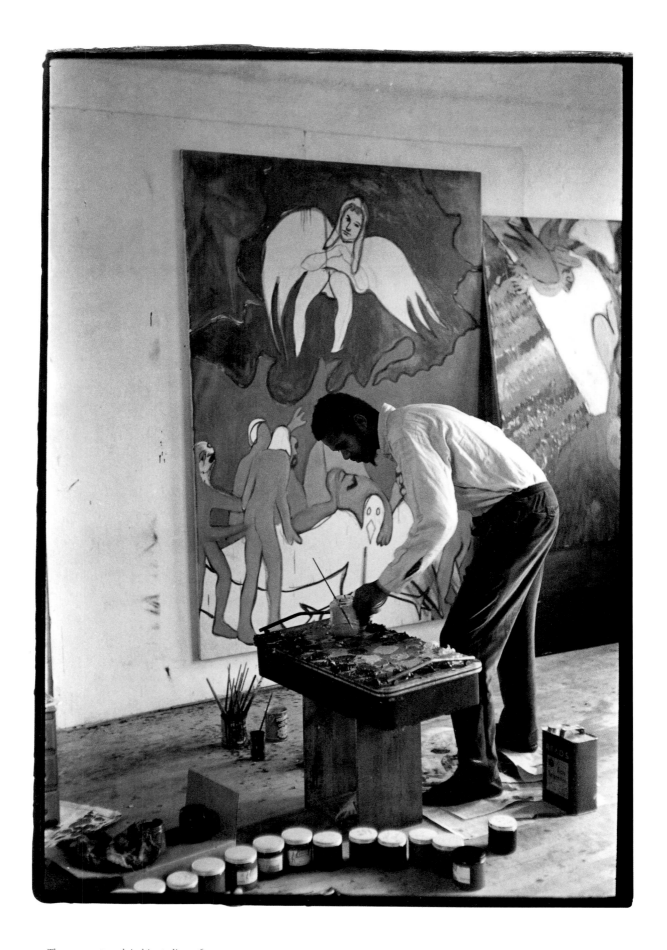

19. Thompson at work in his studio, 1963.
Photo copyright © by Fred W. McDarrah

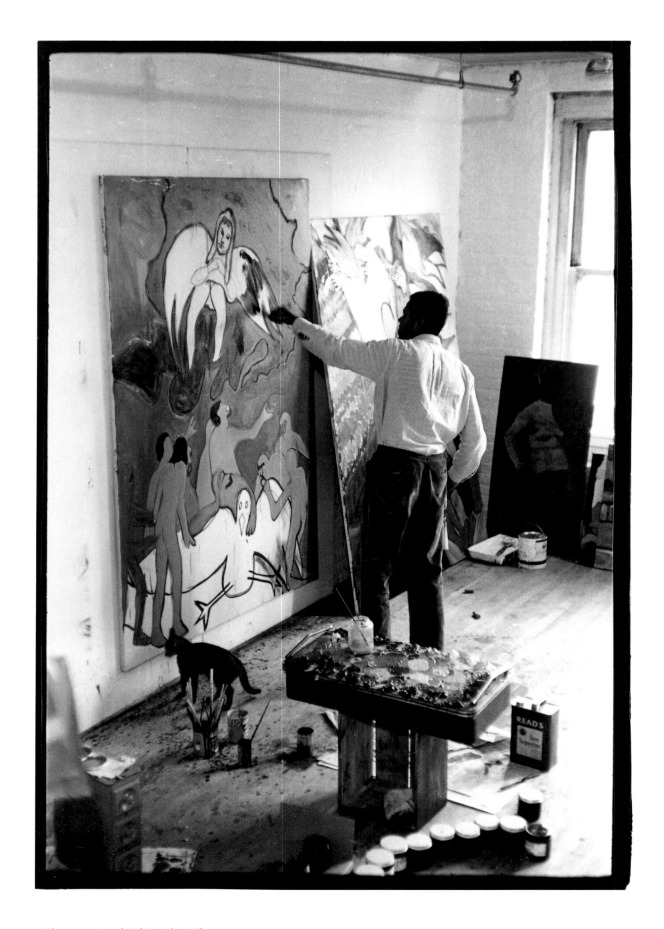

20. Thompson at work in his studio, 1963.
Photo copyright © by Fred W. McDarrah

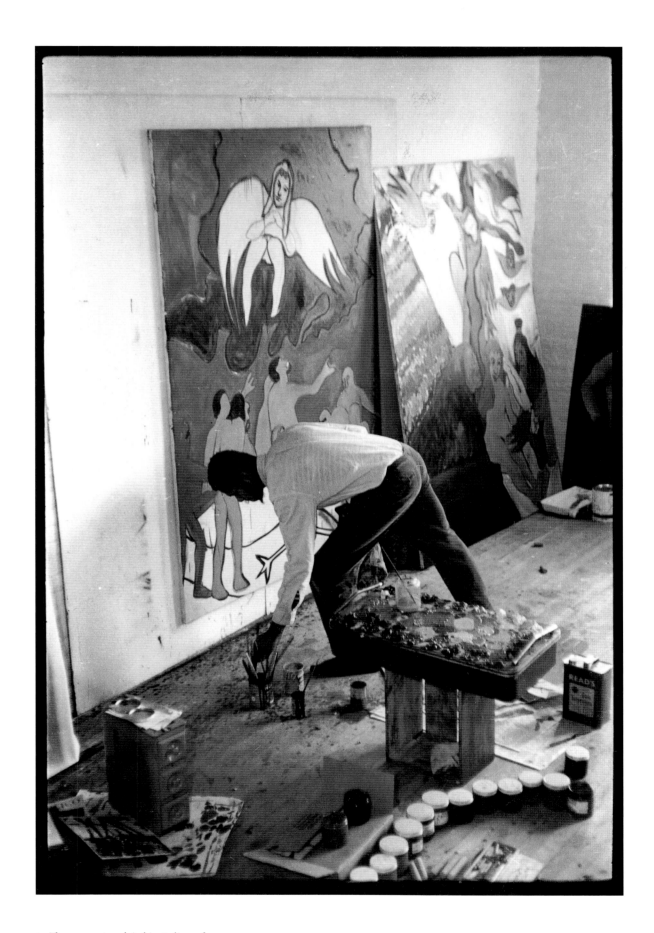

21. Thompson at work in his studio, 1963.
Photo copyright © by Fred W. McDarrah

Prior to his move north, Thompson had been no stranger to interracial liaisons.[153] But in 1959—only four years after the brutal murder of Emmett Till, a fifteen-year-old Northern black youth who made the mistake of whistling at a white woman on a Mississippi street—a Southern-born black male like Thompson must have been struck by the relative absence of prohibitions against interracial sex in New York's bohemian enclaves.[154] Equally striking would have been the fact that, even in Greenwich Village, interracial couples faced varying degrees of tension, hostility, and occasionally outright violence. Nor was Thompson immune to more mundane forms of racism. Sheila Milder wrote:

> I remember, one day, Jay and Bob went uptown to some collector on Park Avenue. They had been told to bring up some paintings. This was in 1959–60. The doorman took one look at them and sent them around to the back door. They both looked pretty scruffy, but…Jay had been [there] before [without this happening]. It was being with Bob…that sent them around to the back door.[155]

The dark emotional content and rich symbolism of Thompson's steadily maturing work—and persona—did not deter patronage. Art historian and critic Meyer Schapiro purchased, from the Delancey show, "a beautiful little triptych," which he described as having been "painted on the outer board of a bureau drawer. In its color it was inspired, I think, by the work of Jan Müller, but had already a decided personal quality and showed [Thompson's] exceptional gift of color."[156]

Two months after Thompson's Delancey Street exhibition, a pair of his canvases appeared in a show at the Mint Museum in Charlotte, North Carolina. In late May, he and Jay Milder graduated from downtown loft shows to a two-artist show in midtown at the Zabriskie Gallery. The Mint Museum exhibition featured contemporary art from Horace Richter's

collection, and Meyer Schapiro's famous essay "The Liberating Quality of Avant-Garde Art" was reprinted as the catalogue's principal text. Thompson's fellow exhibitors ranged from Franz Kline, Hans Hofmann, and Robert Motherwell through Lee Bontecou, Richard Diebenkorn, and Larry Rivers to Gandy Brodie, Red Grooms, and Lester Johnson.[157]

Johnson credits Jay Milder with having introduced him to Bob Thompson. In the eyes of the laconic older man, the gregarious Milder was "mayor of the loft," the nucleus of the community of young figurative painters to which Bob Thompson belonged.[158] Johnson recalls that, perhaps as early as 1958, Milder had arranged for him to see Thompson's work, which consisted of small gouaches and watercolors "from the Italians."[159] Subsequently, Johnson would recommend Thompson and Milder to his own dealer, Virginia Zabriskie.

A gallery press release identifies the two men as "relatively little known" but already in the collections of the Chrysler Museum and the Dayton Museum in Ohio.[160] Reviews by Edith Burckhardt in *Art News* and by Sidney Tillim in *Arts* were mixed. Burckhardt considered Milder "the more mature" of the two artists and identified the influence of Lester Johnson in his canvases, while Thompson's struck her as "awkward fables, influenced by Jan Müller, [that] were invented by an obviously young talent. Not its shoots of imagination, but its form and color need pruning and ripening…."[161] In contrast, Tillim was clearly more intrigued (or perhaps more intensely irritated) by Thompson's art than by Milder's. (The latter's work receives about half as much space as Thompson's.) "In his twenties, Thompson is overexcited by shock values," the critic declared, tempering this reproach with the conclusion that "his work shows the promising if mannered beginnings of a potential artist."[162]

The photograph of Bob Thompson that appears on the exhibition announcement evokes familiar

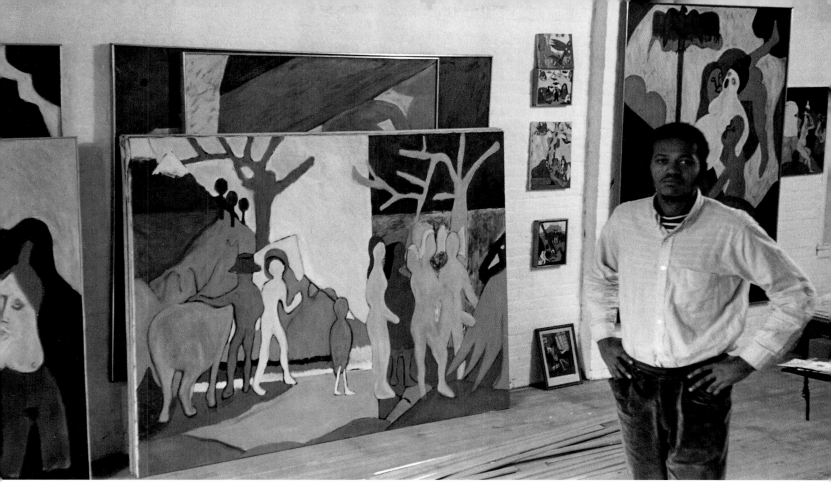

racial stereotypes. Seated in his studio, in a thicket of canvases that include *Beauty and the Beast*, the artist is seen playing a set of drums. Yet neither of the reviewers mentions his race or links his art's thematic content or style to issues of ethnicity. In fact, most critics wrote about Thompson as if they were aligned with the civil rights movement's integrationist goals. An etiquette of "racelessness" masked the contradictions of Bob Thompson's simultaneous status as exotic Other and art-world insider.

The majority of the reviews Thompson received in his lifetime minimized his art's thematic content, as they were written at the height of Greenbergian formalism's sway over the US art critical establishment. Jane Harrison's critique of a pair of Thompson shows that took place in 1964 at the Drawing Shop, where he showed small gouaches, and at the Martha Jackson Gallery, where he showed larger works, is typical of this orientation. Harrison's preference for the more abstracted, decorative imagery and flattened pictorial space of the small works reflects the prevail-

ing formalist biases of the period. Her objections to the larger works seem to center on the fact that "on a larger scale the figuration assumes more importance" and the "handling becomes more literary." [163]

Certain writers also tended to underrate the complexity of Thompson's subject matter or to overlook the recurrent preoccupations revealed by his use of symbols, such as hats, harpies, and horses. In Thompson's *The Traveler* (1960), for example, a black-silhouetted man in a broad-brimmed hat appears in circumstances that recall the medieval legend of the *belle dame sans merci*, who lies in wait for unsuspecting males—a vein of imagery richly mined by Jan Müller.[164] Three years later, when Thompson cribs a scene from one of Piero della Francesca's Arezzo panels to create his own *Queen of Sheba's Visit to King Solomon* (Fig. 95), we see that one of Piero's grooms has become a gray-silhouetted man wearing a broad-brimmed purple hat. The 1964 *Ascension to the Heavens* contains two silhouettes of men wearing hats—one, either a half-human/half-chimerical com-

22. Thompson in his studio with finished paintings, *Queen of Sheba's Visit to King Solomon* and *Caledonia Flight*, 1963.
Photo copyright © by Fred W. McDarrah

23. Thompson, art historian and collector Stephen Pepper, and Pepper's friend Betsy on the *Queen Elizabeth*, March 1961.

24. Stephen Pepper pointing to Carol Thompson on the *Queen Elizabeth*, March 1961.

posite or a man wearing some fantastic disguise. And, though he shifts to a more naturalistic treatment of his silhouetted males in 1965, men wearing hats still show up sporadically in such late works as his *Horsemen of the Queen of Sheba* (1966).

Perhaps the most telling of Thompson's equestrian images is *Two and the Same*, a 1960 work in which one silhouetted man in a broad-brimmed hat watches as his double is pitched forward, but not unseated, by a mount that kicks up its heels at the sight of a woman whose nude torso and thighs stretch the length of the left side of the canvas.[165] In 1965, when he discussed his monster pictures with Jeanne Siegel, Thompson stressed that they "involved a sort of poetry," or symbolic equivalence of "man and woman to nature and beasts."[166] Through an act of anthropomorphic projection in *Two and the Same*, the unruly impulses unleashed in the male rider by the sight of the nude woman are transferred to the bucking horse. As Robert Farris Thompson has observed, the rambunctious spirit of Thompson's bucking horse differs considerably from the sense of alarm conveyed by Jan Müller's rearing steeds.[167]

Freud, in *The Interpretation of Dreams*, lists the wild horse among the "wild beasts" that are "employed by the dream-work to represent passionate impulses of which the dreamer is afraid, whether they are his own or those of other people." He adds, "It might be said

that the wild beasts are used to represent the libido, a force dreaded by the ego, and combated by means of repression."[168]

In *Two and the Same*, Man is symbolically equated with Beast, while Woman seems firmly tied to Nature—an opposition equivalent to the "passive object/active subject duality" discussed by Simone de Beauvoir in *The Second Sex*.[169] The artist has framed his composition in a manner that decapitates the female subject—leaving her all body, no mind or will. Continuing the stress on the physical, Thompson aligns the female figure with the verticality of a tree trunk at the picture's left edge, thereby literalizing the identification of woman with nature.

The equine imagery of the 1962 canvas *The Journey* (Fig. 81) provides an instructive contrast to this bucking bronco picture. Here, the horse's significance initially seems less obvious. But, again, we have the artist's own words as clues to a possible interpretation. In 1965, he described his method of integrating forms by rhyming their contours:

> I paint a woman that is real fine and has got a lot of groovy things about her, and then I am going to put her right beside...a horse,...a real fine horse, with a great fine figure and shape, and relate the two. The buttocks of the woman and the buttocks of the horse, the sensuality of the tree and the mountain and...all of that. That's the way it is going in my mind when I work.[170]

25. Stephen Pepper and Thompson on the *Queen Elizabeth*, heading for London, March 1961.

In *The Journey*, a continuous play of curves seems to emanate from the pronounced arc of the blue horse's rump, located near the center of the canvas. There is the wide curve of the left edge of the path receding into the distance behind the horse—a curve placed diagonally above the horse's hindquarters, the shape of which it reflects in exaggerated form. There is a second, horizontal pair of countercurves created by the animal's belly and back. Then there is the smaller vertical curve of the edge of the horse's blanket—a parabola mirrored by the opposing double curves of the buttocks and back of the woman beside the horse, at right. This series of paired, echoing curves can be followed through the contours of the painting's other figures, including the rear-view image of a female torso inscribed on the horse's blanket.

Thompson has activated and orchestrated the entire composition by linking horse, humans, and landscape elements in the same voluptuous rhythms. Formally and symbolically, the horse's role here is the opposite of its disruptive character in the 1960 canvas. While the earlier painting suggests that woman's sensual appeal triggers discordant behavior in the male animal, *The Journey* shows man, woman, and beast united in sensuous harmony.

Although the scene depicted in *Beauty and the Beast* shows a woman menaced by male figures, the painting seems to be more about its male creator's

feelings of vulnerability. Consider the blue horse in the foreground: in comparison with the equine imagery of *The Journey*, the animal here is not particularly sensuous. Nor does this horse project the hostile or unruly force conveyed by the bucking steed in the untitled 1960 painting. Instead, it stares impassively at some object outside the picture frame, wholly uninterested in the nearby monster-and-maiden drama. The horse's indifference seems to echo the disaffected tone of the artist's remarks about his own sexual experiences:

> *It was always a reverse situation. You would be attracted and approached from a mental standpoint and you would arrive at a physical relationship and that would be all.*[171]

In search of something more lasting than erotic intimacy, Thompson married Carol Plenda at the Judson Memorial Church on December 1, 1960. Three months later, thanks to a grant from Wall Street stockbroker and avant-garde angel Walter Gutman, the Thompsons departed for London on the *Queen Elizabeth*, accompanied by art historian and collector Stephen Pepper. They would remain abroad for two years.

26. Bob and Carol Thompson on their wedding day, Judson Memorial Church, New York, 1960. Margaret M. Bridwell Art Library, University of Louisville.

"CROISSANTS AND COCA-COLA"
BOB THOMPSON AND THE OLD MASTERS

1961(?) in Paris...saw him in Left Bank hotel studio—we talked and turned on, I dug his new candy-bright colored style making Poussin-esque space, flat colors surface amorphism delineating 3-D figures....I thought him the most original visionary painter of his days, a first *natural* American psychedelic colorist.

— ALLEN GINSBERG [172]

In April 1961, after a brief stay in London, Bob and Carol Thompson arrived in Paris, where they settled on the Left Bank, initially at a hotel on rue de l'Ancienne Comédie. Eventually, the couple took up residence at Glacière, a warren of heatless, hot-waterless, cement studio domiciles bordering a junkyard near Montparnasse. [173] Home to some twenty to thirty artists from various parts of Europe, the Middle East, and North America, Glacière was a type of low-rent Cité des Arts with two groups of studios arranged around separate courtyards. [174]

Painter Robert DeNiro described Glacière as "not very comfortable—thin-walled, like a garage," but "rents were very cheap." DeNiro moved there when "a place in St. Germain fell through" and lived next door to Bob Thompson for "a couple of months." The older figurative expressionist remembers that his neighbor typically consumed "crois-sants and Coca-Cola" for breakfast. He also considered Thompson "very enterprising"—someone who was "always running around looking at art" and whose studio was frequented by "some Rothschild" who was a friend of collector Joseph Hirshhorn. [175]

Prior to his departure for Europe, the artist had applied to the John Hay Whitney Foundation for one of its "Opportunity Fellowships," grants earmarked for nonwhite artists under age thirty-five. [176] Awards were not slated to be conferred until April, and the Thompsons had originally timed their

departure accordingly. But they were persuaded by their traveling companion, Stephen Pepper, to leave in March. They did so, confident that Thompson would be awarded one of the $3,000 grants and expecting the funds to be forwarded to them in London. But because the artist had neglected to notify the foundation of his departure or leave a forwarding address, the award was passed on to another candidate. [177] Despite this foul-up, Thompson had a gift for self-promotion, which would be crucial to the couple's survival during the next year and a half.

The painter's erstwhile roommate Christopher Lane had been in Paris since the spring of 1959. He recalls the French art scene was "a jolt" for Thompson, with whom he frequented the galleries in the Latin Quarter. [178] Thompson painted furiously. A photograph of his Glacière studio shows a room filled with finished canvases leaning against one another and propped against every possible support. Painter Jim Sullivan, who lived off the same courtyard at Glacière, remembers that Thompson was extremely prolific, producing "stacks" of work in "all sizes," including some "three-dimensional stuff on wood blocks." [179]

Fascinated with traditional European painting since his University of Louisville days (an interest further inspired by Dody Müller's advice early on to seek inspiration in the Old Masters), Bob Thompson now studied the Old Masters firsthand. Years later, critic Barbara Rose would report that she "used to run into him in the Louvre, where he went almost daily to sketch." [180] The effect of Thompson's stay in France is clearly apparent in his art. Like his former comrade Red Grooms, who had left New York a year before him and remained abroad for eighteen months, Thompson's primary response to being in Europe was to refine his style. [181] Comparison of his *Assistance of a Woman*, painted in 1960 in New York, with *The Blue Path*

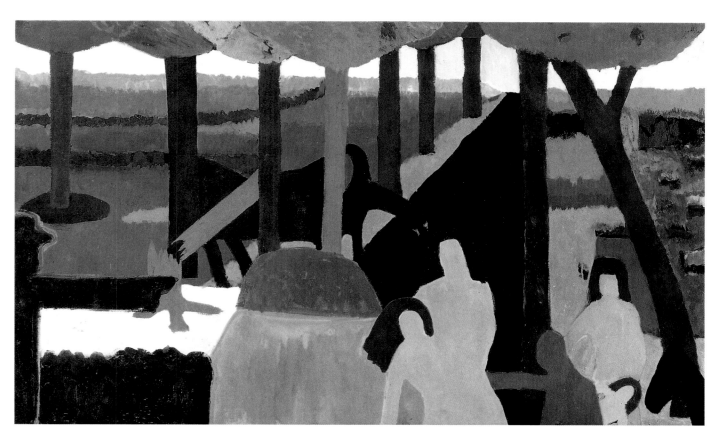

27. *THE BLUE PATH*, c. 1962
Oil on canvas, 57 x 35 (144.8 x 88.9)
Private collection

(Fig. 27), a return to the same composition later in Paris, makes this clear.

In the Paris picture, the previous, almost-square format has been stretched horizontally and several figures have been eliminated. The resulting clarity of design is further enhanced by Thompson's more geometrized treatment of the landscape, a complete absence of modeling and anatomical detail in the figures, flatter, more even color areas, and the artist's more controlled brushwork. Also painted in Paris, The Detroit Institute of Arts' 1961 *Blue Madonna* (Fig. 72) shows Thompson combining his newly refined technique with a complex, collagelike mode of composition. Although it marks the peak of his development during this period, he would not repeat *Blue Madonna*'s fragmentary spatial effects in subsequent work. The artist would later state:

> I think painting should be...like the theatre...
> [T]he painters in the Middle Ages, and the
> Renaissance...were employed to educate the
> people...they could walk into a cathedral, look at the
> wall, and see what was happening....I am not specifi-
> cally trying to do that....but, in a certain way, I am
> trying to show what's happening, what's going on...
> in my own private way.[182]

In August 1962, the letter that Bob and Carol Thompson had hoped to receive the year before finally arrived.[183] With the funds provided by the Whitney Opportunity Fellowship, the couple lost no time moving from their grim quarters at Glacière to the Mediterranean island of Ibiza. They settled there in the Old Town section of the island's capital—also called Ibiza—an ancient quarter that had been the site of successive Phoenician and Roman occupations. The Thompsons rented "an apartment that was like a cave," according to Bill Barrell, who attributes to it the archways and tunnels that are a prominent feature of such works as Thompson's 1963 *The Spinning, Spinning, Turning, Directing* (Fig. 108).[184]

It was an extremely inexpensive place to live:

28. Bob and Carol Thompson at their home in Ibiza, summer 1963.

29. Bob and Carol Thompson in Ibiza, fall 1962.

most residents could afford maids, and Bob Thompson had good working space there, according to Iris Samson (then Clay), a fledgling artist who was staying with her writer husband at Ibiza. Days slipped by in Old Town, a place with no telephones, where total strangers easily became "very close." Samson recalls sitting in Thompson's studio sipping wine with Thompson and watching his wife stretch canvases. "Their house was always open to everyone; it was a hang-out," she says. [185]

An African-American couple who roamed Europe during the 1960s, fabric artist Andrea Phillips and painter Maurice Phillips, were similarly impressed with the Thompsons' hospitality. "Other artists—people you've never heard of—could come to Ibiza and knock on their door in the middle of the night and get food, get put up," Andrea Phillips says. "Bob and Carol were always giving these great parties. And Carol was always cooking for loads of people." [186]

While Iris Samson sensed a desire to be famous on Thompson's part, he also struck her as "very laid back. A kind, playful, fun guy. I don't think I ever saw him depressed. He was a genuinely nice person, with no airs of 'an artist' or [hang-ups about] 'success.'" Occasionally, she and her husband would go with Bob and Carol to hear jazz, or the two couples might join with some of the island's other artists to stage Happenings. The latter events, Samson recalls, were generally inspired by the German or Dutch artists who were part of their circle. Impromptu performances launched in the spirit of ambitious parlor games, they generally resulted from little more than someone's spontaneous "Oh, let's have a Happening tonight!"

Although he created no Happenings himself, Thompson's participation in these events, both in New York and Ibiza, is consistent with the theatricality of his painting. In works as early as *Garden of Music* (Fig. 51), the artist produced tableaux in which dramatic content is not only suggested by the poses, placement, and interaction of figures, but the resulting action is staged in pictorial space that doubles as specific locales—locations that, however

fantastic, can be imaginatively entered by viewers. Thompson's work had already gained greater clarity and, with it, increased narrative force during his stay in Paris. Increasingly, his compositions crystalized into vibrant tapestries of flattened forms in bold, unmodulated colors with rhythmically interlocking contours. In Spain, Francisco Goya's example encouraged Thompson to further simplify his compositions and sharpen the thrust of his iconography.

Thompson's friends recall him as swift to expose human foibles—other people's or his own. He "would see all the political things going on at a party or something, people trying to take over," Sheila Milder explains. "He showed me the absurdity of these power plays." [187] Thompson had a keen eye for folly and pretense, and the fact that monsters and other fantastic creatures were already standard features of his art suggests a predisposition toward the type of grotesque imagery that Goya employed in his critique of eighteenth-century Spanish mores. Furthermore, the attraction to Hieronymus Bosch revealed in several of Thompson's Paris paintings indicates that he was already enamored of an art whose pungent blend of fantasy and satire had also inspired the Spanish master.

In the 1962 painting *Tree* (Fig. 83), two plates from Goya's *Los Caprichos*, nos. 61 and 62, are abruptly fused into a single, vibrant-hued composition. Thompson not only merges the two etchings, he also freely translates Goya's imagery to suit his own compositional and thematic purposes. Thus, for example, the Spanish lady's cape becomes a pair of wings—one of Thompson's recurrent devices—while the witches who crouch beneath her are transformed into an amorphous collection of objects and figures.

A 1963 canvas, *Family Portrait*, demonstrates the artist's newfound ability to reduce settings to the simplest dramatic frameworks and thereby tightly focus his compositions on emblematic groups of figures. As Gylbert Coker has pointed out, the "triangular figure structure" in the left half of the canvas is derived "from Goya's *Los Caprichos*." [188] The toplessness of the figure in the painting's right half is also based on the half-female/half-fowl captive in the Goya etching. Within this canvas, we see Thompson engaged in varying degrees or kinds of appropriation from a single source.

Friends of the artist have claimed that his art is often confessional—exposing his deepest feelings about specific individuals, especially intimate acquaintances. [189] In this context, it seems plausible to read the three shawled women in *Family Portrait* as symbolic representations of his mother and two sisters, women whose black bourgeois values and lifestyles had come to seem as stagnant to Thompson as the deeply entrenched cultural conservatism often identified with Spain's veiled peasant women. [190] And in direct contrast, the bare-bosomed redhead at right might be associated with the artist's wife, a woman attuned to the painter's own bohemian mores who radiated a frank, unselfconscious sexiness. Completing the family portrayed here, the spectral creature in the foreground can be seen as either a morbid premonition of the artist's own death or an evocation of his dead father, while the dark, menacing silhouette that looms in the background seems linked to the large, winged creatures that appear in a number of other Thompson canvases from this period. In an interview two years later, the artist would equate birds with freedom, [191] but their appearance in his art often suggests a preoccupation with the ultimate flight of death.

In a lighter vein, the imagery of Thompson's 1963 *Caledonia Flight* (Fig. 91) is almost entirely derived from plate 65, *"Donde va mamá?"* ("Where is mother going?") of *Los Caprichos*. Yet, the contemporary artist's schematized, monochromatic treatment of Goya's figures effectively transforms the finely detailed image. This sort of overt quotation and inspired alteration of iconographic sources is a key

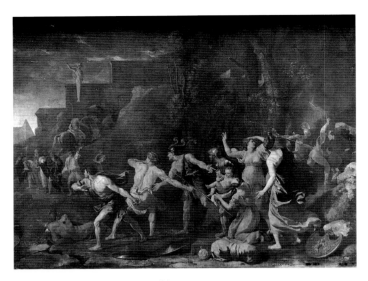

30. NICOLAS POUSSIN (1594–1665)
Rescue of the Young Pyrrhus, c. 1634
Oil on canvas, 45³/4 x 63 (116 x 160)
Musée de Louvre, Paris

31. *SAVING OF PYRRHUS (POUSSIN)*, 1964
(See Fig. 129)

trait of Thompson's work from his first European
stay to his last. Both honoring the Western painting
tradition through frank and frequent quotations and
irreverently subverting, supplementing, and generally
adapting it to his own purposes, Thompson uses
Old Master sources in a way that seems analogous
to the familiar improvisational strategies of the
African-American music he loved. Critic Frank
Bowling would later recall:

> One might say "This painting reminds me of that
> Piero—God! Which one is it? "The Nativity?" But
> then one looks hard and...what we thought was Piero
> disappears and we have a Thompson. A rich, sump-
> tuous, and undeniably complex painting generating
> its own personal heat, comparable only to a Picasso's
> use of tribal sculpture or a Van Gogh's use of
> Japanese prints.[192]

In October 1963, Bob and Carol Thompson re-
turned to New York.[193] While they were abroad, the
artist had exhibited in a few shows, contributing a
wash drawing to "S.O.S. Glacière," a group show
protesting the threatened demolition of Glacière, in
Paris in February 1962, and showing several large oils
and a group of small gouache studies in a one-artist
exhibition at Galeria El Corsario at Ibiza in May

1963.[194] During his European stay, Thompson is also
thought to have sold some work on a consignment
basis through the French dealer Iris Clert in Paris and
to have had some sort of financial arrangement with
Virginia Zabriskie.[195] Back in the United States dur-
ing the summer of 1962, his patron-friend Stephen
Pepper mounted a show of Thompson gouaches, and
included oils and gouaches by the artist in a two-man
show of work by Thompson and Terry Barrell at his
Upper West Side gallery, the Friendly Art Store, in
May 1963.[196] For the most part, however, the years in
France and Spain were a period of immense growth
and activity for Thompson, but of relatively little
display, sales, or critical recognition.

The Thompsons settled in a loft at 6 Rivington
Street on the Lower East Side. Lester Johnson's
studio, at 222 Bowery, off Spring Street, was only "a
block or so away."[197] In January, Johnson had begun
exhibiting with Martha Jackson, one of the period's
most important uptown dealers. Her 1954 show of
de Kooning's second Women series had played a key
role in establishing the importance of those contro-
versial works, while such figures as Karel Appel, Christo,
Adolph Gottlieb, John Chamberlain, Jim Dine, Louise
Nevelson, Barbara Hepworth, and Antoni Tàpies
had received their first New York one-artist shows at

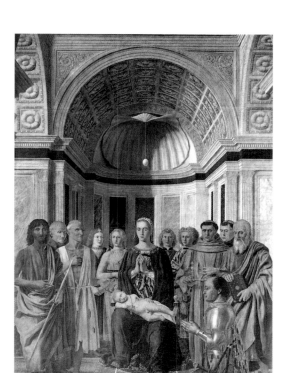

32. PIERO DELLA FRANCESCA (c. 1420–1492)
The Montefeltro Madonna, c. 1472–74
Panel, 98 x 79 (248.9 x 200.7)
Pinacoteca di Brera, Milan

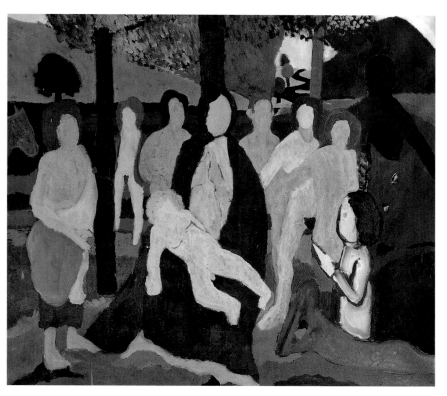

33. *NATIVITY*, 1961
Oil on canvas, 36 1/2 x 40 1/2 (77.5 x 102.9)
Collection of John Sacchi

Jackson's Upper East Side gallery.[198] And Jackson's 1960 and 1961 exhibitions, "New Forms—New Media I" and "II" and "Environments, Situations, Spaces," would herald the eclipse of New York School painting and mark the rise of such modes as events, assemblage, and environments, as well as Pop Art's use of ordinary, recycled, or found mass-culture imagery.[199]

Shortly after Thompson's return from Europe, Lester Johnson arranged for Martha Jackson to visit the young painter's studio.[200] The result was a one-artist exhibition of "7 large oils and 4 gouaches" that opened on December 3, 1963.[201] Critic Jill Johnston, herself a habitué of the new dance, Happenings, and events emanating from the Judson Church, wrote enthusiastically in *Art News*:[202]

> *Thompson makes an impressive transference of the subjects and techniques of his smaller gouaches to large oils on canvas. His fantastic dream figures crowd the space with no less of vitality in the flat*

> *brilliance of color and the interlocking or ruggedly juxtaposed shapes which curve, bulge, swoop and thrust in spontaneously regulated contrasts and variations....[His] scenes...are grim and prophetic-looking even while they spring with the erotic pleasure of pure color, voluptuous shapes and vigorous line.*[203]

A show at the Drawing Shop devoted to Thompson's gouaches had opened in late November and continued through the first weeks of the Jackson show. *The New York Times'* John Canaday commented favorably on the November show, describing the work as "[c]olorful Ensor-Munch type gouaches (with an occasional bow to Gauguin)" and declaring it "good enough to make such obvious references unimportant as they present pungent little myths and moralities."[204]

Now, in rapid succession, mainstream art-world doors began opening to the twenty-six-year-old artist. In February 1964, he had a one-artist exhibition at the Richard Gray Gallery, one of Chicago's leading outlets

34. Bob and Carol Thompson in the garden behind the Martha Jackson Gallery, New York, c. 1965.

for contemporary art. Thanks again to Lester Johnson, who had begun teaching at Yale University's School of Art that year, Thompson was included in "Seven Young Painters," a show at the Yale School of Art Gallery. In the fall, Paula Cooper (then Paula Johnson) gave Thompson a one-artist show and brought collector Joseph Hirshhorn to his studio.[205] During the next year, Hirshhorn would acquire twenty canvases by the artist.[206]

When Thompson's second show at Martha Jackson's opened the gallery's fall 1965 season, it is said to have "broke[n] the gallery's attendance records."[207] But, despite this conspicuous success,

all was not well in Bob Thompson's "garden."

Bob Thompson left New York for Rome not long after his triumphant one-artist show at the Martha Jackson Gallery closed in October 1965. Seven months later, at age twenty-eight, he died, apparently the victim of a drug overdose.[208] He is said to have essentially fled the fruits of his success in New York, where his growing artistic prominence made him subject to the pressures of the period's increasingly polarized racial politics, and where he was enmeshed in social networks that encouraged excessive use of alcohol and drugs to the point where he was consumed by them.[209]

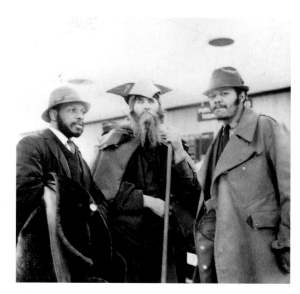

35. Bob and Carol Thompson in the garden behind Martha Jackson Gallery, New York, c. 1965.

36. Ornette Coleman, Moondog, and Bob Thompson at an airport, 1965.

As he had done at the start of his career in 1958 and 1959, Thompson had spent the summer of 1965 in Provincetown, now accompanied by his wife, Carol. During that time, his circle of friends and acquaintances included the controversial singer Nina Simone. Simone had catapulted from obscurity to a degree of fame in the late 1950s, when her recording of the George Gershwin lament "I Loves You Porgy" became a hit. A triumphant 1959 solo concert at New York's Town Hall consolidated her reputation, but presented pop pundits with a conundrum—how to classify this mercurial diva's art. In her autobiography, Simone recalls:

> It was difficult for them because I was playing popular songs in a classical style with a classical piano technique influenced by cocktail jazz. On top of that I included spirituals and children's songs in my performances, and those sorts of songs were automatically identified with the folk movement....[210]

It seems likely that this stylistic eclecticism accounts for much of Simone's appeal to Bob Thompson, a painter whose work exhibits a comparable hybrid quality and advertises an equally cosmopolitan sensi-

bility. Where Nina Simone dared to render Kurt Weill's "Pirate Jenny" in a voice whose bluesy inflections conjured up Southern juke joints, rather than Weimar Germany's smoky dens, Bob Thompson similarly translated Old Master compositions. In his *St. George and the Dragon* of c. 1961–62 (Fig. 80), we see the artist "borrowing" his general design and major compositional elements from Tintoretto's *St. George and the Dragon* (Fig. 38). Here, Thompson is obviously engaged in "taking liberties with color," as Steve Lacy put it.[211] He does so in ways that not only raise his work's temperature, giving it the visceral immediacy of contemporary mass media and advertising's intensely saturated hues, but also invest his canvases with that other kind of color, described by Mimi Gross as being "related to the fact that he was colored."[212]

By the mid-1960s, both Nina Simone's passion and her candor had gained a distinctly political resonance. In 1963, the rising tide of violence in response to Southern black demands led her to compose "Mississippi Goddam," a song that was promptly banned from the airwaves and became an unofficial anthem of the more militant, student-led faction of

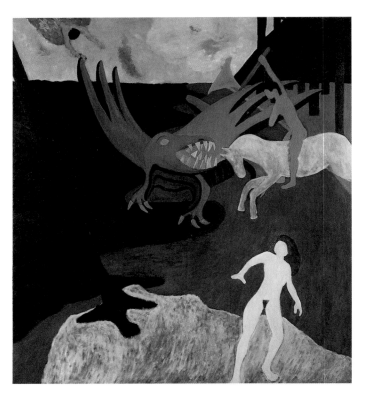

37. *ST. GEORGE AND THE DRAGON*, c. 1961–62 (see Fig. 80)

38. TINTORETTO (1518–1594)
St. George and the Dragon, c. 1560–80
Oil on canvas, 62 x 39 1/2 (157.5 x 100.3)
National Gallery, London

the civil rights movement.[213] Throughout the remainder of the decade, the singer would repeatedly register the period's shifting ideological currents in works ranging from a sung version of the Langston Hughes poem "Backlash Blues" to the paean "To Be Young, Gifted and Black," a dual tribute to the late playwright/activist Lorraine Hansberry and to her intellectual progeny, the period's militant black youth.

This aspect of the singer's public persona—her role as an overtly politicized black cultural icon—seems to have motivated Thompson's 1965 painting *Homage to Nina Simone* (Fig. 39). Yet, the very form of his tribute seems antithetical to the upsurge of black social and cultural self-assertion during the 1960s with which Simone is generally associated, for its compositional source is Nicolas Poussin's *Bacchanal with a Guitarist* (Fig. 40).

Thompson's use of this composition seems par-

ticularly odd, in that the singer to whom he pays homage does not replace Poussin's central figure— the guitarist—but is situated obliquely, to the left of the musician. In neither placement nor pose does she directly correspond to either of the two figures who occupy the same location in Poussin's canvas, leaving us with an iconographic puzzle: if the painting is a tribute to Simone, why is she placed on the sidelines? Who is the central figure meant to be? What role is he meant to play with respect to the singer? Is he the emcee of an outdoor concert?[214] Or is he a stand-in for the painter, sharing his enthusiasm for Simone with fellow music lovers?

In other respects, however, *Homage to Nina Simone* seems typical of Thompson's procedures. A shameless appropriator of Old Master compositions, Thompson also indulged in freewheeling improvisations that suggest a startling blend of awe and irrever-

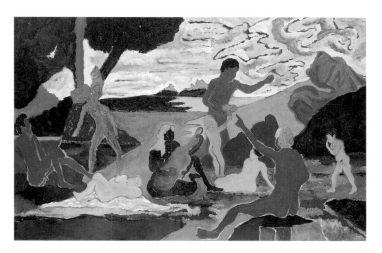

39. *HOMAGE TO NINA SIMONE*, 1965 (see Fig. 143)

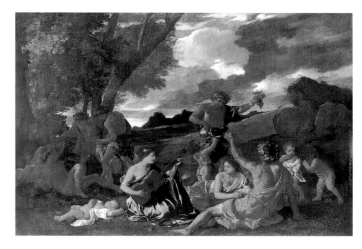

40. NICOLAS POUSSIN (1594–1665)
Bacchanal with a Guitarist, c. 1627–33
Oil on canvas, 47 5/8 x 68 7/8 (121 x 175)
Musée du Louvre, Paris

ence toward his sources: his 1965 *Recreation of Cephalus and Procris* (Fig. 41), for example, derives from Claude's *Landscape with Cephalus and Procris Reunited by Diana* (Fig. 42). His 1964 *Spain Being Secured* comes from Titian's *Religion Succoured by Spain*.

The September 6, 1965 issue of the French journal *Jazz Magazine* featured an interview with Simone, who had recently performed at the Antibes jazz festival. At one point, journalist Philippe Carles' remarks suggest that the singer was wearing her hair either *au naturel* or in an Afro at this time. ("Votre coiffure, certaines de vos chansons et de vos gestes sur scène évoquent l'Afrique.") [215] It is precisely this physical evocation of Africa, proudly advertised in her stage mannerisms, some of her songs, and even her hairstyle, that made Simone a potent cultural symbol at a pivotal moment in US black history—a moment of transition from the integrationist civil rights movement to the cultural nationalism of the black consciousness movement.

Although he showed little interest in joining his friends LeRoi Jones (soon to become Amiri Baraka) and A.B. Spellman in an early sixties proto-black cultural nationalist group called the Organization of Young Men, it seems evident that Bob Thompson's thinking was aligned with theirs in at least one important respect: he shared with figures like Jones and Spellman an unusual capacity for cultural self-asser-

tion. [216] For the two poets, however, immersion in white avant-garde circles as a rejection of intellectual ghettoization had ultimately proved unsatisfactory, because it left unanswered (or even unexamined) questions of cultural difference and hegemony. In contrast, Bob Thompson was loath to relinquish a mythic "universalism" that has had special force for academically trained black practitioners of the visual arts. [217]

Nevertheless, he felt a love of certain aspects of African-American culture—ranging from blues and jazz to cornbread (his wife had to go to great pains to find corn and have it ground when the couple lived in Spain)—and the self-confidence to enact those preferences in virtually any context. [218] Thus, while he may have felt alienated from the separatist portion of his friends' agendas, Thompson was, as Jones has put it, "not unsympathetic" to the self-assertive aspect of their project. [219] And a particularly telling sign of this orientation is the painter's attitude toward African-American hair. In a 1966 *Ebony* magazine article, Phyl Garland says:

> [A]n increasing number of Negro women are turning their backs on traditional concepts of style and beauty by wearing their hair in its naturally kinky state. [T]hey remain a relatively small group, confined primarily to the trend-making cities of New York and Chicago.... [220]

41. *RECREATION OF CEPHALUS AND PROCRIS*, 1965 (see Fig. 150)

42. CLAUDE LORRAIN (1600–1682)
Landscape with Cephalus and Procris Reunited by Diana, 1645
Oil on canvas, 40 x 52 (101.6 x 132.1)
National Gallery, London

When shown a slide of Bob Thompson's 1962–63 painting *The Hairdresser*, A.B. Spellman remarked that the painter had been "one of the original [wearers of] Afros." Indeed, Thompson—who frequently "would sit and twist" pieces of his hair—had "anticipated dreadlocks," Spellman declared. [221] Don Fiene, a friend from Thompson's St. James Court days in Louisville, recounts a chance encounter with the artist at The Metropolitan Museum in 1959, which suggests that Thompson's break with tonsorial convention dates to his early days in New York. Fiene recalls initially thinking that Thompson looked "really fantastic in the first Afro I ever took close notice of." On further examination, though, Fiene realized "that Bob had merely forgotten to get a haircut in the previous six or eight months." [222] Thus, in a conspicuous manner, Thompson chose to defy or ignore prevailing African-American grooming standards, which in the late 1950s and early 1960s dictated that middle-class black males wear their hair either neatly close-cropped, if left with its texture unaltered, or pressed into rippling, low-relief waves through the application of a heavy layer of pomade and a stocking cap. Bob Thompson not only took an unorthodox position with respect to his own hair care, he also made it his art's subject, in at least one case.

Thompson appears to have been a pioneer of the

ideological representation of black hair. [223] Characteristically for this artist, the race and gender implications of his 1963 oil *The Beauty Parlor* seem at once obvious and obscure. Both the silhouetted black man whose head and shoulders loom in the foreground and a silhouetted black background figure wearing a broad-brimmed hat read as ethnically black, while the pale, pink-fleshed woman who faces the hatted man reads as ethnically white. In front of this pair stand two figures—a cadmium yellow woman with bright red hair and an orange woman with a flowing black mane—whose pigmentation, rather than encoding ethnicity, seems simply to signal the artist's penchant for eye-searing, expressionistic color. In the middle distance, a cobalt blue-winged creature flails its legs in resistance as a red-winged creature grips the blue creature's head with one hand and prepares to apply a grooming implement of some kind to the blue creature's hair. Both the painting's title—*The Beauty Parlor*—and the long, flowing tresses of this central pair of anthropomorphic birds suggest the artist aimed to mock female beauty rites as a form of socially reinforced, cosmetic violence.

When we turn to the small gouache-on-paper version of the same scene, entitled *The Hairdresser*, Thompson's commentary in *The Beauty Parlor* seems more racially specific. In the earlier work, only the

second of the two pairs of background figures appears. A tall cone of curly dark hair, resembling an Afro, crowns the red, left-hand member of this pair. She is flanked by a pale beige woman who seems to be ushering her to the center of the canvas, where a pair of winged creatures is once again engaged in hair-grooming activities. One senses that Ms. Red is about to have her towering mass of kinky hair tamed by the bird/hairdresser. This suspicion is reinforced by Thompson's compositional source—plate 35 of Goya's *Los Caprichos*.

Goya's etching, in which a seductive-looking female barber shaves an adoring male, is captioned "She Fleeces Him!" (*"La descañona"*). In Thompson's rendition of this cosmetic morality play, however, women serve as both victim and victimizer, while men seem to occupy roles that are either peripheral or transcendent. In *The Beauty Parlor*, the man in a broad-brimmed hat is stationed so far in the rear, nearly lost in the gloom of the dark green area behind him, that his cryptic exchange with the pink female seems staged in the wings, as it were, of the painting's central drama. In both *The Beauty Parlor* and *The Hairdresser*, a second dark male—painted black in the former work, brown in the latter—looms in the foreground, at the lower edge of the canvas. Peering out at the viewer, he seems psychologically detached from the scene in progress behind him.

In *The Hairdresser*, this figure's hands are raised in a gesture that can be read as either that of someone pressing against a window in order to peer through it or shouting to a distant auditor. The ambiguity stems from an eschewal of outline that obscures the location of the figure's digits. The resulting sensory confusion or conflation seems particularly apropos in light of Thompson's interest in musical paradigms for his art, as well as his frequent use of the figure of a pointing man as a *repoussoir* in other canvases. While the indexical function of Thompson's figurated *repoussoirs* is most obviously visual, the pointing gesture also

functions as a familiar graphic equivalent of the verbal injunction, "Look!" Thus, his *repoussoirs* parallel the visual-verbal duality of the foreground figures in *The Hairdresser* and *The Beauty Parlor*. Like omniscient narrators or Greek choruses, these audience-addressing figures seem to double as both witnesses and judges. According to A.B. Spellman:

> *The problem of Afro-American painters and poets is that they are hunting for a form which relates to their traditions in a useful way....The African tradition of sculpture might perhaps have been transmuted into some Afro-American form as original as jazz had not the artisans of New Orleans, Charleston and other Southern cities been replaced by whites....[I]t must be remembered that jazz developed as a form of work, as a job. I imagine the painters of the Italian Renaissance must have regarded their commissions in much the same way.*[224]

Bob Thompson's painted tribute to Nina Simone seems to have been motivated by his conscious or unconscious identification with the singer's ideological position—a position written on the body in the medium of hair that represented the transitional character of black cultural politics around 1965. For Thompson is a transitional figure in the history of African-American art.

By standards that became pervasive during the second half of the decade, Thompson's reliance upon European iconographic sources and his disinterest in overt social protest have become problematic. But rather than viewing his work anachronistically— in terms of a cultural nationalist agenda still in its infancy at the time of the painter's death—we should adjust our historical lenses.

Thompson portrayed LeRoi Jones on several occasions.[225] A 1960 pen-and-ink drawing shows the poet, with a female companion identified only as "Barbara," at the Cedar Bar, principal watering hole of the New York School painters and other denizens of the city's

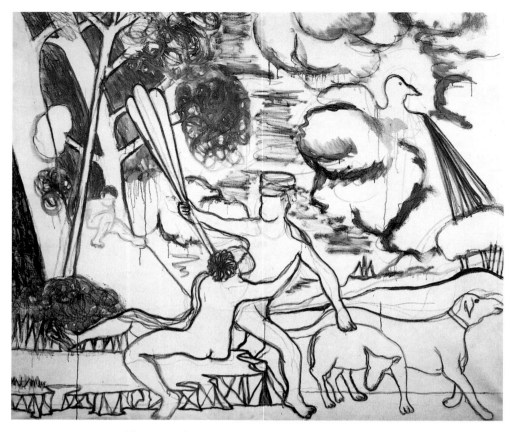

43. *LAST PAINTING*, 1966 (see Fig. 158)
Ink and oil on canvas, 55 x 63 (139.7 x 160)
Collection of Carol Thompson

downtown bohemia. Dating from the same year as
the Cedar Bar drawing, the painting *Portrait of LeRoi
Jones* shows the poet seated, reading a magazine
or book, probably in the artist's studio.[226] It is an
intimate scene, in which the artist seems to have
captured his subject almost unawares. The resulting
image conveys a sense of casual informality consis-
tent with a high degree of mutual familiarity. And,
finally, there is Thompson's 1964 *LeRoi Jones and
His Family* (Fig. 151), a painting in which the poet is
seen with the wife and two daughters he would leave
a few months later, in the wake of Malcolm X's assas-
sination in February 1965.[227]

Just as any adequate assessment of Jones/Baraka,
as author or as ideologue, must take into account
this complex before-and-after narrative, so we cannot
successfully evaluate Bob Thompson's art or its sig-
nificance unless we relinquish monolithic views of
black artistic activity during the 1960s. We need to
probe beyond the glamorous aura of late sixties black

militancy in order to retrieve a more complicated
history that has been obscured. The story of African-
American art during the first half of the decade differs
from that of the second half at least as much as the
integrationist black politics of the early 1960s differ
from the separatist black politics of the late 1960s.
Bob Thompson's public achievements and private
self-destruction are central features of that missing
chapter in the history of African-American art.

1. Interview with Lou Mercado, New York, June 24, 1988.

2. Undated letter from Bob Thompson to his mother, "Thompson, Robert—Correspondence, Miscellaneous" file, Art Library, University of Louisville, Louisville, Kentucky. I have determined that the letter was written in May 1959, because of internal references to Thompson, Red Grooms, and Jay Milder's stay at Milder's family home in Omaha, Nebraska, which took place during that period.

3. Barbara Haskell, *BLAM! The Explosion of Pop, Minimalism, and Performance 1958–1964*, exh. cat. (New York: Whitney Museum of American Art, 1984), pp. 32–33; Michael Kirby, *Happenings: An Illustrated Anthology* (New York: E.P. Dutton, 1965), pp. 124, 130–31; Fred W. McDarrah, *The Artist's World in Pictures: The New York School* (1961, ed. New York: Shapolsky Publishers, 1988), p. 184.

4. Haskell, *BLAM!*, pp. 19–20.

5. Interview with Steve Lacy, New York, March 20, 1988; interview with Charlie Haden, New York, March 21, 1988.

6. Interview with Diana Powell, New York, February 18, 1987.

7. Interview with Amiri Baraka, New York, March 19, 1984; author's notes from screening, *Bob Thompson Happening!* (16mm film, color), by Dorothy Beskind, New York, February 14, 1983. Commenting on Thompson's musical eclecticism, soprano saxophonist Steve Lacy said, "[H]e didn't have the musical constraints someone like me did. He could like anything that was good"; Lacy, 1988 interview.

8. Exhibition announcement, "Bob Thompson," Delancey Street Museum, 1960.

9. Press release and announcement, "Jay Milder and Bob Thompson," Zabriskie Gallery, 1960.

10. Interview with Carol Thompson, New York, November 24, 1982.

11. Painter Kenneth Young, who wit-nessed Thompson's Louisville departure, has stated that after the two of them had stayed "out all night," Thompson loaded a number of his paintings onto the roof of an "old car with no brakes," dropped Young off at work, and headed north; interview with Kenneth Young, Washington, D.C., November 8, 1986. Jay Milder provided further details about the vehicle, adding that he believed it was a "1948 or so" model. Interview with Jay Milder, New York, February 11, 1983.

12. Baraka, 1984 interview.

13. Interview with Emilio Cruz, New York, February 12, 1983.

14. Author's notes, Emilio Cruz, panel discussion, "Bob Thompson: His Life and Friendships," New York, Hatch-Billops Collection, May 6, 1984. Similarly, dealer Florence Morris recalls hearing Thompson say that he "was going to die young like Modigliani"; interview with Florence Morris, Birmingham, Michigan, December 16, 1986.

15. Interview with Dorothy White, Brooklyn, New York, March 10, 1984.

16. Mimi Gross and Sheila Milder, "Bob Thompson: His Life and Friend-ships," in Leo Hamalian and Judith Wilson, eds. *Artist and Influence 1985* (New York: Hatch-Billops Collection, 1985), pp. 120, 136.

17. Poet and cultural critic Thulani Davis, for example, has compared Thompson's use of Old Master sources with that of contemporary figurative expressionist Robert Colescott, stating that while Colescott's racially altered "take-offs of the classics...make a clear point of his 'complex [aesthetic] ances-try,'" Thompson's appropriations of European sources "seem to be fraught with ambiguity," which she finds "con-fusing"; Thulani Davis, "Canon Fodder," *The Village Voice*, March 21, 1989, p. 94.

18. Michael Brenson, "Black Artists: A Place in the Sun," *The New York Times*, March 12, 1989, sect. 2, p. 3.

19. In describing Bob Thompson's birth, the older of his two sisters paused and reflected: "Rushing into life, did he rush through it?"; telephone interview with Phyllis Cooper, July 26, 1987.

20. Ralph Ellison, "Introduction," *Shadow and Act* (New York: Vintage Books, 1972), p. xvii (emphasis original).

21. "In 1940, Elizabethtown had an official population of 3,667....In 1950, Elizabethtown had grown to 5,807...."; Daniel E. McClure, Jr., *Two Centuries in Elizabethtown and Hardin County, Kentucky* (Elizabethtown, Kentucky: Hardin County Historical Society, 1979), p. 544.

22. Interview with Robert and Cecile Holmes, Louisville, Kentucky, March 28, 1987.

23. Both sisters dispute claims by Rosalind Jeffries and Gylbert Coker concerning Bob Thompson's youthful exposure to agrarian life. Although their maternal grandparents owned a farm in Maceo, Kentucky, where the two girls spent their childhood summers, both state that their younger brother was never taken there. Jeffries claimed that "Thompson's early childhood was spent on a farm in Elizabeth [*sic*], Kentucky"; Rosalind R. Jeffries, "Bob Thompson," *Bob Thompson*, exh. cat. (Amherst, Massachusetts: University Art Gallery, University of Massachusetts at Amherst, 1974), n.p. Coker stated that "[m]any of his summers were spent on a farm where he enjoyed the land and the ani-mals"; Gylbert Coker, "Introduction," *The World of Bob Thompson*, exh. cat. (New York: The Studio Museum in Harlem, 1978), p. 13. Holmes, 1987 interview; Cooper, 1987 interview.

24. Cooper, 1987 interview.

25. Ibid.

26. Holmes, 1987 interview.

27. Robert Holmes, statement, *Bob Thompson 1937–1966: Memorial Exhibit*, exh. cat. (Louisville, Kentucky: J.B. Speed Art Museum, 1971), n.p.

28. McClure, *Two Centuries in Elizabethtown and Hardin County*, p. 599.

29. George C. Wright, *Life Behind a Veil: Blacks in Louisville, Kentucky*

1865–1930 (Baton Rouge: Louisiana State University Press, 1985), p. 139.

30. Ibid. Author and civil rights activist Angela Davis offers a useful corrective to any tendency to romanticize the positive effects of segregated education, however. In her autobiography, Davis, who began high school in Birmingham, Alabama, a year after Bob Thompson graduated from Louisville's Central High, writes:

> We had been pushed into a totally Black universe; we were compelled to look to ourselves for spiritual nourishment. Yet while there were those clearly supportive aspects of the Black Southern school, it should not be idealized. As I look back, I recall the pervasive ambivalence at school....On the one hand, there was a strong tendency affirming our identity as Black people that ran through all the school activities. But on the other hand, many teachers tended to inculcate in us the official, racist explanation for our misery....

An Autobiography (New York: Bantam Books, 1975), pp. 91–92.

31. Cooper, 1987 interview.

32. Wright, *Life Behind a Veil*, p. 1; see also "The Week's Events:...Careful Plans, Calm Change," *Life*, September 24, 1956, pp. 48–49; Allen J. Share, *Cities in the Commonwealth: Two Centuries of Urban Life in Kentucky* (Lexington, Kentucky: University of Kentucky Press, 1982), pp. 101–02.

33. Wright, *Life Behind a Veil*, p. 1, n. 1. See also John Hope Franklin, *From Slavery to Freedom: A History of Negro Americans*, 3rd edition (New York: Vintage Books, 1969), p. 270.

34. Wright, *Life Behind a Veil*, p. 2; Young, 1986 interview; interview with Sam Gilliam, Washington, D.C., November 10, 1986; Share, *Cities in the Commonwealth*, p. 99; Franklin, *From Slavery to Freedom*, p. 555.

35. "Louisville, Ky.: The City That Integrated Without Strife," *Look*, August 13, 1963, pp. 41–44; see also Share, *Cities in the Commonwealth*, pp. 104–06.

36. Holmes, 1987 interview.

37. "Culture's New Kentucky Home," *Life*, April 8, 1957, p. 128.

38. Ibid., p. 127.

39. "Scholarships, Hite Scholarship Lists 1946–59" files, University Archives,

University of Louisville. Dario Covi, secretary, Hite Scholarship Committee, letter to Robert Thompson, January 27, 1959, accepting his scholarship resignation; "Scholarships, Hite Applications (Accepted) Fall 1958–59" file, University Archives, University of Louisville.

40. Stanley Appelbaum, *Simplicissimus: 180 Satirical Drawings from the Famous German Weekly* (New York: Dover Publications, 1975), pp. ix, xii; Mark Rosenthal, "Rudolf Wilke, 1873–1908," in *Rudolf Wilke*, exh. cat. (Iowa City, Iowa: The University of Iowa Museum of Art, 1973), p. 7.

41. *Music to Be Seen: A Portfolio of Drawings by Ulfert Wilke* (Louisville, Kentucky: Erewhon Press [1957?]), n.p.; Creighton Gilbert, biographical note, *Ulfert Wilke*, exh. cat. (Louisville, Kentucky: Allen R. Hite Art Institute, University of Louisville, 1948), n.p.; Ulfert Wilke, "Introduction," *An Artist Collects: Ulfert Wilke Selections from Five Continents*, exh. cat. (Iowa City: The University of Iowa Museum of Art, 1975), pp. 6–7; *Ulfert Wilke Retrospective Exhibition*, exh. cat. (Lexington, Kentucky: Fine Arts Gallery, University of Kentucky, Lexington, 1953), n.p.

42. Ulfert Wilke, diaries, February 7, 1959, and March 12, 1959.

43. Ibid., January 4, 1959.

44. An additional positive effect is suggested by Gilliam's statement that Wilke's primitivist enthusiasms led another of his black students, Gregory Ridley, to "go back in memory" to the African collection of Fisk University, where Ridley had earned his undergraduate degree and subsequently taught before entering the Hite Institute as a graduate student; Gilliam, 1986 interview.

45. Ibid.

46. "Biographical Notes and Chronology," in *Mary Spencer Nay: Recent and Retrospective Works*, exh. cat. (Louisville, Kentucky: J.B. Speed Art Museum, 1977).

47. Creighton Gilbert, biographical essay, *Mary Spencer Nay*, exh. cat. (Louisville, Kentucky: Allen R. Hite Art Institute, University of Louisville, 1950), n.p.

48. Dario A. Covi, "Mary Spencer Nay," in *Mary Spencer Nay: Recent and*

Retrospective Works, (Louisville, Kentucky: J.B. Speed Art Museum, 1977), n.p.

49. Ibid., "Biographical Notes."

50. "Staff," *The Art Center Association School: 1954–1955*, exh. cat. (Louisville, Kentucky: Art Center Association, 1954), n.p.

51. "Culture's New Kentucky Home," *Life*, April 8, 1957, p. 130; "Chronology 1970 of the Art Center, Art Center Association and Louisville School of Art."

52. Raoul Middleman, *Eugene Leake: Recent Paintings*, exh. cat. (Baltimore: The Decker Gallery, Mount Royal Station, Maryland Institute, College of Art, 1975), n.p.

53. Interview with Frederic Thursz, New York, October 14, 1986.

54. Based on the "Schedule of Courses" in the 1955–56 through 1958–59 catalogues for the Art Center Association School, University Archives, University of Louisville.

55. Interview with Dario Covi, Louisville, Kentucky, March 24, 1987. Kenneth Young adds that Hite Scholarship students served as projectionists for Covi's art history classes and feels that, as a result, Covi's expertise in Italian art influenced scholarship recipients especially. Young remembers that Thompson wrote a paper on Piero, but is uncertain whether it was done for Covi's art history class or for Ernest Hassold's humanities class; interview with Kenneth Young, Washington, D.C., November 8, 1986.

56. Covi, 1987 interview; "Scholarships, Hite Applications (Accepted) Fall 1958–59."

57. In April 1958, when he applied for renewal of his Hite Scholarship, Thompson listed Leake, Nay, and Boles as references. In a written endorsement of Thompson's bid for renewal, Boles mentioned that Thompson was his studio assistant. Thompson's brother-in-law, Robert Holmes, and a high school associate, Ken Clay, stated that Thompson had shared a residence with Boles for a period. Robert Thompson, April 15, 1958, application for Hite Scholarship; Daniel Boles, May 5, 1958, recommendation form for Hite Scholarship, "Scholarships, Hite Committee Action 1958–59" file, University Archives, University of Louisville; Holmes, 1987 interview; inter-

view with Ken Clay, Louisville, March 26, 1987; Thursz, 1986 interview; Ulfert Wilke, diaries, 1959.

58. Statement by Charles Crödel, *Bob Thompson 1937–1966: Memorial Exhibit*, n.p.

59. Interview with Eugene Leake, Baltimore, October 21, 1988.

60. Wilke, diaries, 1959.

61. Leake, 1988 interview.

62. Young, 1986 interview.

63. Interview with Robert Douglas, Louisville, Kentucky, March 26, 1987.

64. The painting, entitled *Partly Morbid*, was included in the 1971 Bob Thompson memorial show at Louisville's J.B. Speed Art Museum. In an unpublished portion of a statement for the exhibition catalogue, the owner writes: "I guess it was toward the end of 1957 or the beginning of 1958, [Bob] gave Judy and me one of his paintings—of a couple of impressionistic flower pots with some muddy but interesting flowers growing in them....We've always had it hanging... since 1957 when Bob did the painting. It's signed and dated...." Don Fiene, typescript of statement for *Bob Thompson 1937–1966: Memorial Exhibit*, pp. 2–3.

65. Allan Kaprow, "The Legacy of Jackson Pollock," *Art News*, 57 (October 1958), pp. 56–57, claimed that, in Pollock's wake, artists were left with only two alternatives: "One is to continue in this vein...without...going further. The other is to give up the making of paintings entirely...." Instead of "the *suggestion* through paint of our other senses," Kaprow envisioned an interdisciplinary practice that would "utilize the specific substances of sight, sound, movements, people, odors, touch...."

66. I am using "sincere brushstroke" to allude to what might be termed "the Expressionist fallacy" at the core of much of the critical rhetoric of the 1950s. For a discussion that places this trope in a broader historical framework, see Carter Ratcliff, "The Short Life of the Sincere Stroke," *Art in America*, 71 (January 1983), pp. 73–79, 137; for a theoretical perspective, see Hal Foster, "The Expressive Fallacy," *Art in America*, 71 (January 1983), pp. 80–83, 137.

67. "Gestural realist" is Irving Sandler's term for artists who, in the wake of first-generation Abstract

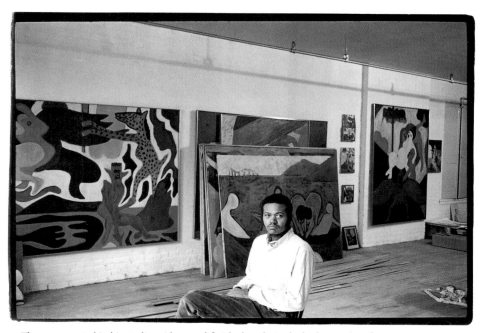

44. Thompson seated in his studio, with several finished works in the background, 1963. Photo copyright © by Fred W. McDarrah

Expressionism, "turned toward 'realism' while painting in a gestural manner...." Sandler, *The New York School: The Painters and Sculptors of the Fifties* (New York: Harper & Row, 1978), pp. 90, 211. Sandler also provides a sustained discussion of de Kooning's and Hofmann's primacy as sources of inspiration for both figurative and abstract gesturalists of the fifties.

68. Hartigan's *Chinatown* and Rivers' *Berdie in the Garden* (1954), both appeared in the Corcoran's "25th Biennial Exhibition," 1957, which came to the J.B. Speed Art Museum in October of that year. Goodnough's *Figures* (1956) was included in the 1957 "Whitney Annual," seen at the Speed during February 1958.

69. The exhibitions were Samuel Heavenrich and Grace L. McCann Morley's "California Painting: 40 Painters," organized by the Municipal Art Center, Long Beach, California, and the San Francisco Museum of Art, which traveled to the J.B. Speed Art Museum, January 17–February 10, 1957, and the Santa Barbara Museum of Art's "2nd Pacific Coast Biennial Exhibition," on view at the Speed, October 1–22, 1958.

70. Douglas, 1987 interview; Young, 1986 interview.

71. Robert Carter has described this abode as a one-room sleeping and painting space and noted that, by locating

himself in this "bohemian-style" residence, Thompson "severed his middle-class ties"; interview with Robert Carter, November 19, 1988.

72. Thursz, 1986 interview.

73. Douglas, 1987 interview.

74. Gilliam, 1986 interview; Young, 1986 interview; Douglas, 1987 interview; telephone interview with Robert Carter, October 7, 1988; Carter, 1988 interview.

75. Young, 1986 interview; Gilliam, 1986 interview; Douglas, 1987 interview.

76. Interview with Horace Bond, Louisville, Kentucky, March 23, 1987; interviews with Ted Joans, New York, June 6, 1986, and December 13, 1986.

77. Gilliam, 1986 interview.

78. Ibid.; Young, 1986 interview; Douglas, 1987 interview.

79. The jurors included Daniel Boles, Mary Spencer Nay, and Frederic Thursz; see *1958 Louisville Art Center Annual*, exh. cat. (Louisville, Kentucky: J.B. Speed Art Museum, 1958), n.p.

80. It is unclear whether the 20 x 5 1/2-inch monoprint of this, titled, dated 1958, and owned by Robert and Cecile Holmes, is the same one exhibited in the 1958 Art Center Annual. In a 1960 letter thanking Bob Thompson for the gift of a print, Hite Institute art librarian Margaret M. Bridwell reports: "I recently had the print you gave me entitled 'Family,' framed and it looks very hand-

some with my other prints."

81. I have been unable to locate either the original or a reproduction of the 1957 oil still life *Partly Morbid* (see note 64 above), the only earlier work for which I have any information. The other works from 1958 are all oils. Two I have seen firsthand: *Cecil [Clay]*, an 18 x 24-inch oil on canvas, private collection, Louisville; and *The Funeral of Jan Müller*, a 36 x 48-inch oil on masonite, private collection, New York. Jeanne Siegel's 1966 master's thesis includes black-and-white photographs based on color slides from the artist's collection that reproduce two others: *Girl in Yellow Raincoat* and *Girl in Orange Sweater*. Siegel does not give the media or dimensions. See Jeanne Siegel, "Four American Negro Painters, 1940–1965: Their Choice and Treatment of Themes," MA thesis (New York: Art History department, Columbia University, 1966), pp. 127, 128, pls. 29, 30.

82. Thursz, 1986 interview; Young, 1986 interview.

83. Interview with Marie Zimmerman, Louisville, Kentucky, March 27, 1987.

84. Senta Beier, "[Kentuckiana Art...] Thompson Show," *The Courier-Journal*, March 1, 1959.

85. Robert Thompson, quoted in "Academic Strait Jacket: Disdainful Thompson," *Gazette of the Arts in Louisville*, February 9, 1959, p. 1.

86. The painting is signed and dated with its title and place of execution scrawled across the back of the canvas.

87. This canvas, too, is signed and dated with its title and location inscribed on the back.

88. James Baldwin, "Notes for a Hypothetical Novel," *Nobody Knows My Name: More Notes of a Native Son* (New York: Dell, 1962), p. 152.

89. Holmes, 1987 interview; Robert Carter, telephone interview, November 5, 1988.

90. Cruz, in *Artist and Influence 1985*, p. 112.

91. Seong Moy School brochure. Judging by a June 1959 ad that also gives the 7 Brewster Street address, the school was located in its own building during Thompson's first summer in Provincetown. Advertisement for the Seong Moy School of Painting and Graphic Arts, in handout for the Provincetown Art Association "First 1958 Show," n.p.

92. Cruz, in *Artist and Influence 1985*, p. 112.

93. Ibid., p. 112; interview with Mimi Gross, New York, March 9, 1987; interview with Marcia Marcus, New York, October 10, 1986.

94. This claim was interjected by Emilio Cruz when Jay Milder decried the critical establishment's tendency to view Thompson's work as derivative of Jan Müller's; author's notes on "Bob Thompson: His Life and Friendships" panel, Hatch-Billops Collection, New York, May 6, 1984.

A further clue to Brodie's importance in Thompson's early development is provided by the young painter's remarks in a 1965 interview with Jeanne Siegel. Discussing his 1958 Provincetown stay, Thompson told Siegel, "I did a lot of figure painting" and immediately mentioned that this included a portrait of Gandy Brodie "at the time we met there"; Thompson, quoted in Siegel, "Four American Negro Painters," p. 71.

95. Cruz, in *Artist and Influence 1985*, pp. 113–14.

96. Ibid., p. 114.

97. Ibid.

98. Barrell seems to be referring to Müller's work, not the artist himself, who had died in January 1958. Work by Müller was prominently featured in a group show at the HCE Gallery in July 1958. Bill Barrell, in *Artist and Influence 1985*, pp. 107–08. "Group Show HCE Gallery," *The Provincetown Advocate*, July 17, 1958, p. 9.

99. Bob Thompson, quoted in Siegel, "Four American Negro Painters," p. 70.

100. Interview with Dody Müller, New York, March 19, 1984.

101. Measurements are my own. When I viewed the painting in June 1988, one of two labels attached to its reverse side bore the information "Chrysler Art Museum of Provincetown" and gave the title and dates of the show in which the canvas had been exhibited—"'Provincetown Past and Present,' September 27–December 7, 1958,"—along with the artist's name and the work's title and medium. In addition, the words "masonite tempered presswood made in U.S.A." were visible on the back surface of the panel itself. Author's notes on viewing *The Funeral of Jan Müller*, New York, June 24, 1988. My thanks to Richard Powell for informing me of the location of this painting.

102. Dorothy Gees Seckler, "History of the Provincetown Art Colony," *Provincetown Painters: 1890's–1970's*, exh. cat. (Syracuse, New York: Everson Museum of Art, 1977), p. 82.

103. Dody Müller, author's notes from telephone conversation, October 29, 1988.

104. Irving Sandler, *The Triumph of American Painting: A History of Abstract Expressionism* (New York: Harper and Row, 1970), p. 138; April Kingsley, *The Turning Point: The Abstract Expressionists and the Transformation of American Art* (New York: Simon & Schuster, 1992), p. 272.

105. Seckler, "History of the Provincetown Art Colony," p. 81.

106. Martica Sawin, "Jan Müller: 1922–1958," *Arts*, 33 (February 1959), p. 40.

107. Four of Müller's 1953 works in this manner exemplify this democratic attitude toward supports. He painted *The Heraldic Ground* on burlap, his *Cross Mosaic* and *Abstraction, Landscape* on wood, and his *Erlkönig II* on canvas, mounted on wood. (All four works photographed by the author, Oil and Steel Gallery, New York, February 13, 1985.)

In a discussion of the Hansa Gallery members' "lifestyle," Sawin writes that "to care unduly about art materials might be construed as materialistic. They painted on old bed sheets, cigar box lids and wood from orange crates or, in the case of Stankiewicz, scoured sidewalk scrapheaps for material to weld into sculpture." Martica Sawin, *Wolf Kahn* (New York: Taplinger Publishing, 1981), p. 14.

Similarly, Dore Ashton describes the pioneers of the co-op gallery movement as "idealists" who "found satisfaction in...the 'purity' of the co-op ideal" and "tried to remain true to a hallowed romantic tradition in which the artist recognized himself as voluntarily alienated from the functions of a materialistic society." Ashton, "Introduction," in Joellen

Bard, *Tenth Street Days: The Co-ops of the 50s*, exh. cat. (New York: Pleiades Gallery and The Association of Artist-Run Galleries, 1977), p. vii.

108. Sawin, "Jan Müller," p. 39.

109. Dody Müller, "Jan Müller's Life," in *Jan Müller: 1922–1958*, exh. cat. (New York: The Solomon R. Guggenheim Museum, 1962), n.p.

110. Seckler, "History of the Provincetown Art Colony," p. 82; *Newsweek*, January 15, 1962, p. 76.

111. Jeffrey Hoffeld, "Jan Müller," *The Figurative Fifties: New York Figurative Expressionism*, exh. cat. (Newport Beach, California: Newport Harbor Art Museum, 1988), p. 120; Brian O'Doherty, "Art: Jan Müller's Work in Retrospect," *The New York Times*, January 10, 1962, p. 23.

112. Müller, "Jan Müller's Life," n.p.

113. Interview with Budd Hopkins, New York, March 6, 1987.

114. Dore Ashton, "Art," *Arts and Architecture*, 80 (January 1963), p. 4.

115. Dore Ashton, "Display Offers—Work by Lester Johnson," *The New York Times*, March 5, 1958.

116. Author's notes on the introductory remarks by a Columbia University faculty member for the program, "Words and Images: Red Grooms and Kenneth Koch," Encore Series, Columbia University, New York, May 12, 1988.

117. Paul Goodman, *Growing up Absurd: Problems of Youth in the Organized Society* (New York: Vintage Books, 1960), p. 217.

118. Johnson, who was romantically involved with Jack Kerouac at the time, is writing about the emergence of the Beat scene in Lower Manhattan in 1957. Joyce Johnson, *Minor Characters* (Boston: Houghton Mifflin, 1983), p. 158.

119. Sheila Milder, in *Artist and Influence 1985*, p. 135.

120. Milder, 1983 interview; interview with Christopher Lane, San Francisco, California, December 27, 1983. Milder's statement that Grooms lived with them at this time seems to conflict with Judith Stein's claim that, on his return to New York from Provincetown at the end of summer 1958, Grooms briefly occupied "a small second-floor loft on Sixth Avenue near Twenty-fourth Street," then moved "to a more spacious third-floor loft in a

nearby building." Mimi Gross, who was dating Milder at the time and would subsequently marry Grooms, however, explains that Grooms lived with Thompson, Milder, and Lane "for a short period." Judith E. Stein, *Red Grooms: A Retrospective, 1956–1984*, exh. cat. (Philadelphia: The Pennsylvania Academy of the Fine Arts, 1985), pp. 33-34; Mimi Gross, 1987 interview.

121. Thomas Albright, *Art in the San Francisco Bay Area 1945–1980* (Berkeley: University of California Press, 1985), p. 81.

122. Allen Ginsberg, undated manuscript, material related to *Bob Thompson 1937–1966: Memorial Exhibit*.

123. The painting was given its current title by the artist's widow sometime after his death. Telephone interview with Carol Thompson, March 24, 1988.

124. These identifications were provided by Charlie Haden, who was present in Thompson's studio during much of the painting's execution. Charlie Haden, 1988 interview.

125. In his 1965 interview with Jeanne Siegel, the painter said of his 1960 work, "When I did figures, I would do a group...each girl that I knew in the nude...." Siegel, "Four American Negro Painters," p. 77. According to Emilio Cruz, the painting includes dancer Sally Gross. A.B. Spellman thinks the brick-red–faced man at far right, at the lower edge of the canvas, may be Gross' husband, Teddy. Cruz, 1983 interview; interview with A.B. Spellman, Washington, D.C., January 13, 1987.

126. "In those days," Steve Lacy explained, "people played six-week gigs at the Five Spot, so you could really study what happened in their music from night to night." Steven Lacy, 1988 interview.

127. Gary Giddins, "The Highs and Lows of a Great Jazz Club," *The Village Voice*, February 16, 1976, p. 16; Hettie Jones, *How I Became Hettie Jones* (New York: E.P. Dutton, 1990), p. 172.

128. Giddins, "The Highs and Lows of a Great Jazz Club," p. 16; Joyce Johnson, *Minor Characters*, p. 158.

129. Haden, 1988 interview.

130. Jay Milder, "Jay Milder Remembers Bob Thompson," undated manuscript, material related to the catalogue for the *Bob Thompson 1937–1966:

Memorial Exhibit*, n.p.

131. His sister Cecile's recollection that he had been an extremely timid child, who never fought back when attacked, and who became upset and hovered at her bedside when she was ill, as well as his acute physical reaction to his father's death, seems to confirm this view of the artist as someone with an extremely low threshold to pain and therefore, in one current medical theory, according to Charlie Haden, a prime candidate for substance abuse. Holmes, 1987 interview; Haden, 1988 interview.

132. Cruz, 1983 interview.

133. Haden, 1988 interview; A.B. Spellman, *Black Music: Four Lives* (New York: Schocken Books, 1973), p. 114.

134. Haden, 1988 interview.

135. Milder, 1983 interview; Jay Milder, "Jay Milder Remembers Bob Thompson," n.p., sent by Fred F. Bond to Carol Thompson, August 18, 1971.

136. Postcard "signed" with a thumbnail self-portrait sketch by Bob Thompson, addressed to "Mr. & Mrs. Robt. Holmes," April 30, 1959.

137. Undated, illustrated letter to the artist's mother, also "signed" with a thumbnail self-portrait sketch by Bob Thompson.

138. Sketchpad diary, "May 1st Omaha, Nebraska," collection of Carol Thompson.

139. Sketchpad diary, "May 2nd."

140. Sketchpad diary, "May 3rd."

141. Gross, 1987 interview; Marcus, 1986 interview.

142. Tony Vevers, *The Sun Gallery*, exh. cat. (Provincetown, Massachusetts: Provincetown Art Association, 1981), p. 31.

143. Interview with George Preston, New York and Philadelphia, July 30, 1986; Thompson, 1982 interview.

144. Thompson, 1986 interview. The catalogue for the 1985 exhibition "Expressionism: An American Beginning" incorrectly assigns the painting a "1955-57" date. Siegel and photographic material from the David Anderson Gallery both supply a 1959 date, which is compatible with Carol Thompson's estimation that the picture was painted in either the summer of 1959 or in 1960, and with the first owner's recollection that the canvas appeared in Thompson's

February 1960 show at the Delancey Street Museum. *Expressionism: An American Beginning*, exh. cat. (Provincetown, Massachusetts: Provincetown Art Association and Museum, 1985), p. 11; Siegel, "Four American Negro Painters," p. 98; slide labeled *Beauty and the Beast* (1959), donated to the Hatch-Billops Collection by the David Anderson Gallery, viewed by the author, New York, February 11, 1986; Thompson, 1986 interview; interview with Reginald Cabral, Provincetown, September 24, 1986. Siegel, who cites the artist himself as the source of her photo of the work, gives the painting a different title—*Nude with Monsters*—however. Siegel, "Four American Negro Painters," pp. 98, 129.

145. Announcement, "Bob Thompson: Paintings and Sculpture," Delancey Street Museum, February 12–March 13, [1960]. The year was added in his mother's hand.

146. Cabral, 1986 interview.

147. The scene Tabachnick describes here took place at the opening of Thompson's joint show with Jay Milder at the Zabriskie Gallery. Anne Tabachnick, "Bob Thompson, 1937–1966" (unpublished manuscript written in 1966), quoted in Sheila Milder, in *Artist and Influence 1985*, pp. 138–39.

148. By "signature work," I mean to exclude his portraits, works in media other than oil or acrylic, pre-1959 canvases, and certain other stylistically anomalous examples of his oeuvre.

149. Siegel, "Four American Negro Painters," p. 72.

150. Ibid.

151. Two drawings based on this composition differ slightly in their treatment of the woman's hairdo. In a brush-and-ink drawing, the nude woman's hair is parted on the right and covers one eye, Veronica Lake–style. In the other drawing, a work in oil on paper, the woman's coiffure is essentially the same as in the painted canvas.

152. My thanks to artist Willie Birch for pointing this out; personal communication, New York, July 10, 1986. Two other Thompson paintings—the Chrysler Museum's 1959 *Figure in a Landscape (The Hanging)* and a privately owned work, *L'Exécution*, done in Paris in 1961—both depict lynchings and thus

seem to reinforce this interpretation of *Beauty and the Beast.*

153. According to his University of Louisville instructor, Eugene Leake, Thompson had dated the daughter of *The Louisville Times'* publisher, for example; Eugene Leake, 1988 interview.

154. In his 1989 autobiography, musician Miles Davis recounted his reaction to seeing photographs of Till's mutilated and bloated body in the newspaper. "Man,...I won't forget them pictures of that young boy as long as I live." Miles Davis with Quincy Troupe, *Miles: The Autobiography* (New York: Simon and Schuster, 1989), p. 194.

155. Sheila Milder, in *Artist and Influence 1985*, p. 136.

156. Meyer Schapiro, undated manuscript material related to *Bob Thompson 1937–1966: Memorial Exhibit*, sent by Fred F. Bond to Carol Thompson, August 18, 1971.

157. *The Horace Richter Collection: Contemporary American Painting and Sculpture*, exh. cat. (Charlotte, North Carolina: The Mint Museum of Art, 1960), n.p.

158. "We always considered him as the mayor of the loft; if he had a party, everybody would come." Lester Johnson quoted in Judith Stein, in *Jay Milder: Urban Visionary, Retrospective 1958–1991*, exh. cat. (Brooklyn, Connecticut: New England Center for Contemporary Art, 1991), n.p.

159. Interview with Lester Johnson, New Haven, Connecticut, February 8, 1984.

160. Press release, undated, Zabriskie Gallery, New York [c. May 1960].

161. E[dith] B[urckhardt], "Reviews and previews:...Jay Milder and Bob Thompson," *Art News*, 59 (Summer 1960), p. 18.

162. S[idney] T[illim], "In the Galleries:...Bob Thompson, Jay Milder," *Arts*, 34 (June 1960), p. 59.

163. J[ane], H[arrison], "In the Galleries: New York Exhibitions—Bob Thompson," *Arts*, 38 (February 1964), pp. 24–25.

164. Sawin, "Jan Müller," p. 40.

165. "Catalogue," *The Horace Richter Collection*, pp. 7, 13, fig. 107.

166. Siegel, "Four American Negro

Painters," p. 72.

167. Robert Farris Thompson, personal communication, New Haven, January 23, 1985.

168. Sigmund Freud, "The Dream-Work. (F) Some Examples—Calculations and Speeches in Dreams," *The Interpretation of Dreams* (London: The Hogarth Press and the Institute of Psycho-Analysis, 1978), p. 410.

169. Simone de Beauvoir, *The Second Sex*, H.M. Parshley, trans. and ed. (New York: Bantam Books, 1970), pp. 134–35.

170. In Siegel, "Four American Negro Painters," p. 77.

171. Ibid., p. 72.

172. Allen Ginsberg, material related to *Bob Thompson 1937–1966: Memorial Exhibit* (emphasis original).

173. Thompson, 1982 interview.

174. Lane, 1983 interview; telephone interview with Jim Sullivan, March 21, 1984.

175. Telephone interview with Robert DeNiro, February 27, 1987.

176. Elton C. Fax, *Seventeen Black Artists* (New York: Dodd, Mead, 1971), p. 59. My thanks to Richard Powell for making me aware of the special character of this award.

177. Thompson, 1982 interview; letter to Mrs. Bessie Thompson from Charles F. Jones, program secretary, Opportunity Fellowship, John Hay Whitney Foundation, May 18, 1961, located in "Box I: Thompson, Robert—Correspondence, Miscellaneous" file, University of Louisville Art Library, consulted by the author, March 24, 1987.

178. Lane, 1983 interview.

179. Sullivan, 1984 interview.

180. Barbara Rose, "Art: In Cold Duck," *New York*, March 17, 1975, p. 73.

181. Grooms has stated, "When I got to Europe I got interested in 'going European,' that is, being more precise in my work." John Ashbery, "Red's Hero Sandwich," in Stein, *Red Grooms*, p. 16.

182. Siegel, "Four American Negro Painters," p. 69.

183. Photograph of Carol Thompson holding the Whitney Foundation letter, Paris, August 1962, collection Carol Thompson, viewed by the author, New York, August 13, 1986.

184. Barrell, in *Artist and Influence 1985*, pp. 108–09.

185. Iris Samson, interview with the author, Louisville, Kentucky, March 27, 1987.

186. Andrea Phillips, personal communication, Staten Island, New York, January 8, 1989. My thanks to John Perreault for introducing me to Phillips.

187. Sheila Milder, in *Artist and Influence 1985*, p. 135.

188. Coker, *The World of Bob Thompson*, pp. 20, 24, no. 10.

189. Cruz, 1983 interview; interview with Hettie Jones, New York, February 12, 1983.

190. In a 1960 letter to his sister and brother-in-law, Cecile and Robert Holmes, for example, the artist confessed his alienation from the sort of bourgeois career goals his family had expected him to pursue:

I am sorry Cecile that I have misled myself and you pertaining to the almost foreign thing to me now (academic education) sorry because of not realizing sooner that it is impossible for me to live with such security as a degree or job or position....

Bob Thompson's "Letter Home" is reproduced in both the catalogue for the 1971 memorial exhibition in Louisville and the catalogue for The Studio Museum in Harlem's 1978–79 Bob Thompson show. *Bob Thompson 1937–1966: Memorial Exhibit*, n.p.; *The World of Bob Thompson*, p. 22.

191. "I had a dream once where the birds sort of...swept up everything, including me, and took me away," Thompson explained in 1965. "The wind was so strong and powerful and yet they were so free and soaring." Siegel, "Four American Negro Painters," p. 78.

192. Frank Bowling, "Discussion on Black Art," *Arts*, 43 (April 1969), p. 20.

193. Thompson, 1986 interview.

194. The Glacière show included work by twenty-eight artists. A flyer for the show was attached to the back of Thompson's untitled 1961 watercolor wash drawing, which was viewed by the author at the Vanderwoude Tananbaum Gallery, New York, November 22, 1982. *S.O.S. Glacière*, exhibition flyer (Paris: 93, rue de la Glacière, 1961).

The El Corsario show is documented by photographs—installation shots as well as photos of individual works—in the collection of the artist's widow and by an invitation to the opening sent by the artist to his sister and brother-in-law Cecile and Robert Holmes. The photographs were viewed by the author in New York, August 13, 1986. The invitation was viewed by the author in Louisville, Kentucky, March 28, 1987.

195. Lane, 1983 interview; Müller, 1984 interview.

196. Pepper, who operated the Friendly Art Store for about a year, 1962–63, on the top floor of a three-story building on the corner of West 100th Street and Broadway, recalls showing a series of thirty-odd Thompson gouaches "based on Goya" there; Stephen Pepper, December 4, 1986 interview; J[ill] J[ohnston], "Reviews and Previews:...Bob Thompson," *Art News*, 61 (September 1962), p. 11; V[alerie] P[etersen], "Reviews and Previews:...Robert Thompson and Terry Barrell," *Art News*, 62 (May 1963), p. 62.

197. Both men's addresses appear on an invitation to "The Tenants of Sam Wapnowitz" at The Star Turtle Gallery in New York in 1968; Lester Johnson, 1984 interview.

198. Harry Rand, "The Martha Jackson Memorial Collection," *The Martha Jackson Memorial Collection*, exh. cat. (Washington, D.C.: National Museum of American Art/Smithsonian Institution Press, 1985), pp. 13, 75.

199. Haskell, *BLAM!*, pp. 27–29, 51–53.

200. Carol Thompson, taped interview with Vivian Brown, February 12, 1973 (New York: Hatch-Billops Collection).

201. Press release, "Bob Thompson, December 3–January 4, 1964," Martha Jackson Gallery, New York.

202. According to Judson alumna Yvonne Rainer, Johnston's "columns were the greatest single source of PR since Clement Greenberg plugged Jackson Pollock." In Sally Banes, *Terpsichore in Sneakers: Post-Modern Dance* (Middletown, Connecticut: Wesleyan University Press, 1987), p. 13.

203. Jill Johnston, "Reviews and Previews:...Bob Thompson," *Art News*, 62 (January 1964), p. 15.

204. J[ohn] C[anaday], "This Week Around the Galleries," *The New York Times*, December 8, 1963, section 2, p. 22X.

205. Thompson, 1984 interview.

206. Rosemary De Rosa, Office of the Registrar, Hirshhorn Museum and Sculpture Garden, letter to E.J. Krinsley, Martha Jackson Gallery, New York, April 18, 1975.

207. *Bob Thompson: New Paintings*, exhibition announcement (New York: Martha Jackson Gallery, 1965); Paul Mocsanyi, "Foreword," *Bob Thompson (1937–1966)*, exh. cat. (New York: Wollman Hall, New School Art Center, 1969), n.p.

208. Interview with Paul Suttman, Kent, Connecticut, March 21, 1987; interview with Raymond Saunders, May 26, 1983.

209. Thompson, 1982 interview; Saunders, 1983 interview. Spellman, 1987 interview.

210. Nina Simone with Stephen Cleary, *I Put A Spell On You: The Autobiography of Nina Simone* (New York: Pantheon Books, 1991), p. 68.

211. Lacy, 1988 interview.

212. Gross, in *Artist and Influence 1985*, p. 119.

213. Simone composed "Mississippi Goddam" in the wake of the September 1963 bombing of a Birmingham, Alabama, church that left four members of a children's Bible study class dead. The song, however, drew its name from the assassination earlier in the year of Jackson, Mississippi, NAACP officer Medgar Evers, which Simone has said "was not the final straw for me, [but] it was the match that lit the fuse." Simone, *I Put A Spell On You*, p. 89.

In addition to the singer's own testimony about the importance of her music to the members of the militant, black student-led civil rights organization SNCC (Student Nonviolent Coordinating Committee), critic Gerald Early writes, "I know that Simone's music spoke... to a generation of black people, black women in particular who came of age in the 1960s, more forcefully than any other...." Simone, *I Put A Spell On You*, pp. 94–95; Gerald Early, "Black Political Diva," *Washington Post Book World*, March 1, 1992, p. 11.

214. Donald and Florence Morris

45. Bob Thompson in the garden behind the Martha Jackson Gallery, New York, c. 1965.

recall going to hear Simone with Bob Thompson at Reggie Cabral's nightclub, the "A" House (Atlantic House), during their four-day stay in Provincetown in the summer of 1965. Author's notes on dinner conversation with Donald and Florence Morris, Detroit, December 16, 1986.

215. I was unable to consult a bound copy of this journal and in microfilm the photograph of Simone that accompanies the article was too dark to allow me to read her hairstyle conclusively. Philippe Carles, "Antibes 65: Entretien Avec Nina Simone," *Jazz Magazine* (Paris) (September 8, 1965), p. 48.

216. Cruz, 1983 interview; interview with Amiri Baraka, March 19, 1984; Spellman, 1987 interview. Jones would change his name two years later, in the wake of the 1967 Newark "rebellion" in which he figured prominently. Amiri Baraka, *The Autobiography of LeRoi Jones* (New York: Freundlich Books, 1984), pp. 266–67.

In addition to Jones and Spellman, historian Harold Cruse, musician Archie Shepp, poet Joe Johnson, and cinematographer Leroy McLucas were among the "more active members" of the Organization of Young Men. Based on the Lower East Side and a product of a nascent consciousness of cultural difference among some of the period's young black bohemians, the Organization of Young Men was founded in 1961 by Jones in the wake of a trip to Cuba he had made the previous year. According to him, the group's aims, while unclear, were generally the result of emerging dis-

satisfaction with the integrationist focus of the civil rights movement. Michel Oren, "A '60s Saga: The Life and Death of Umbra, Part I," *Freedomways*, 24 (1984), pp. 171, 179.

217. Spellman, 1987 interview.

218. Andrea Phillips, personal communication.

219. Baraka, 1984 interview.

220. Phyl Garland, "The Natural Look," *Ebony*, 21 (June 1966), pp. 143, 144.

221. Several informants had similar memories of Thompson's hair, which Hettie Jones described as "wild" and "proto-dreadlocked." And in a photo (in which the artist is seated and laughing) taken at Ibiza, several twisted locks are visible. Spellman, 1987 interview; Jones, 1983 interview. Photo in the collection of Carol Thompson, viewed by the author, New York, August 13, 1986.

222. Don Fiene, undated manuscript material related to *Bob Thompson 1937–1966: Memorial Exhibit.* At a later date, Phyllis Cooper recalled, when the artist made a holiday visit to Louisville after his return from Europe, "he hadn't had a haircut in years" and his hair was "sort of dreaded." But he refused to let his alarmed sisters "take care of his hair," she says. "He really wanted us to know he was looking for his place." Cooper, 1987 interview.

223. For further discussion of this trope in contemporary African-American art, see Judith Wilson, "Beauty Rites: Towards an Anatomy of Culture in African-American Women's Art," *The International Review of African American Art*, 11, no. 3 (1994), pp. 11–17, 47–55.

224. A.B. Spellman, "Not Just Whistling Dixie," in LeRoi Jones and Larry Neal, eds. *Black Fire: An Anthology of Afro-American Writing* (New York: William Morrow, 1968), pp. 164–65.

225. Thompson, 1973 interview.

226. This inference is based on the fact that in another 1960 portrait, *Carol Sitting in Green Chair*, the artist's wife is posed in the same chair. A copy of a slide of *Carol Sitting in Green Chair* was obtained by the author from the Hatch-Billops Collection, New York, March 20, 1984.

227. Baraka, *The Autobiography of LeRoi Jones*, pp. 200–201.

PLATES

1959—66

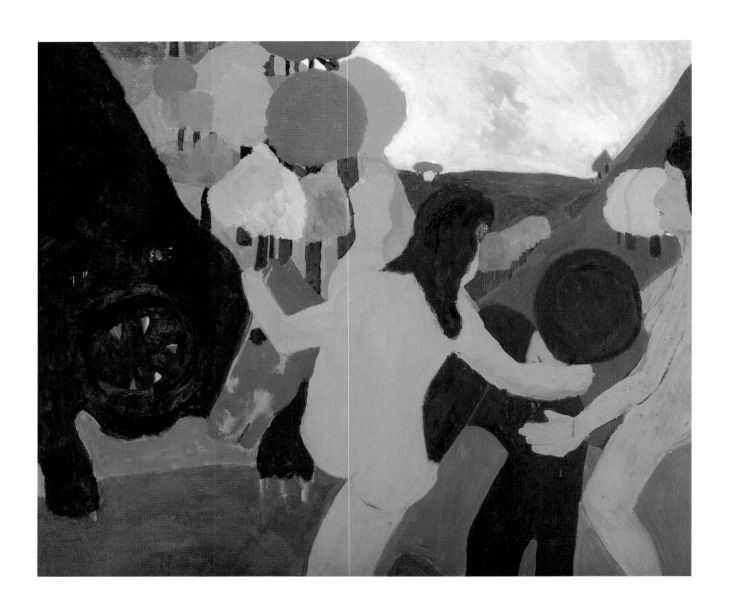

46. *BLACK MONSTER*, 1959
Oil on canvas, 56 3/4 x 66 1/4 (144.1 x 168.3)
Anderson Gallery, Buffalo, New York

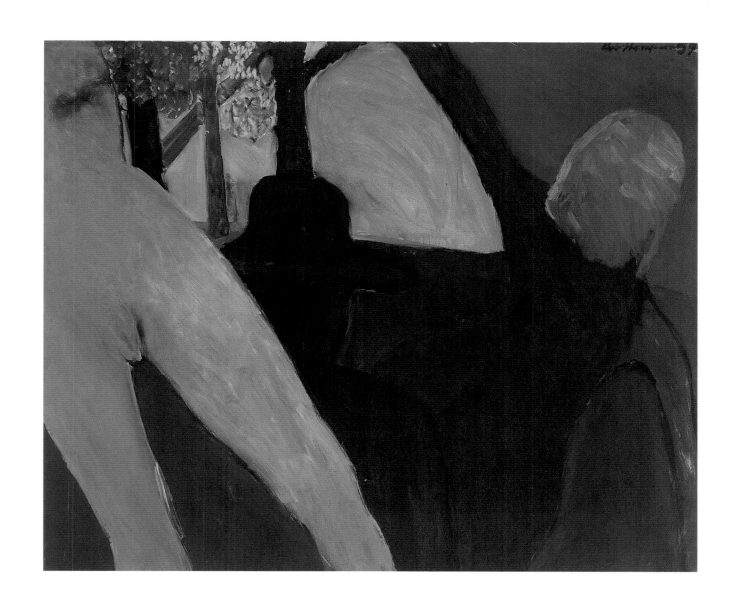

47. *LE POIGNARDER (THE STAB)*, 1959
Oil on canvas, 50 x 60 (127 x 152.4)
Solomon R. Guggenheim Museum, New York;
Gift, Jo and Lester Johnson, 1978

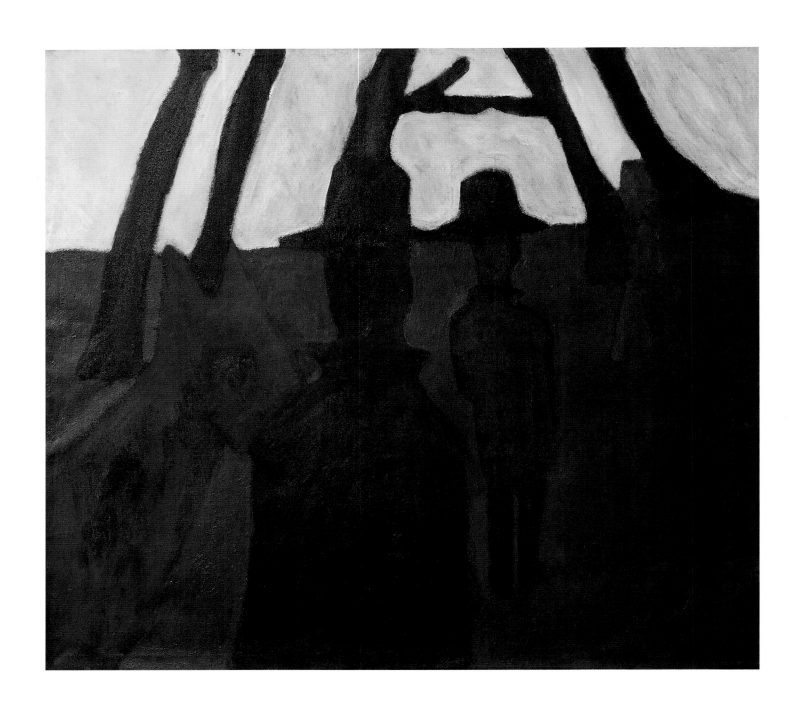

48. *UNTITLED*, 1959
Oil on canvas, 50 x 56 (127 x 142.2)
Collection of Nancy Ellison

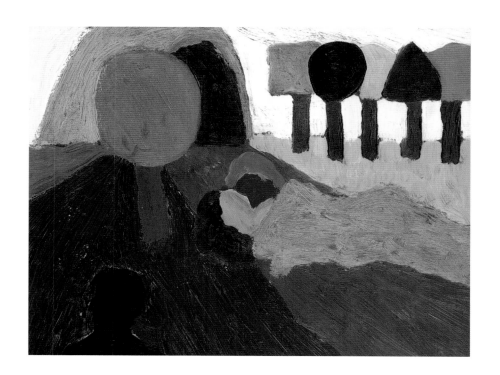

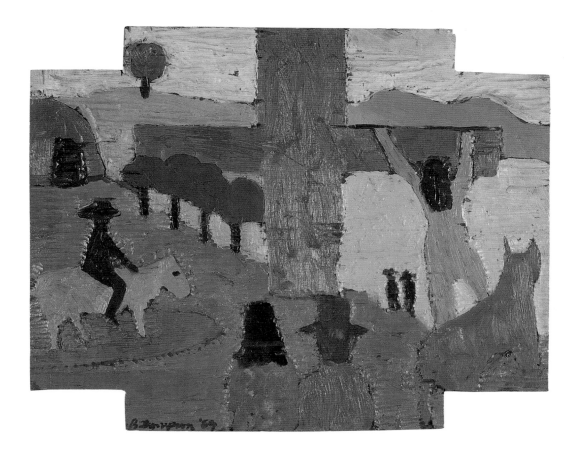

49. *LOVERS*, 1959
Oil on board, 10 ¹/₂ x 13 ¹/₂ (26.7 x 34.3)
Collection of Raymond J. McGuire

50. *RED CROSS*, 1959
Oil on carved panel, 15 x 18 ¹/₂ (38.1 x 47)
Collection of Meredith and Gail Wright Sirmans

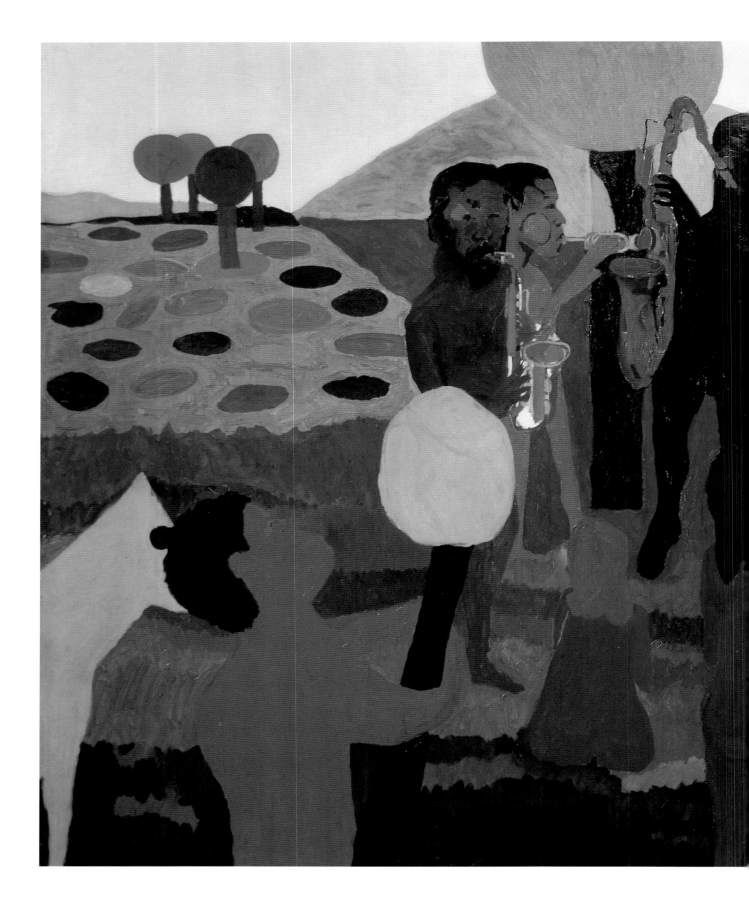

51. *GARDEN OF MUSIC*, 1960
Oil on canvas, 79 ¹/₂ x 143 (201.9 x 363.2)
Wadsworth Atheneum, Hartford, Connecticut; The Ella Gallup Sumner
and Mary Catlin Sumner Collection

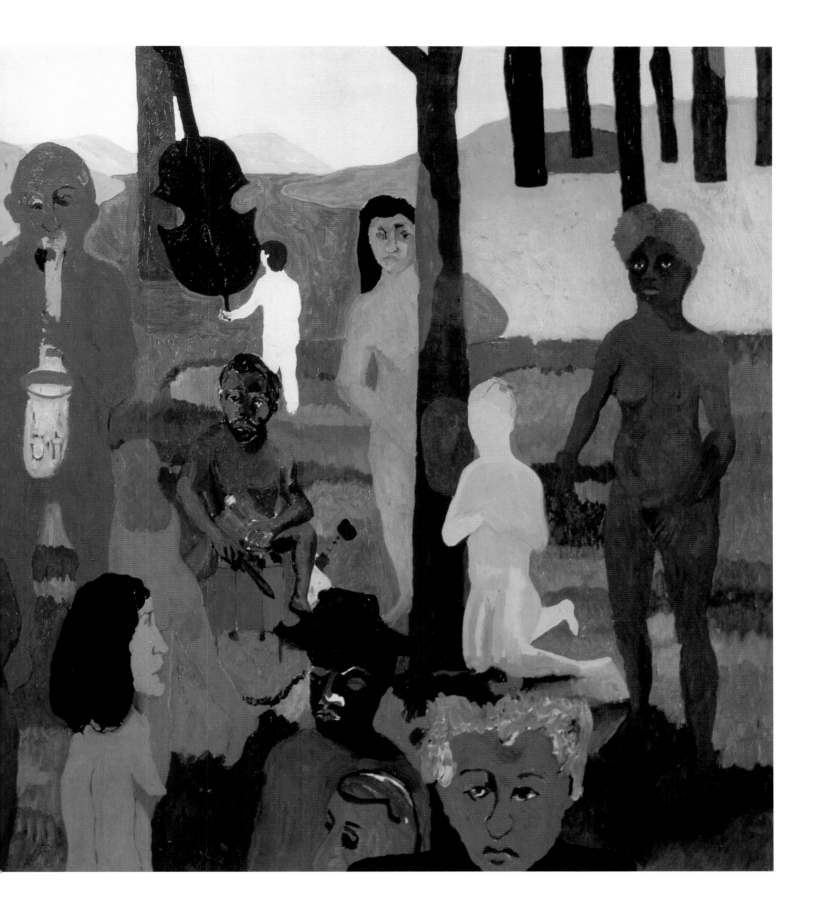

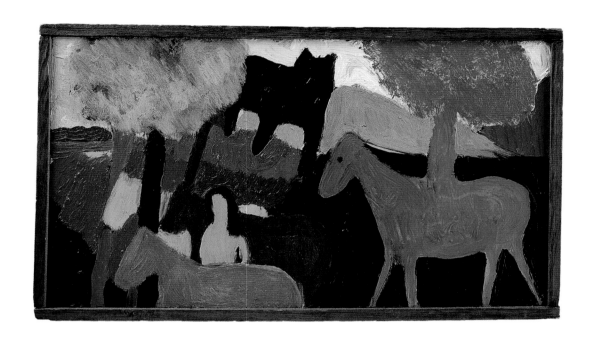

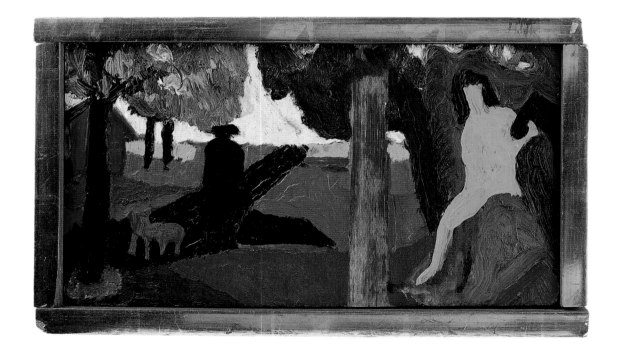

52. *LADY IN BETWEEN*, 1960
Oil on board, 7 x 12 (17.8 x 30.5)
Collection of Miki Benoff

53. *THIS HOUSE IS MINE*, 1960
Oil on board, 7 x 12 (17.8 x 30.5)
Collection of Miki Benoff

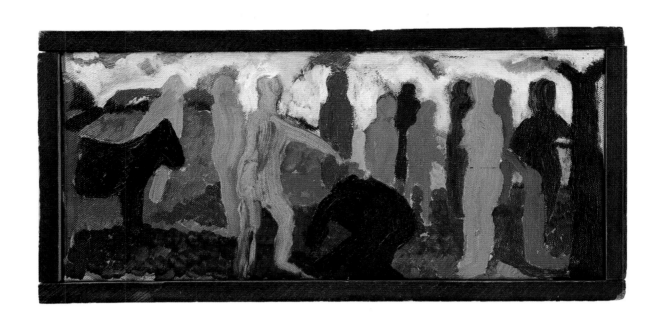

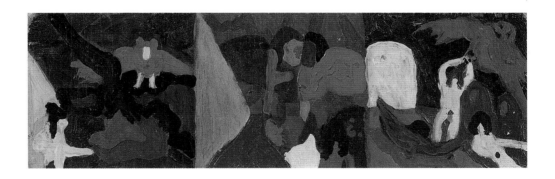

54. *TO THE BENOFFS MERRY XMAS*, 1960
Oil on board, 6 3/4 x 13 3/4 (17.2 x 34.9)
Collection of Miki Benoff

55. *UNTITLED*, c. 1961
Oil on wood, 4 1/2 x 12 (11.4 x 30.5)
Collection of Carol Thompson

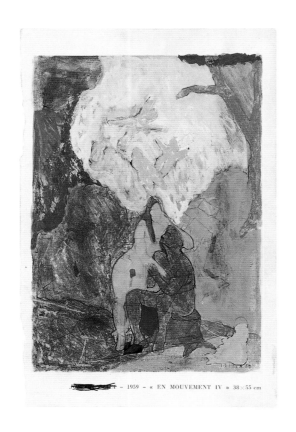

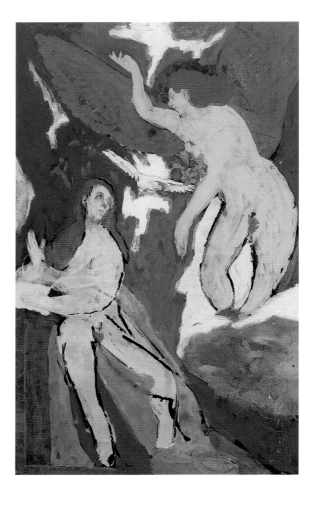

56. *EN MOUVEMENT IV*, 1959
Pastel and gouache on photographic reproduction,
7 5/8 x 5 1/2 (19.4 x 14)
Collection of Martha Henry

57. *AFTER EL GRECO'S ANNUNCIATION*, c. 1960
Gouache on photographic reproduction, 12 1/4 x 9 1/4 (31.1 x 23.5)
Collection of Cornelia McDougald; courtesy Martha Henry, New York

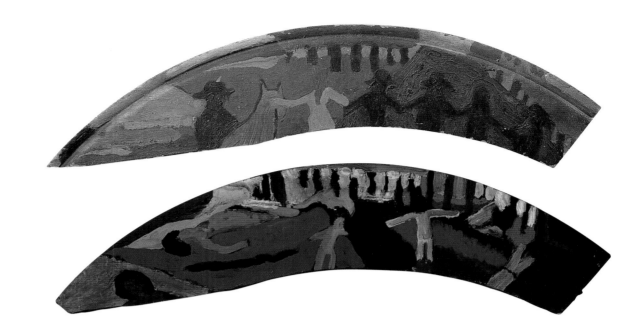

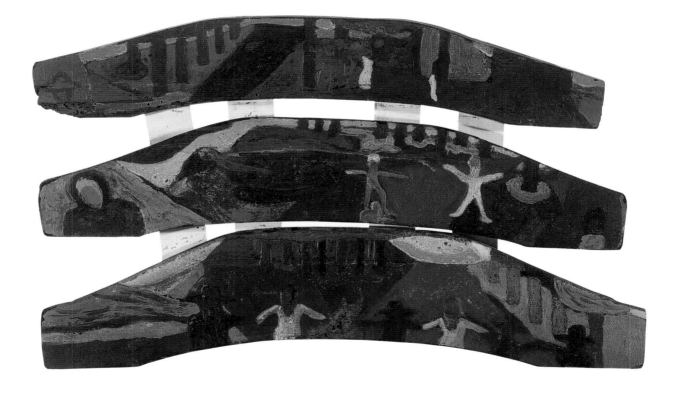

58. *THE TREK*, 1960
Oil on wood, 4 1/4 x 21 3/4 (10.8 x 55.2)
Collection of Martha Henry

59. *UNTITLED*, 1960
Oil on wood, 4 1/2 x 22 1/2 (11.4 x 57.2)
Collection of Harmon and Harriet Kelley

60. *UNTITLED*, c. 1960–61
Oil on wood, 3 parts, 37 1/2 x 6 3/4 (95.3 x 17.1) overall
Collection of Carol Thompson

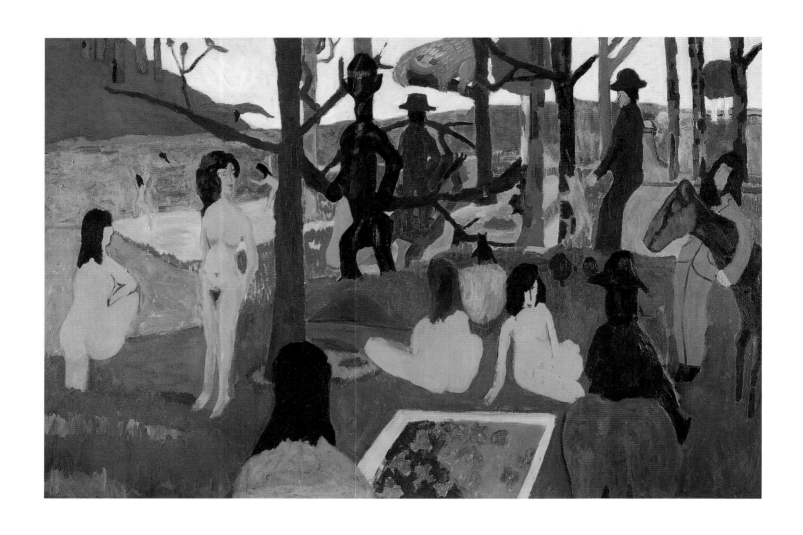

61. *UNTITLED*, 1960
Oil on canvas, 73 1/2 x 111 (186.7 x 282)
Collection of Edward Shulak

62. *WAGADU II*, 1960
Oil on board, 60¾ x 40 (154.3 x 101.6)
Collection of Miki Benoff

63

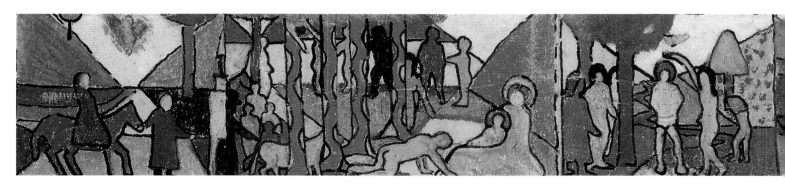

64

63. *LA FEMME DANS LA PEINTURE*, 1961
Oil on paper, 17 13/16 x 16 1/8 (45.2 x 41)
Anderson Gallery, Buffalo, New York

64. *UNTITLED*, c. 1963
Mixed media on paper, 2 1/2 x 23 (6.4 x 58.4)
Private collection

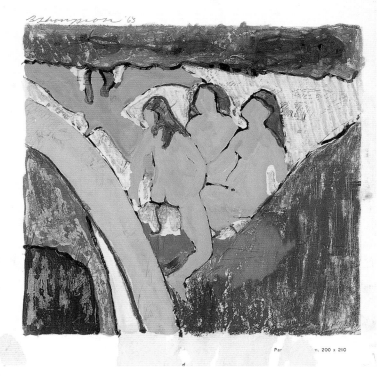

65

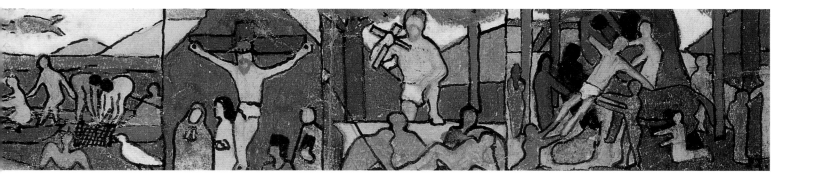

65. *THREE NUDES*, 1963
Pastel and gouache on photographic reproduction,
10 5/16 x 12 (26.2 x 30.5)
Collection of Martha Henry

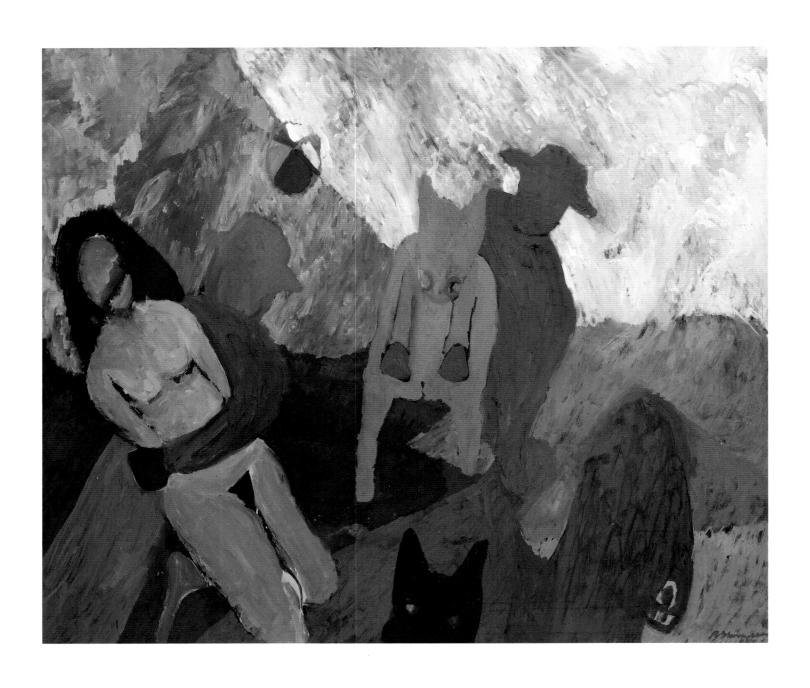

66. *ALLEGORY*, c. 1960
Oil on canvas, 60 x 71 (152.4 x 180.3)
The Metropolitan Museum of Art, New York; George A. Hearn Fund, 1981

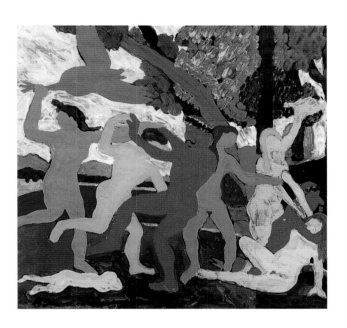

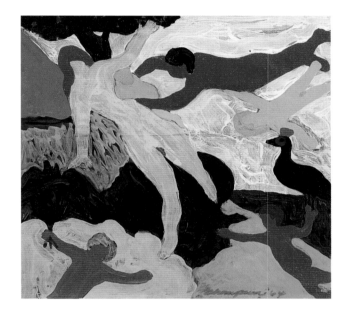

67. *BACCHANAL*, c. 1960
Gouache on paper, 11 x 11 (27.9 x 27.9)
Collection of John Sacchi

68. *NATIVITY*, c. 1960
Gouache on paper, 11 x 11 (27.9 x 27.9)
Collection of John Sacchi

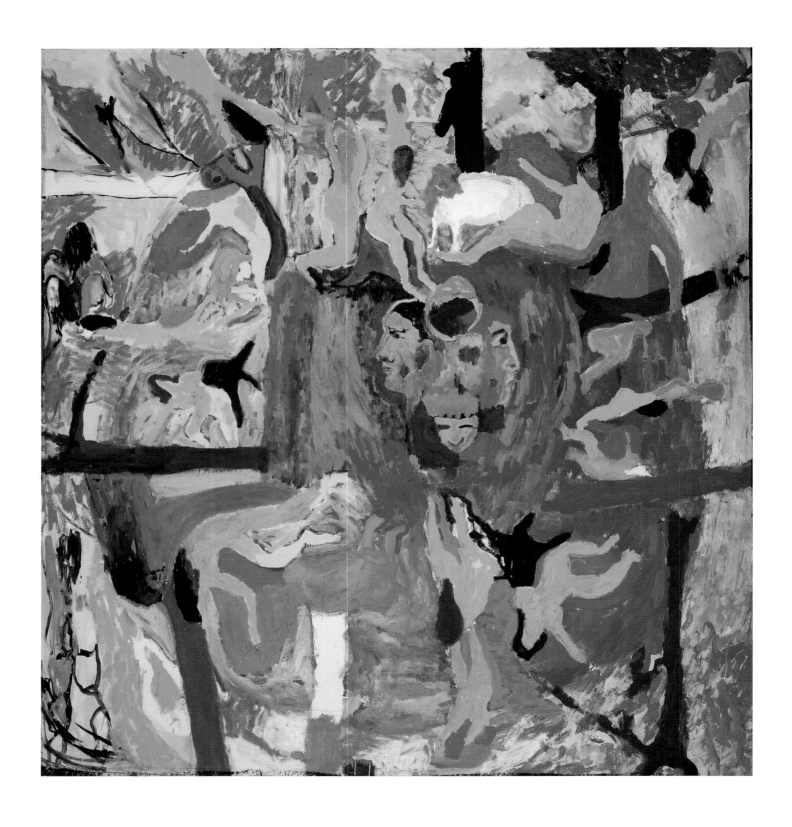

69. *ORNETTE*, 1960–61
Oil on canvas, 81 x 77 3/16 (205.7 x 196.1)
Anderson Gallery, Buffalo, New York

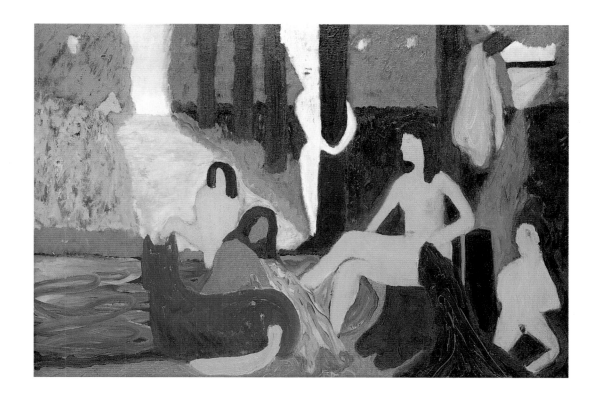

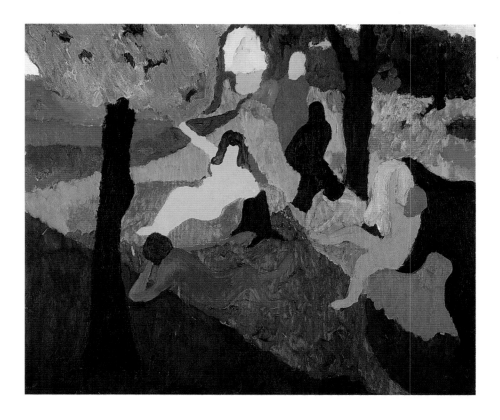

70. *UNTITLED*, c. 1960–61
Oil on canvas, 25 x 36 (63.5 x 91.4)
Private collection

71. *THE DRYING AFTER*, 1961
Oil on wood, 19 7/8 x 23 9/16 (50.5 x 59.8)
The Art Institute of Chicago; Gift of Mr. and Mrs. Joseph Randall Shapiro

72. *BLUE MADONNA*, 1961
Oil on canvas, 51 1/2 x 74 3/4 (130.8 x 189.9)
The Detroit Institute of Arts; Gift of Edward Levine in memory of a friend, Bob Thompson

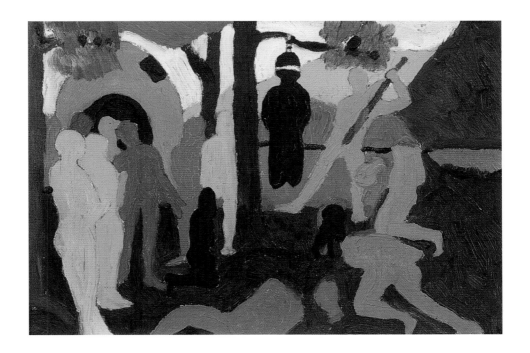

73. *CHRIST*, 1961
Oil on canvas, 4³/4 x 7 (12.1 x 17.8)
Collection of Martha Henry

74. *L'EXÉCUTION*, 1961
Oil on linen, 7 x 10¹/2 (17.8 x 26.7)
Collection of Ellen Phelan and Joel Shapiro

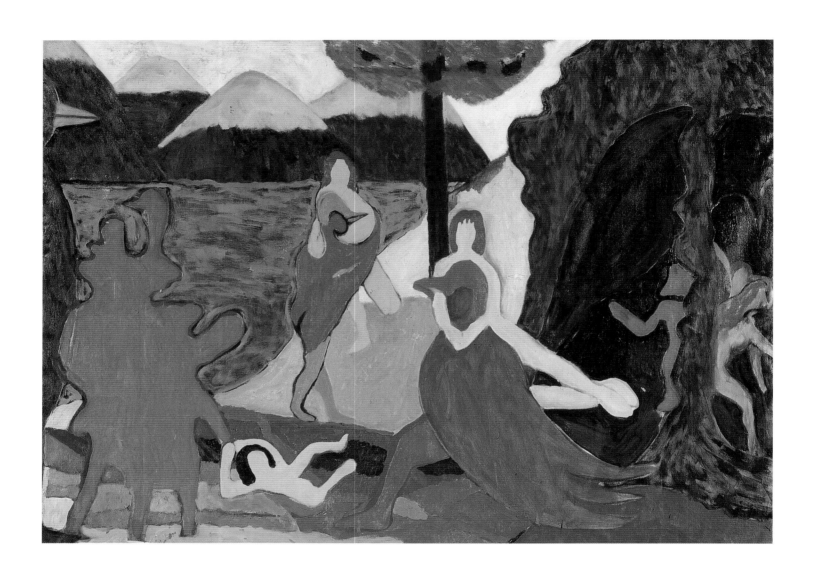

75. *BIRD PARTY*, 1961
Oil on canvas, 54 x 74 (137.2 x 188)
Collection of Elisabeth and William M. Landes;
courtesy Michael Rosenfeld Gallery, New York

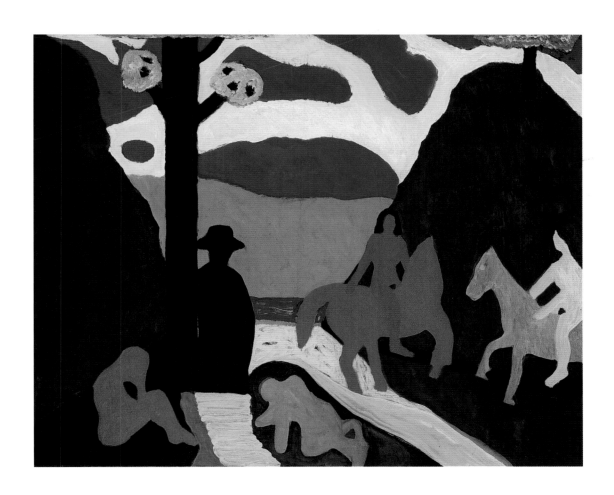

76. **THE FOETUS**, 1961
Oil on canvas, 31 1/2 x 38 1/2 (80 x 97.8)
Private collection; courtesy Michael Rosenfeld
Gallery, New York

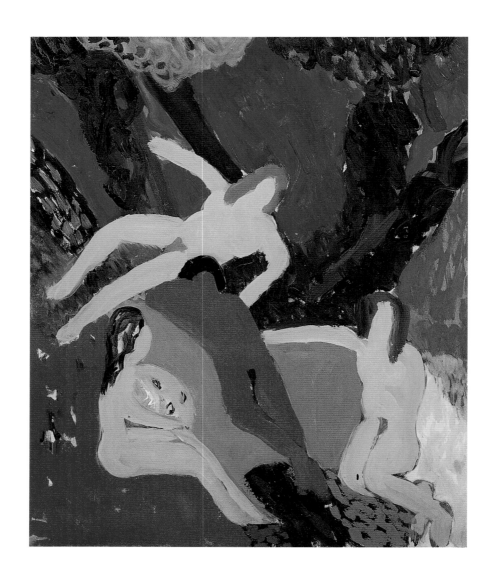

77. *UNTITLED*, 1961
Oil on canvas, 26 x 21 (66 x 53.3)
Collection of the Hudgins Family

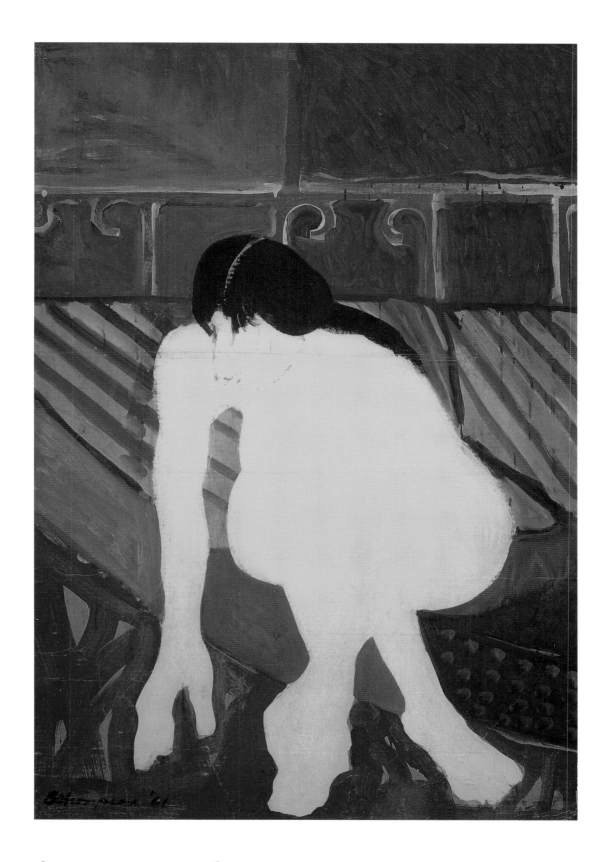

78. *YELLOW CROUCHING FIGURE*, 1961
Oil on paper mounted on board, 41 1/2 x 28 1/2 (105.4 x 72.4)
Anderson Gallery, Buffalo, New York

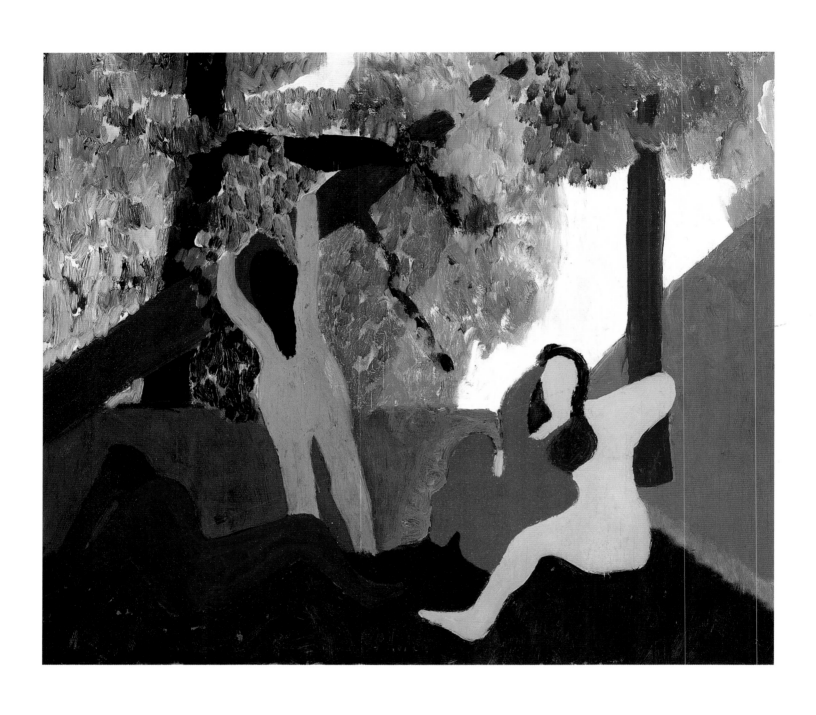

79. *FOUR BATHERS*, c. 1961–62
Oil on wood, 82^1/$_2$ x 90^1/$_2$ (209.6 x 229.9)
The Metropolitan Museum of Art, New York; Gift of Patricia and Francis Mason, 1986

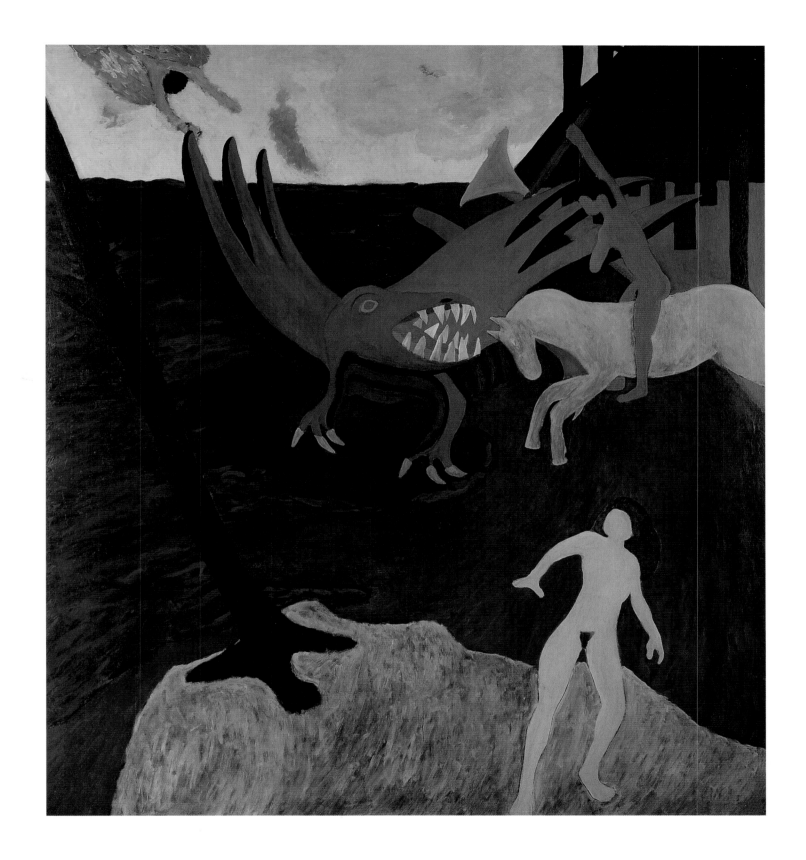

80. *ST. GEORGE AND THE DRAGON*, c. 1961–62
Oil on canvas, 89 1/2 x 81 1/2 (227.3 x 207)
The Newark Museum, New Jersey; Purchase 1982, The Members' Fund

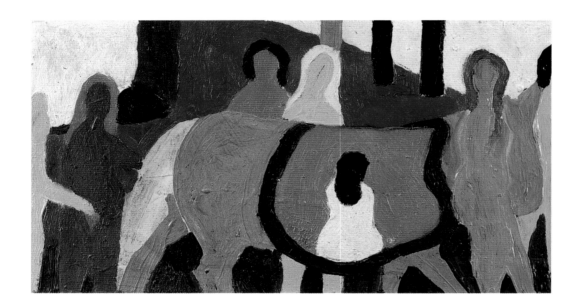

81. *THE JOURNEY*, 1962
Oil on wood, 8 x 11 (20.3 x 27.9)
Collection of Maren and Günter Hensler

82. *GARDEN OF EDEN*, 1963
Oil on canvas, 10 x 8 (25.4 x 20.3)
The Oakleigh Collection

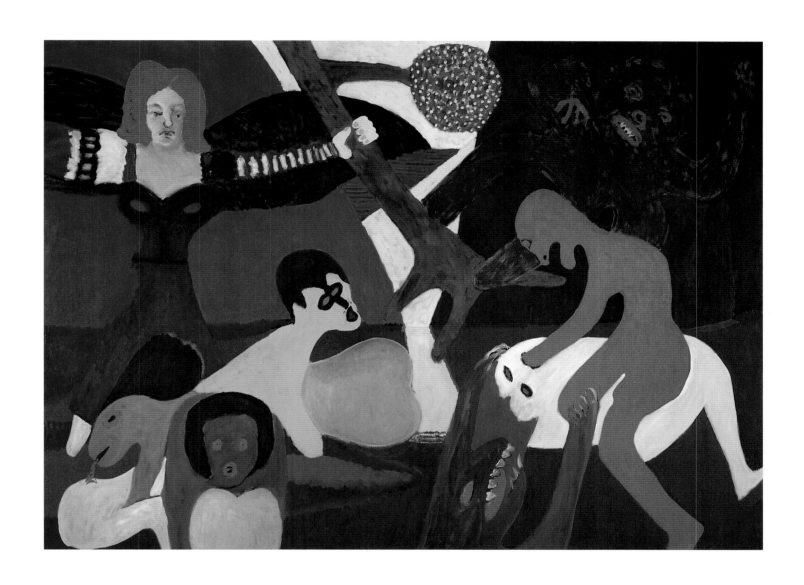

83. *TREE*, 1962
Oil on canvas, 78 x 108 (198.1 x 274.3)
Michael Rosenfeld Gallery, New York

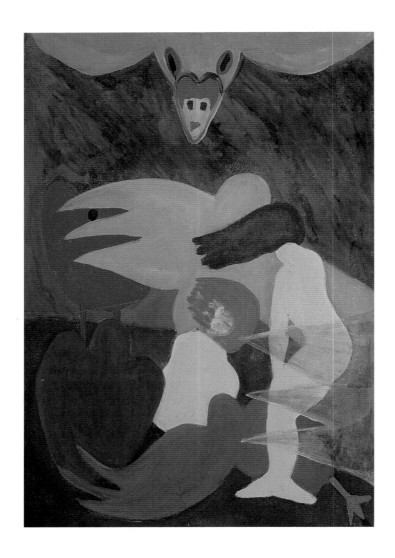

84. **UNTITLED**, 1962
Oil on canvas, 36 1/4 x 25 5/8 (92.1 x 65.1)
Hirshhorn Museum and Sculpture Garden, Smithsonian Institution,
Washington, D.C.; Gift of Joseph H. Hirshhorn, 1966

85. **ZÜCKLER**, 1962
Gouache on paper, 21 x 17 3/4 (53.3 x 45.1)
University Art Museum, University of California, Santa Barbara;
Ruth S. Schaffner Collection

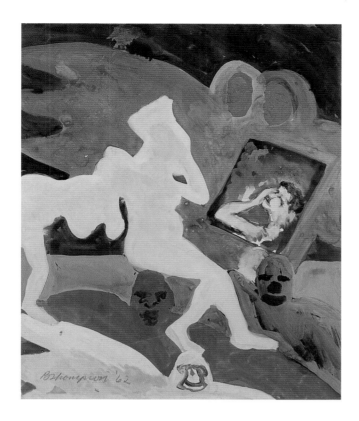

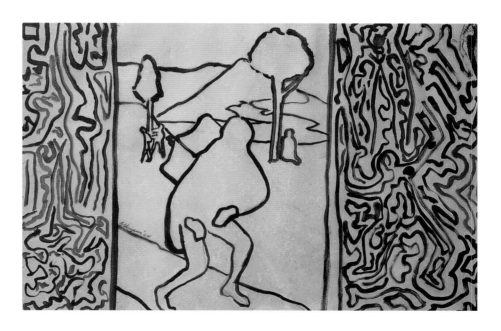

86. *REFLECTIONS*, 1962
Gouache on paper, 21 1/2 x 17 1/2 (54.6 x 44.5)
The Walter O. Evans Collection of African-American Art

87. *UNTITLED*, 1964
Ink on wax paper, 14 1/8 x 21 (35.9 x 53.3)
Anderson Gallery, Buffalo, New York

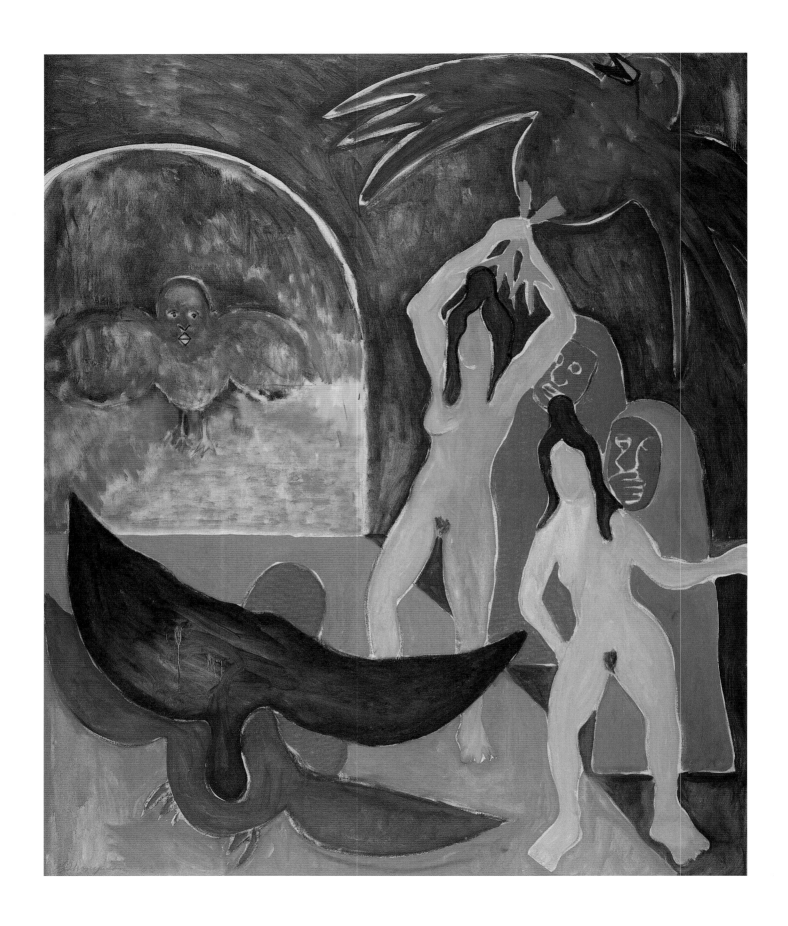

88. *BIRD RITUAL*, 1963
Oil on canvas, 72 x 60 (182.9 x 152.4)
Collection of Jacqueline Bradley and Clarence Otis

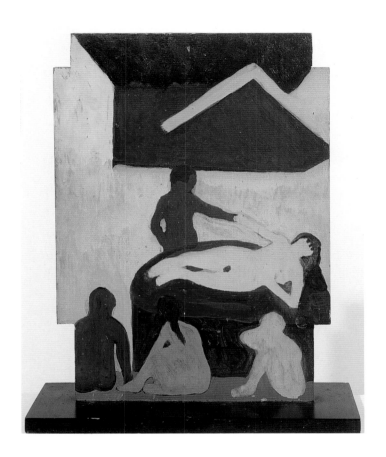 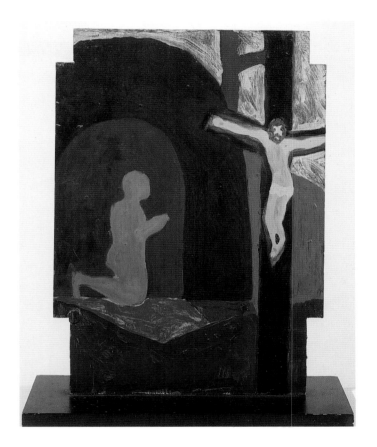

89a–b. *UNTITLED*, c. 1962–63
Oil on wood, two sides: 17 $^1/_2$ x 14 $^1/_4$ (44.5 x 36.2);
16 $^7/_8$ x 12 $^1/_4$ (42.9 x 31.1)
Collection of Paula Cooper

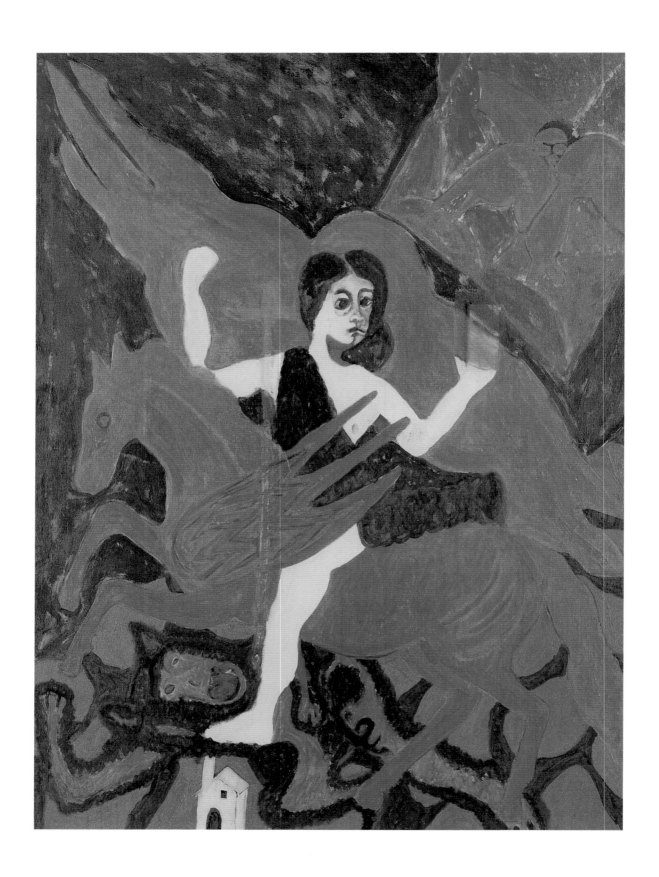

90. ***ENCHANTED RIDER***, c. 1962–63
Oil on canvas, 62 3/4 x 46 7/8 (159.4 x 119.1)
National Museum of American Art, Washington, D.C.; Gift of
Mr. and Mrs. David K. Anderson, Martha Jackson Memorial Collection

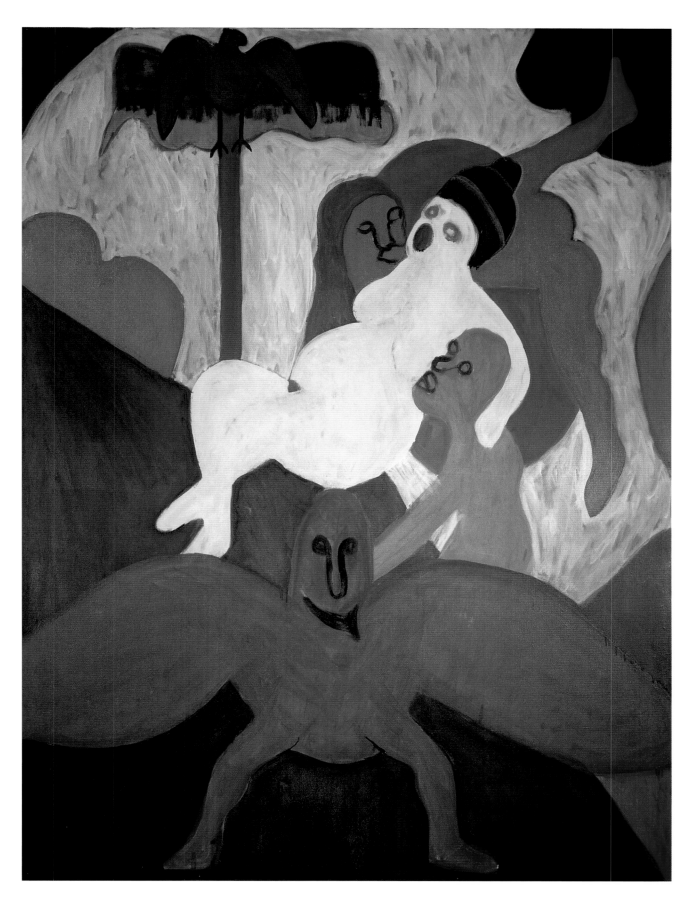

91. *CALEDONIA FLIGHT*, 1963
Oil on canvas, 77 x 57 (195.6 x 144.8)
George R. N'Namdi Gallery, Birmingham, Michigan

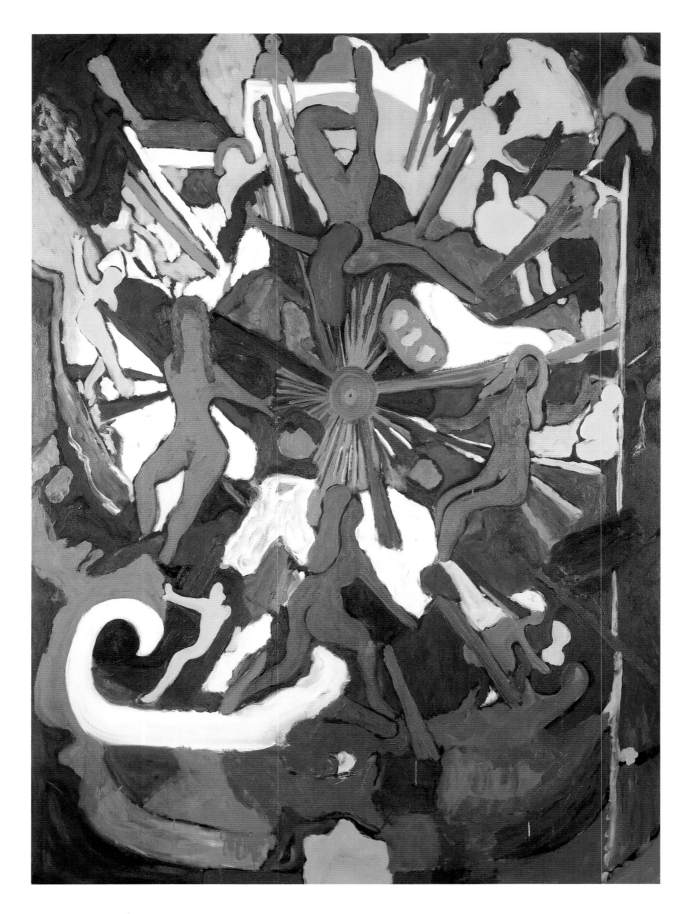

92. *CATHEDRAL*, 1963
Oil on canvas, 86 x 63 (218.4 x 160)
Collection of Andy Williams

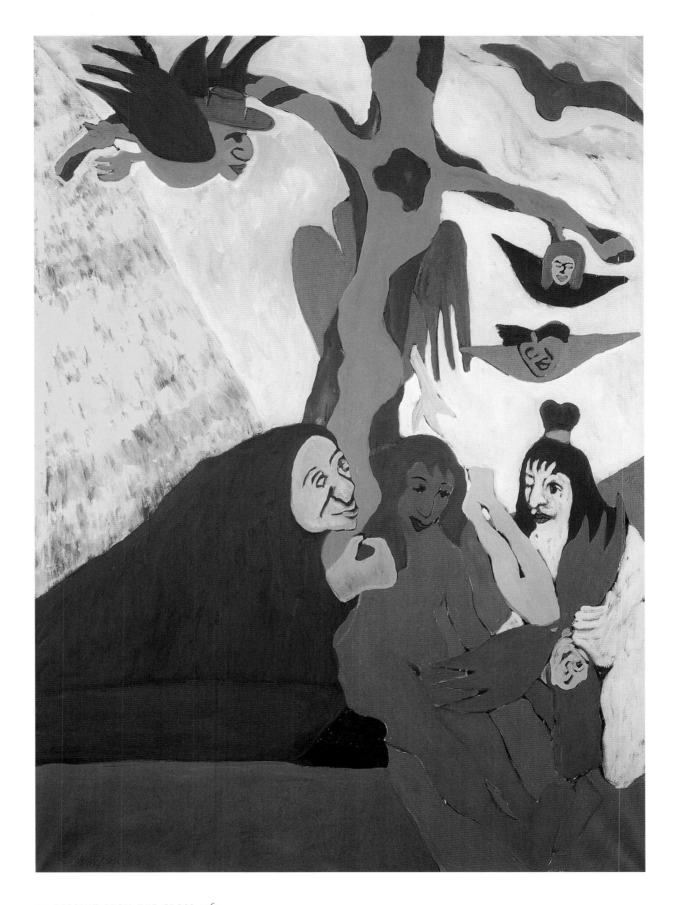

93. **DESCENT FROM THE CROSS**, 1963
Oil on canvas, 84 x 60 1/8 (213.4 x 152.7)
National Museum of American Art, Smithsonian Institution, Washington, D.C.;
Gift of Mr. and Mrs. David K. Anderson, Martha Jackson Memorial Collection

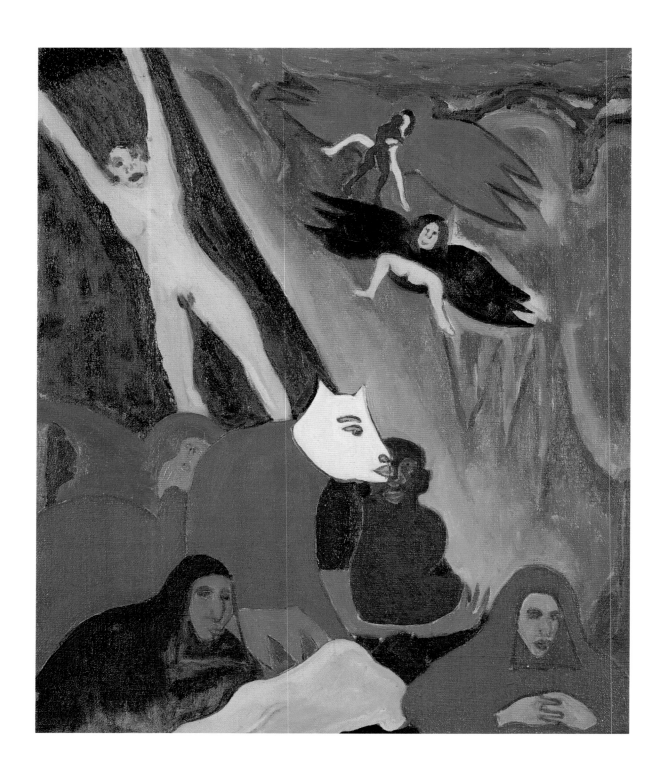

94. *INFERNO*, 1963
Oil on canvas, 24 x 20 (61 x 50.8)
The Oakleigh Collection

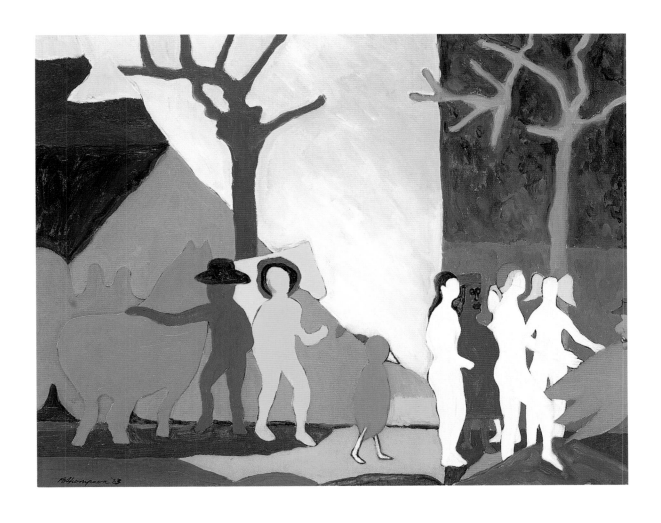

95. *QUEEN OF SHEBA'S VISIT TO KING SOLOMON*, 1963
Oil on canvas, 16 x 20 (40.6 x 50.8)
Collection of Robert L. Shapiro

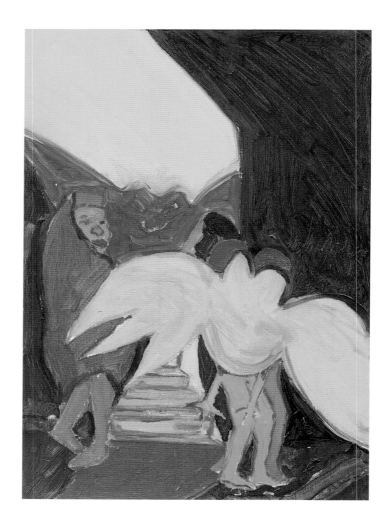

96. *THE SEARCH*, 1963
Oil on canvas, 8 x 10 (20.3 x 25.4)
Collection of Emily Fisher Landau

97. *SOLOMON AND SHEBA*, 1963
Oil on canvas, 14 x 10 (35.6 x 25.4)
The Oakleigh Collection

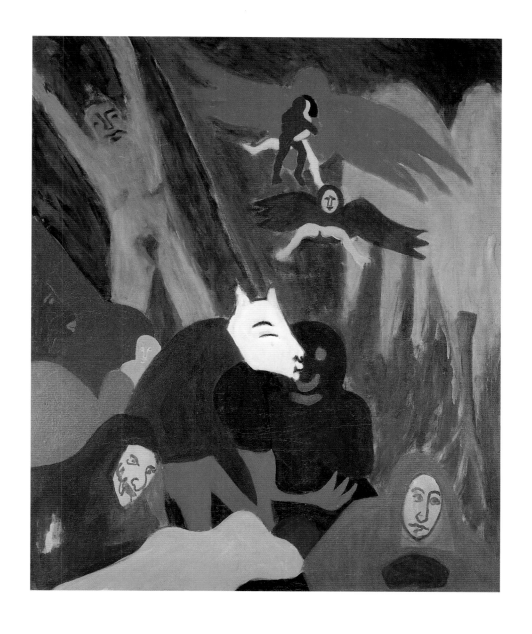

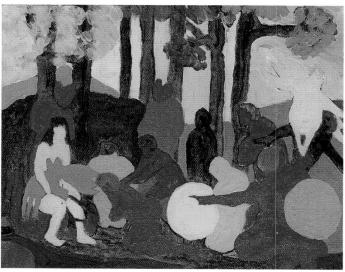

98. *LA CAPRICE*, c. 1963
Oil on canvas, 62 1/4 x 51 1/2 (158.1 x 130.8)
Michael Rosenfeld Gallery, New York

99. *ADORATION OF THE MAGI (AFTER POUSSIN)*, 1964
Oil on canvas, 8 x 10 (20.3 x 25.4)
Collection of halley k. harrisburg and Michael Rosenfeld

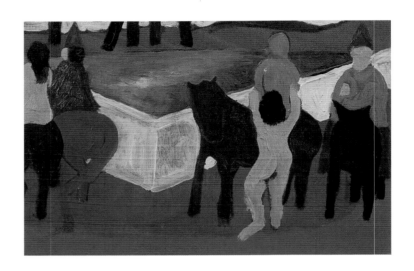

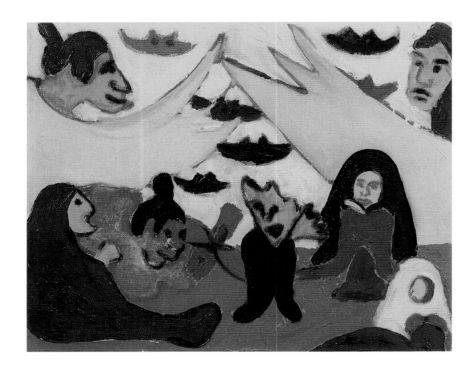

100. *TEN PLAGUES*, 1963
Oil on canvas, 8 x 10 (20.3 x 25.4)
The Oakleigh Collection

101. *ASSISTANCES FOR THE JOURNEY*, n.d.
Oil on wood, 6 3/4 x 10 1/8 (17 x 25.7)
Collection of Katherine Kahan

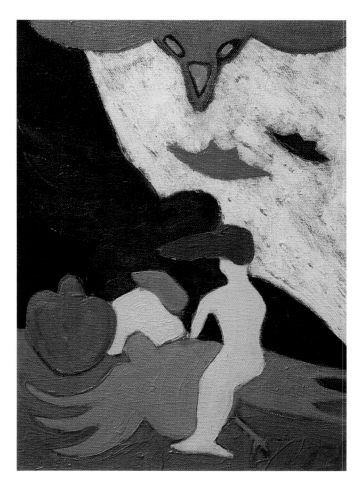

102. *UNTITLED*, 1963
Oil on canvas on board, 12 3/16 x 14 3/16 (31 x 36)
Anderson Gallery, Buffalo, New York

103. *UNTITLED*, 1963
Oil on canvas, 14 x 10 (35.6 x 25.4)
Collection of June Kelly

104 a.

104 b.

104 c.

104a–o. *UNTITLED (SKETCHBOOK)*, 1963
Sketchbook, $9^{1}/_{2}$ x $6^{1}/_{4}$ (24.1 x 15.9)
Vanderwoude Tananbaum Gallery, New York

104 d.

104 e.

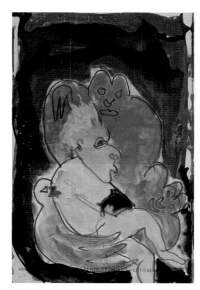

104 f.

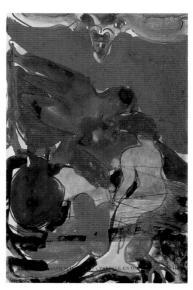

104 g.

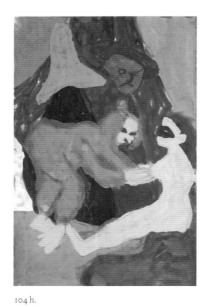

104 h.

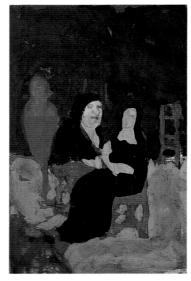

104 i.

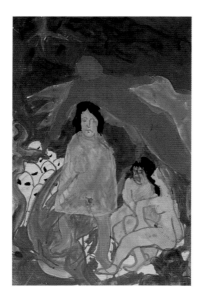

104 j.

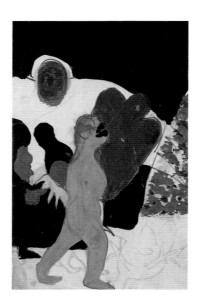

104 k.

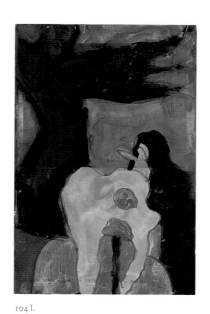

104 l.

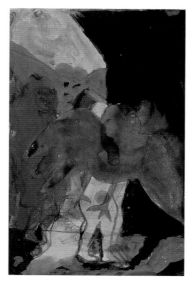

104 m.

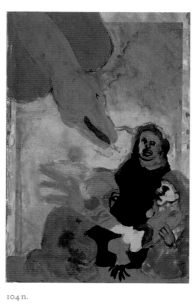

104 n.

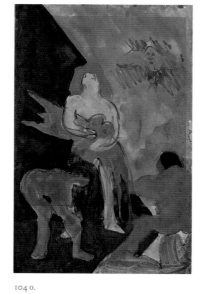

104 o.

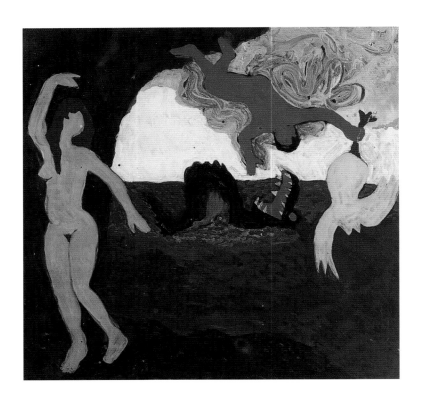

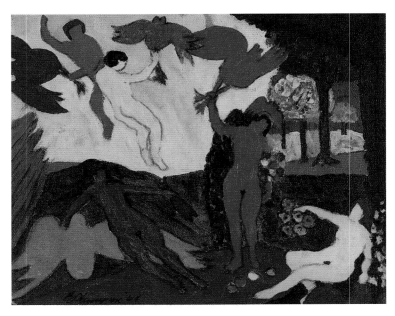

105. *UNTITLED*, c. 1963
Gouache on paper, 10 3/8 x 10 7/8 (26.4 x 27.6)
Collection of Paula Cooper

106. *ABUNDANCE AND THE FOUR ELEMENTS*, 1964
Oil on canvas, 8 x 10 (20.3 x 25.4)
Sheldon Ross Gallery, Birmingham, Michigan

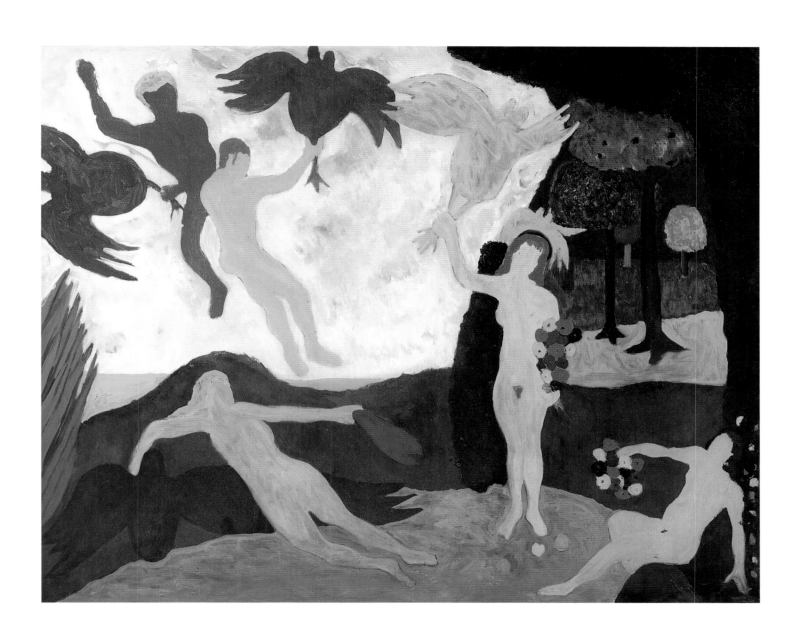

107. *ABUNDANCE AND THE FOUR ELEMENTS*, 1964
Oil on canvas, 48 x 60 (121.9 x 152.4)
The Oakleigh Collection

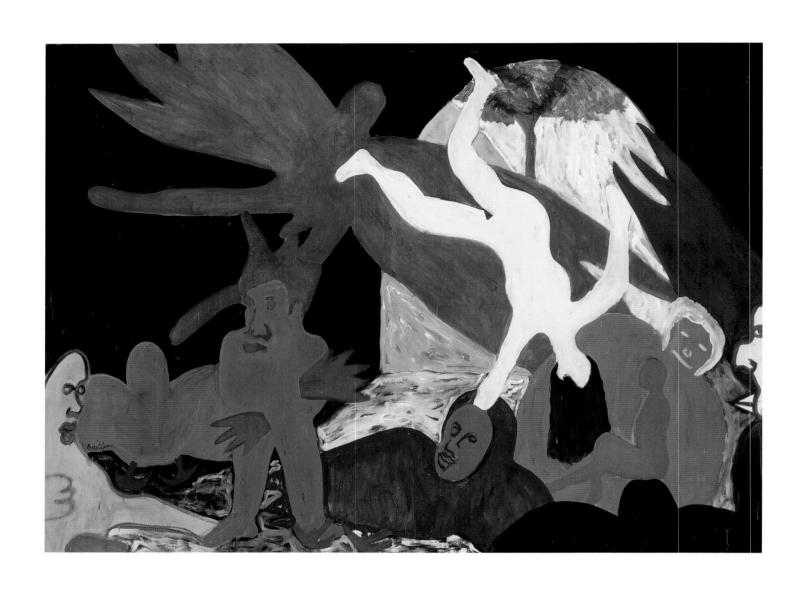

108. *THE SPINNING, SPINNING, TURNING, DIRECTING*, 1963
Oil on canvas, 62 7/8 x 82 7/8 (159.7 x 210.5)
National Museum of American Art, Smithsonian Institution, Washington, D.C.;
Gift of Mr. and Mrs. David K. Anderson, Martha Jackson Memorial Collection

109. *VENUS AND ADONIS*, 1964
Oil on canvas, 60 x 48 (152.4 x 121.9)
Collection of Elizabeth and Eliot Bank

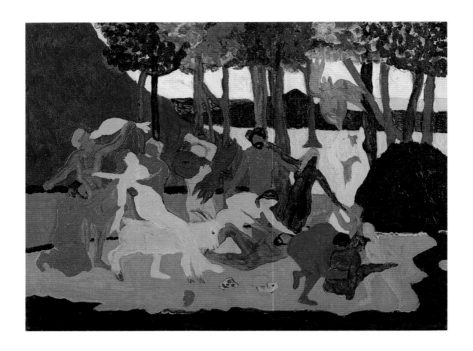

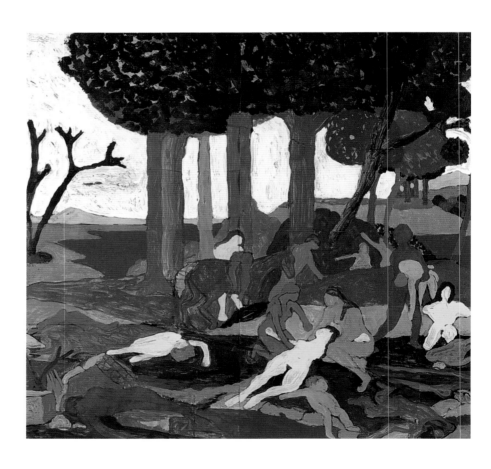

110. **BIRD BACCHANAL**, 1964
Oil on canvas, 12 x 16 (30.5 x 40.6)
Private collection; courtesy Vanderwoude
Tananbaum Gallery, New York

111. **LA MORT DES ENFANTS DE BÉTHEL**, 1964
Gouache on paper, 19 1/2 x 20 1/2 (49.5 x 52.1)
Collection of Ed and Diane Levine

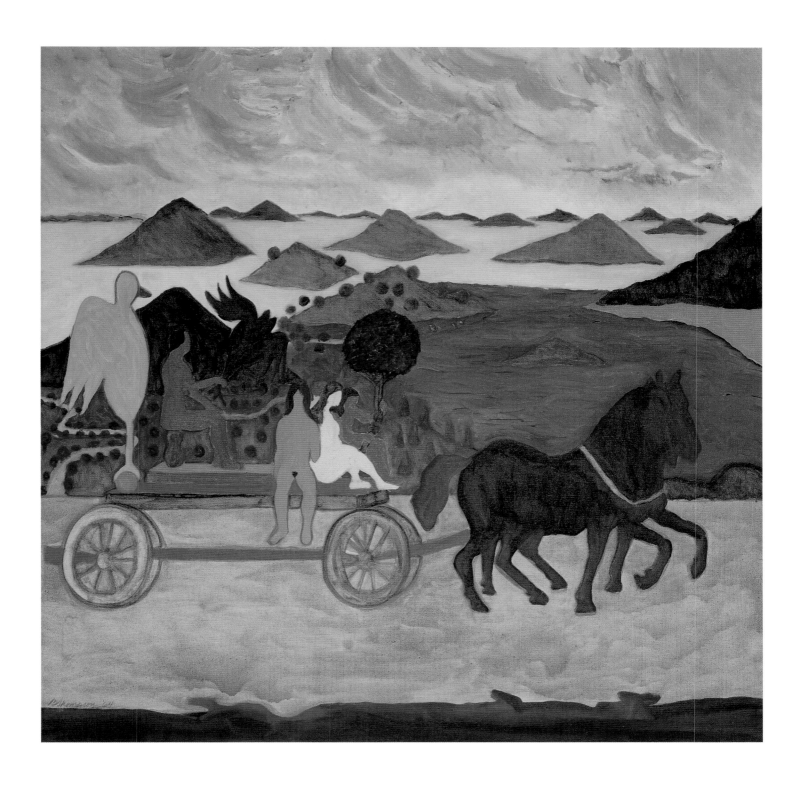

112. *AN ALLEGORY*, 1964
Oil on canvas, 48 x 48 (121.9 x 121.9)
Whitney Museum of American Art, New York; Gift of Thomas Bellinger 72.137

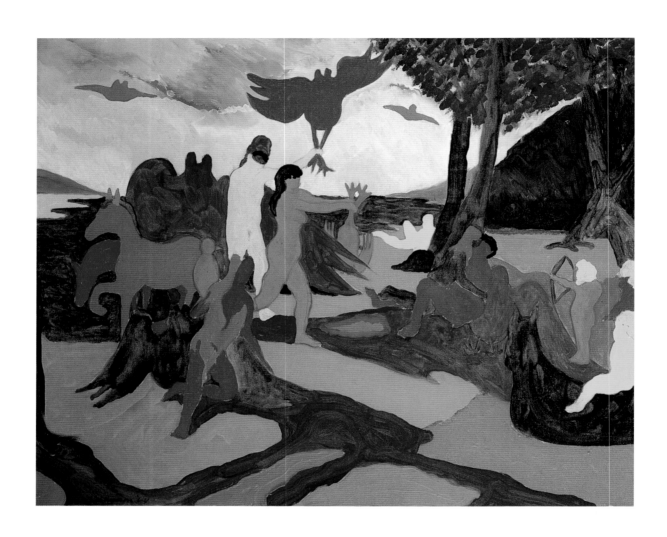

113. *AURORA LEAVING CEPHALUS II*, 1964
Oil on canvas, 24 ¹/8 x 30 ¹/8 (61.3 x 76.5)
Hirshhorn Museum and Sculpture Garden, Smithsonian Institution,
Washington, D.C.; Gift of Joseph H. Hirshhorn, 1966

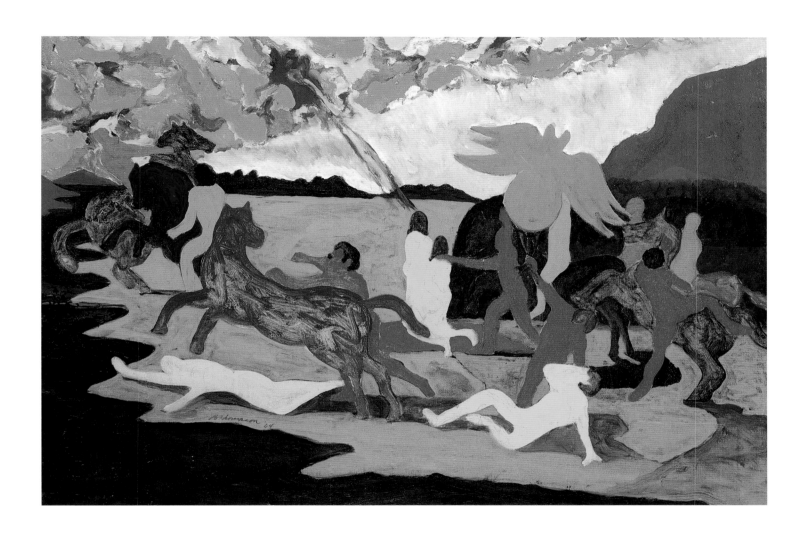

114. *CONVERSION OF ST. PAUL*, 1964
Oil on canvas, 24 5/8 x 36 5/8 (62.6 x 93)
Hirshhorn Museum and Sculpture Garden, Smithsonian Institution,
Washington, D.C.; Gift of Joseph H. Hirshhorn, 1966

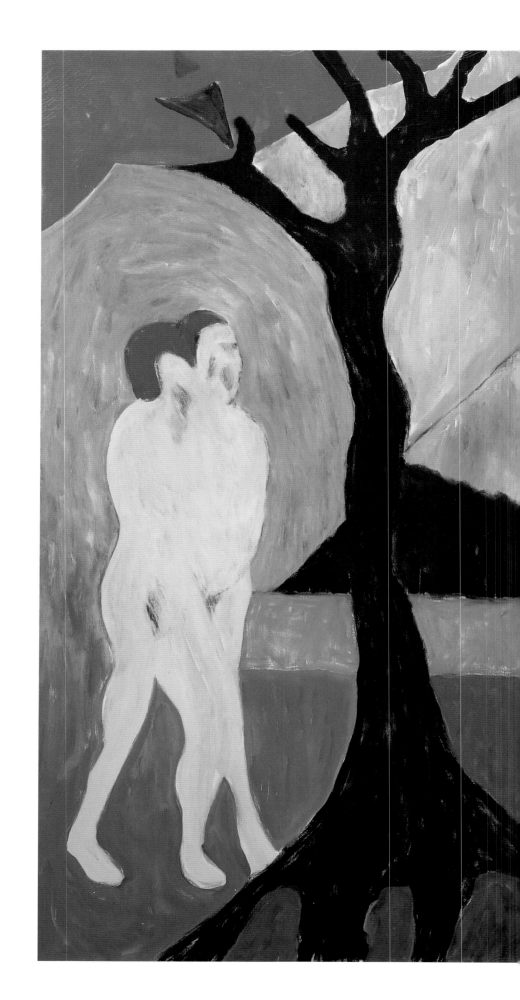

115. *EXPULSION AND NATIVITY*, 1964
Oil on canvas, 63 x 83¹/₂ (160 x 212.1)
Private collection

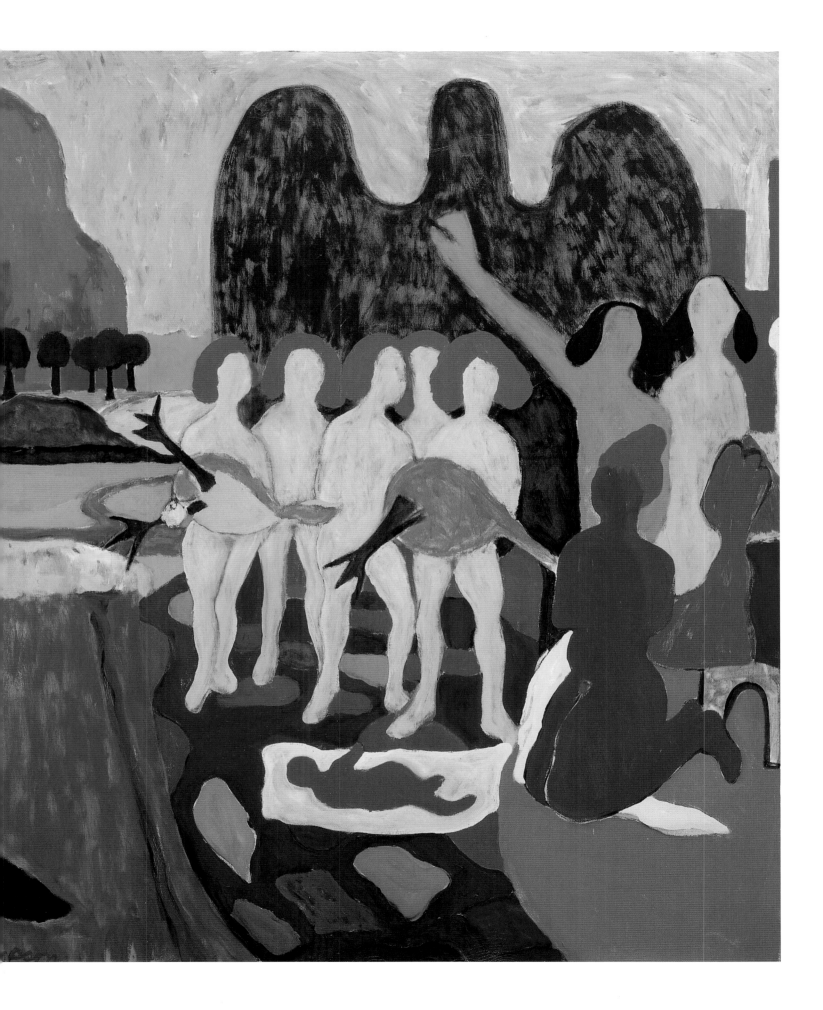

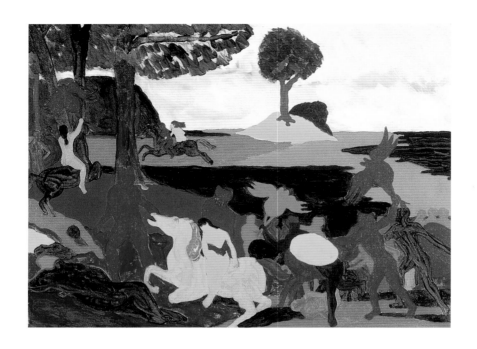

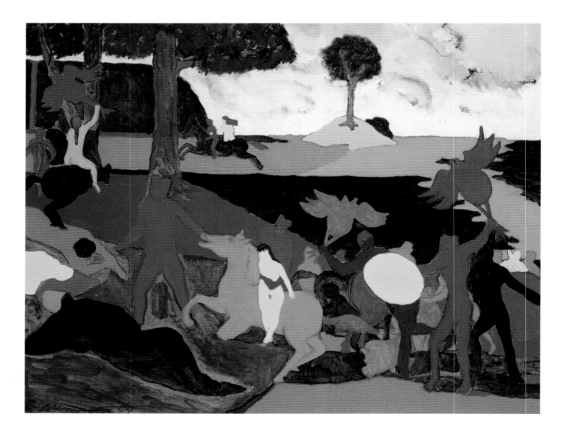

116. *THE DEATH OF CAMILLA*, 1964
Oil on canvas, 18 x 24 1/8 (45.7 x 61.3)
The Detroit Institute of Arts

117. *THE DEATH OF CAMILLA*, 1964
Oil on canvas, 24 1/8 x 30 1/8 (61.3 x 76.5)
Hirshhorn Museum and Sculpture Garden, Smithsonian Institution,
Washington, D.C.; Gift of Joseph H. Hirshhorn, 1966

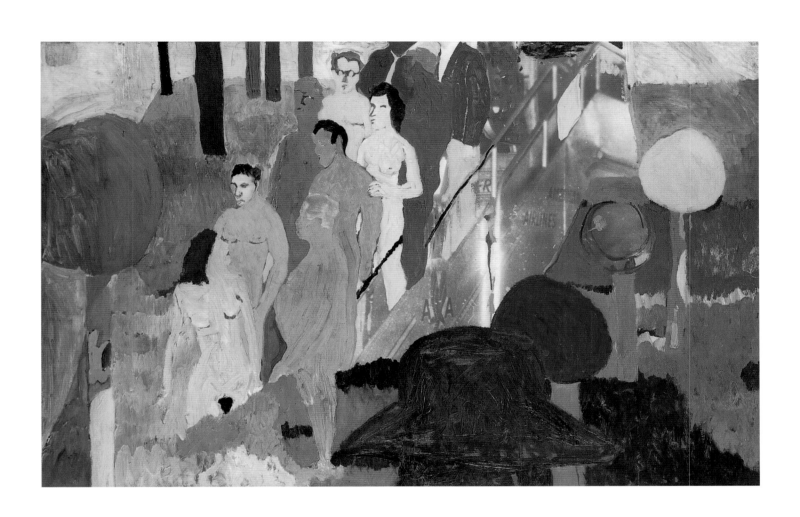

118. *STAIRWAY TO THE STARS*, n.d.
Paper, oil, and photograph on canvas, 40 x 60 (101.6 x 152.4)
Collection of George and Joyce Wein

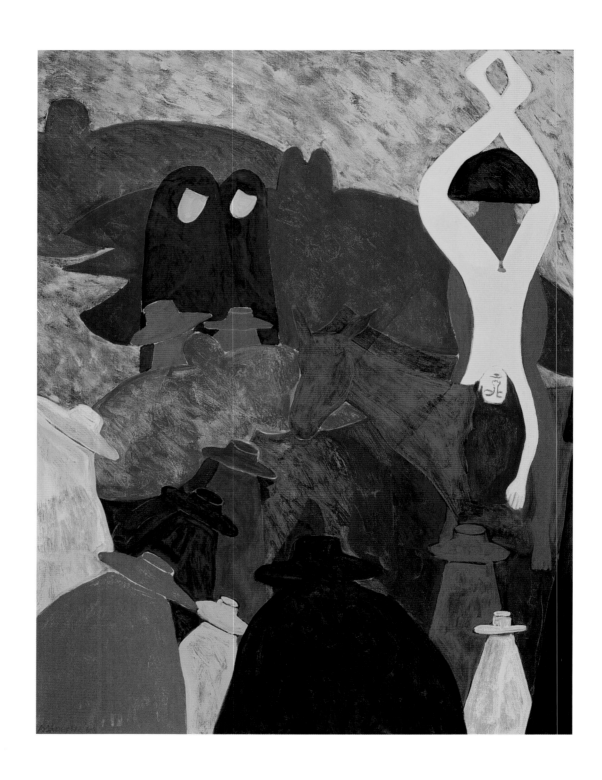

119. *THE PROCESSION*, 1963–64
Oil on canvas, 48 x 36 (121.9 x 91.4)
Collection of Mr. and Mrs. Stanley M. Freehling

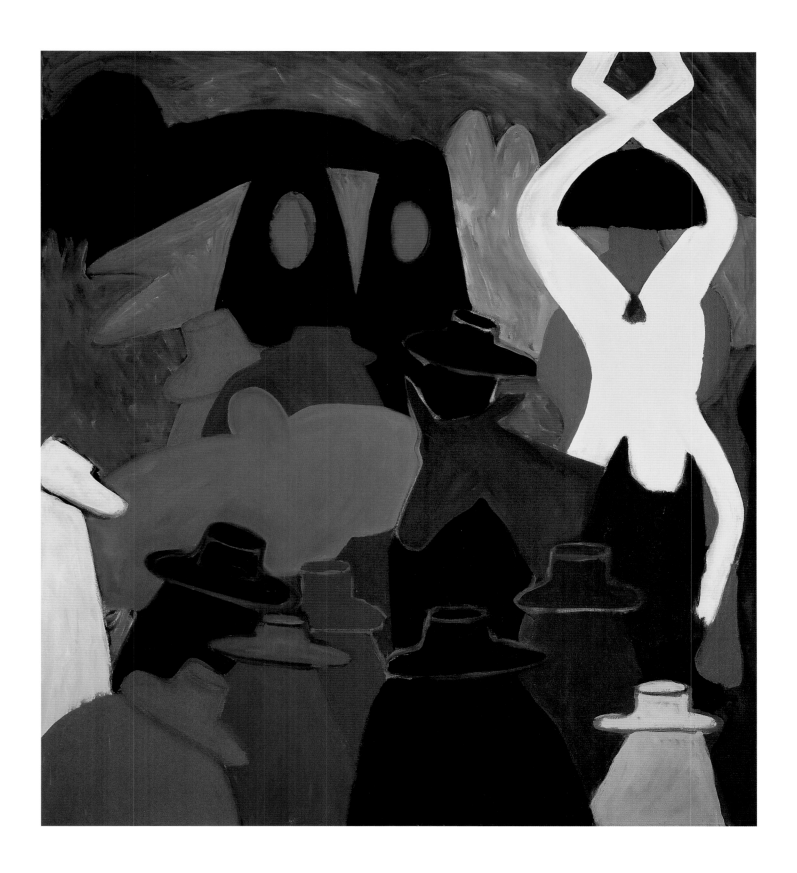

120. *THE PROCESSION*, 1963
Oil on canvas, 65 3/4 x 58 1/2 (167 x 148.6)
The Denver Art Museum; Gift of Kimiko and John Powers

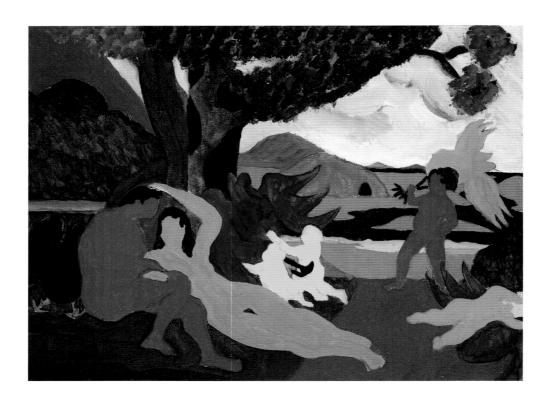

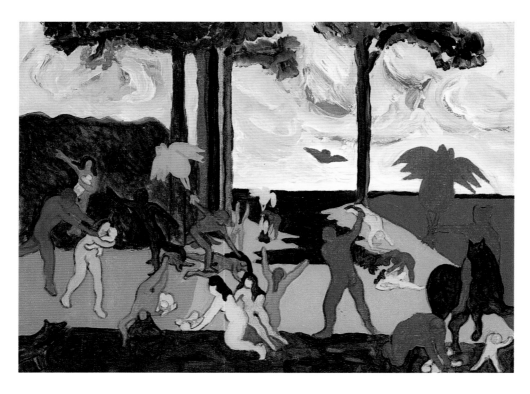

121. *MARS AND VENUS*, 1964
Oil on canvas, 12 ¹/8 x 16 ¹/8 (30.8 x 40.9)
Hirshhorn Museum and Sculpture Garden, Smithsonian Institution,
Washington, D.C.; Gift of Joseph H. Hirshhorn, 1966

122. *MASSACRE OF THE INNOCENTS*, 1964
Oil on canvas, 12 x 16 ¹/8 (30.5 x 41)
Hirshhorn Museum and Sculpture Garden, Smithsonian Institution,
Washington, D.C.; Gift of Joseph H. Hirshhorn, 1966

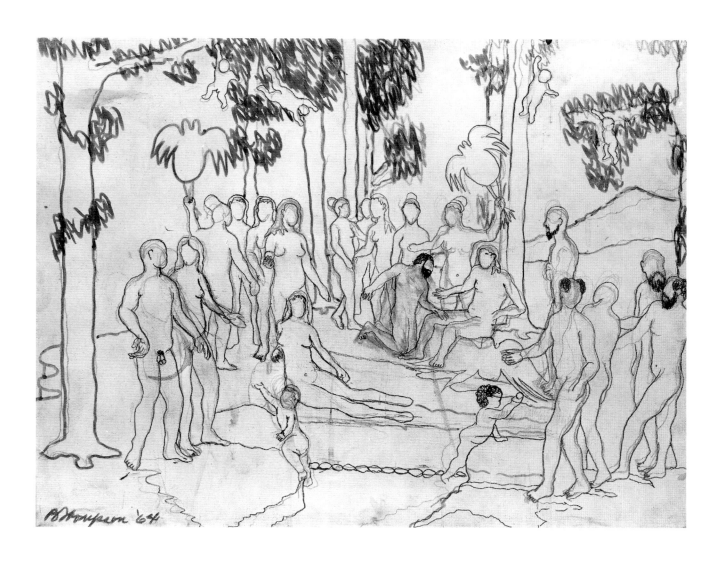

123. *PARNASSUS*, 1964
Oil and graphite on canvas, 20 x 30 (50.8 x 76.2)
The Metropolitan Museum of Art, New York; Gift of Dr. and Mrs. Irwin R. Berman, 1977

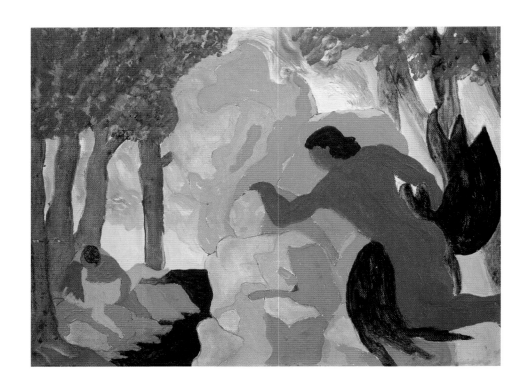

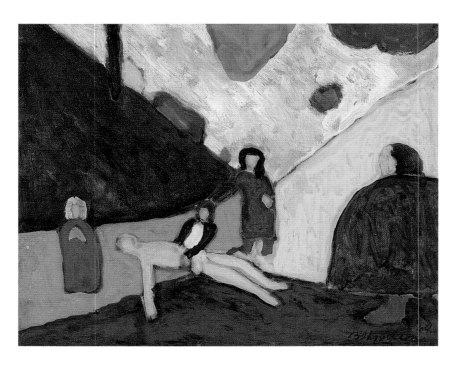

124. *POLYPHEMUS, ACIS AND GALATEA*, 1964
Oil on canvas, 9 x 12 (22.9 x 30.5)
Curtis Galleries, Minneapolis

125. *UNTITLED*, 1964
Oil on canvas, 8 x 10 (20.3 x 25.4)
Collection of Paula Cooper

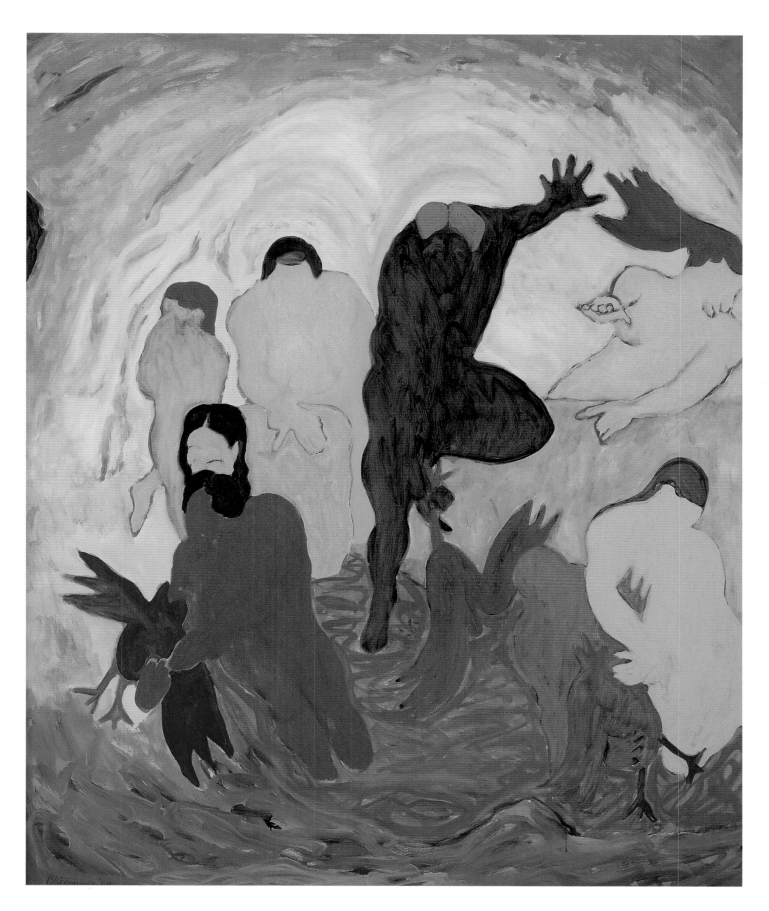

126. *ST. MATTHEW'S DESCRIPTION OF THE END OF THE WORLD*, 1964
Oil on canvas, 72 x 60 ¹/8 (182.9 x 152.7)
The Museum of Modern Art, New York; Blanchette Rockefeller Fund

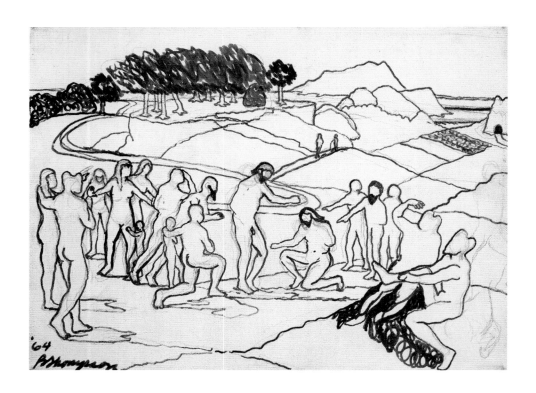

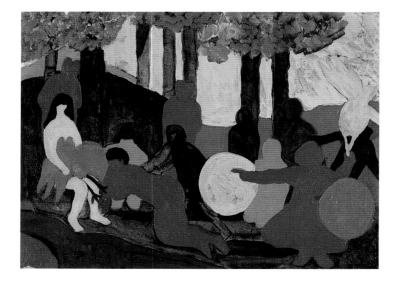

127. *SACRAMENT OF BAPTISM (POUSSIN)*, 1964
Felt-tip pen, ink, and graphite on canvas, 12 x 16 1/8 (30.5 x 41)
Hirshhorn Museum and Sculpture Garden, Smithsonian Institution,
Washington, D.C.; Gift of Joseph H. Hirshhorn, 1966

128. *THE OFFERING*, 1964
Oil on canvas, 9 x 12 (22.9 x 30.5)
Collection of Janice and Mickey Cartin

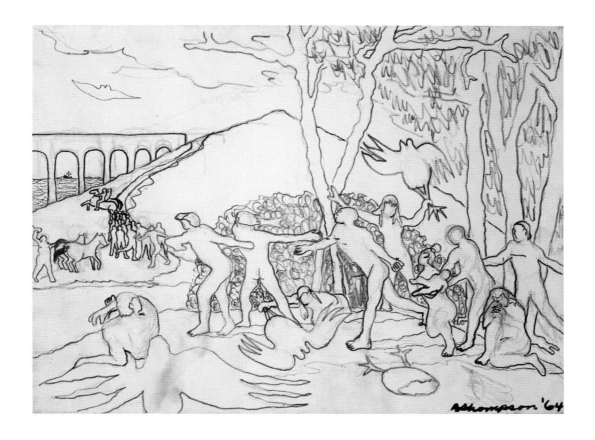

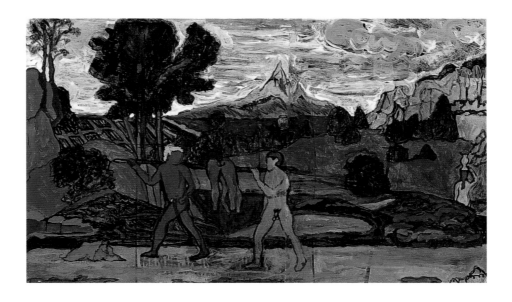

129. *SAVING OF PYRRHUS (POUSSIN)*, 1964
Felt-tip pen, ink, and graphite on canvas, 18 x 24 $\frac{1}{8}$ (45.7 x 61.3)
Hirshhorn Museum and Sculpture Garden, Smithsonian Institution,
Washington, D.C.; Gift of Joseph H. Hirshhorn, 1966

130. *UNTITLED (AFTER POUSSIN)*, 1964
Oil on printed gallery announcement, 10 $\frac{7}{8}$ x 18 $\frac{1}{8}$ (27.6 x 46.1)
The Museum of Modern Art, New York; Gift of Lillian L. and Jack I. Poses

131. *TRIUMPH OF BACCHUS*, 1964
Oil on canvas, 60 x 72 1/16 (152.4 x 183)
Whitney Museum of American Art, New York; Purchase,
148 with funds from the Painting and Sculpture Committee 98.19

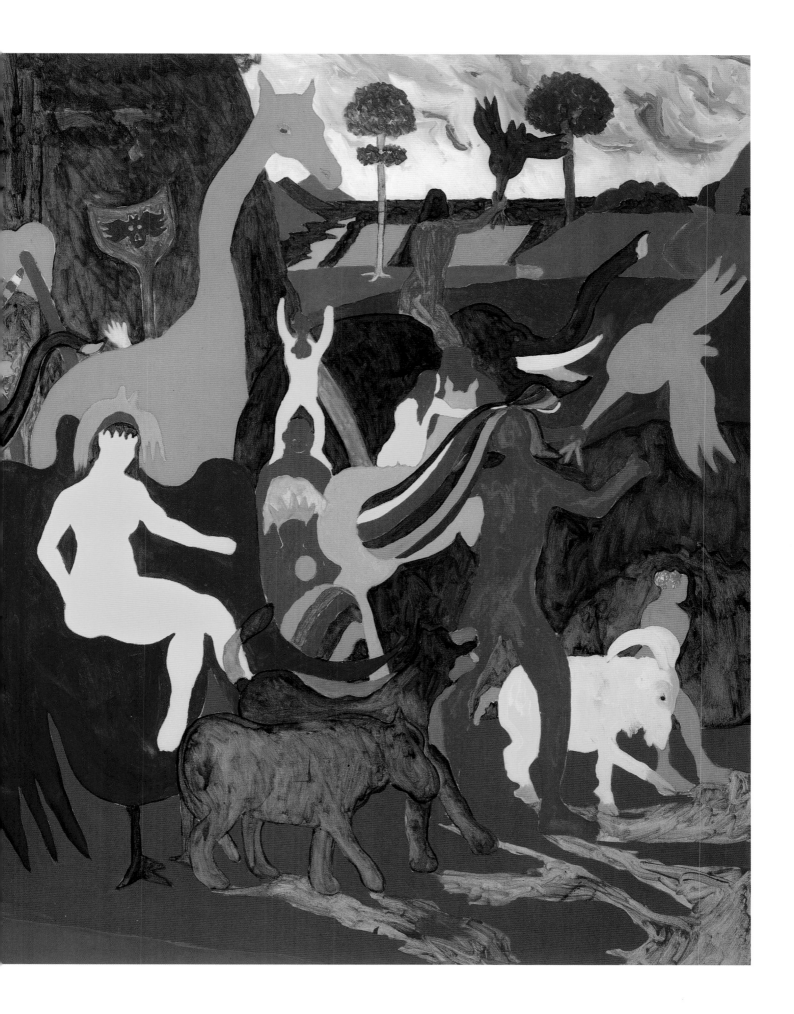

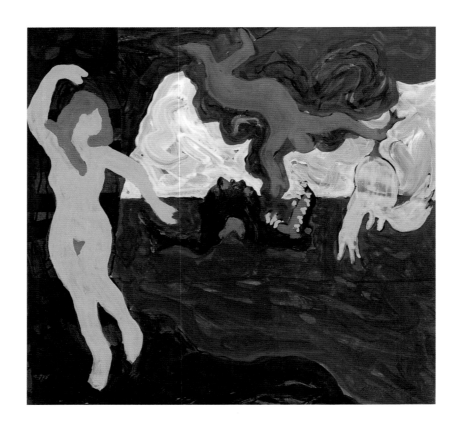

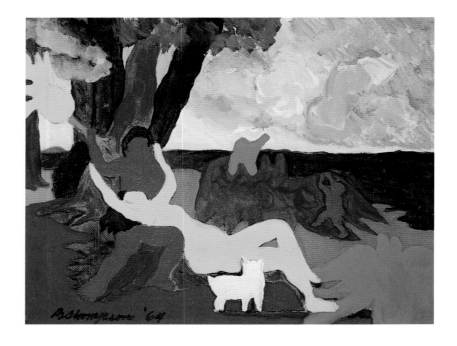

132. *UNTITLED (PERSEUS AND ANDROMEDA)*, 1964
Gouache on paper, 10 x 10 1/2 (25.4 x 26.7)
Collection of Rachelle and Steven Morris

133. *VENUS AND ADONIS*, 1964
Oil on canvas, 8 x 10 (20.3 x 25.4)
Hirshhorn Museum and Sculpture Garden, Smithsonian Institution,
Washington, D.C.; Gift of Joseph H. Hirshhorn, 1966

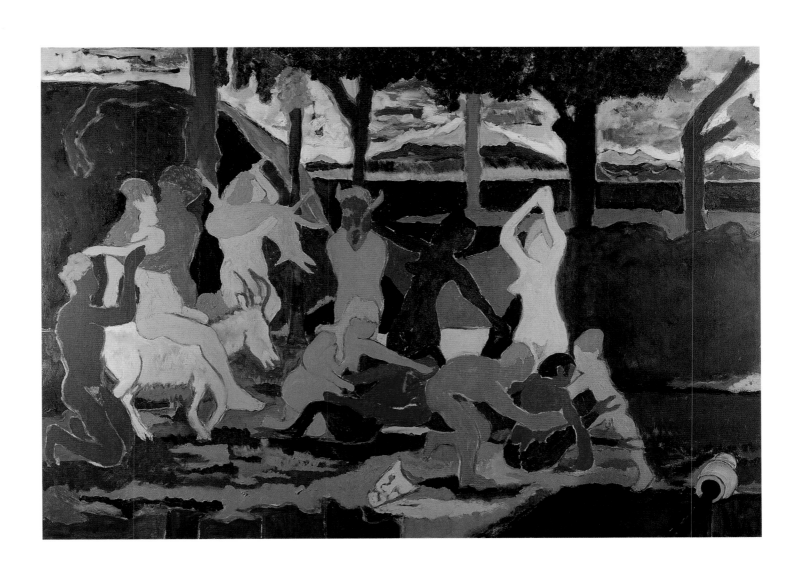

134. *BACCHANAL II*, 1965
Oil on canvas, 60 x 84 (152.4 x 213.4)
Collection of Dr. and Mrs. Paul Todd Makler

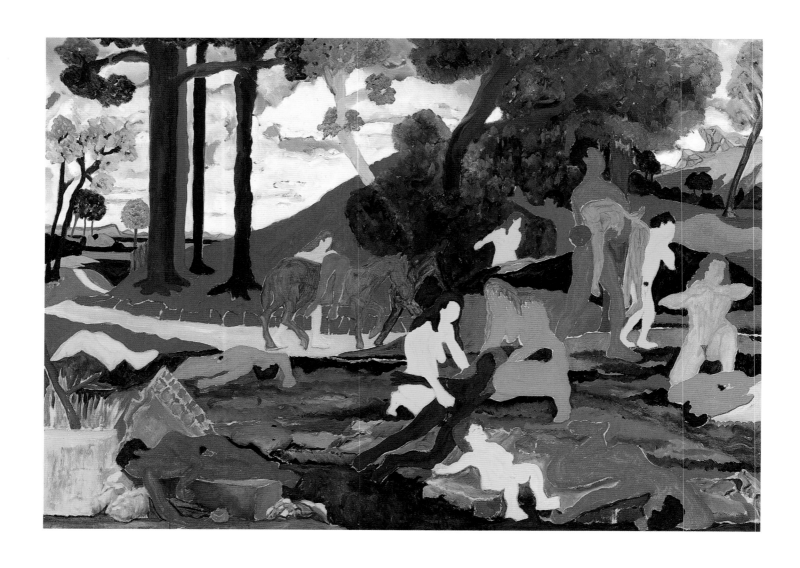

135. ***DEATH OF THE INFANTS OF BETHEL***, 1965
Oil on canvas, 60 x 84 (152.4 x 213.4)
The Art Institute of Chicago; Walter Aitken Endowment

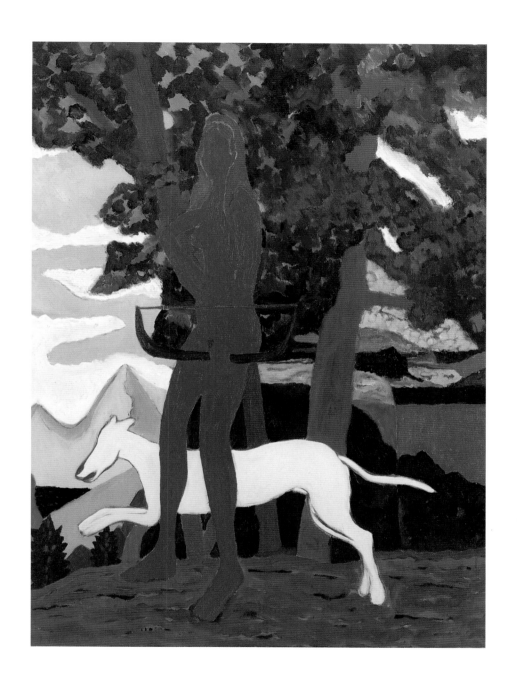

136. *DIANA, THE HUNTRESS*, 1965
Oil on canvas, 48 x 36 (121.9 x 91.4)
Collection of Janice and Mickey Cartin

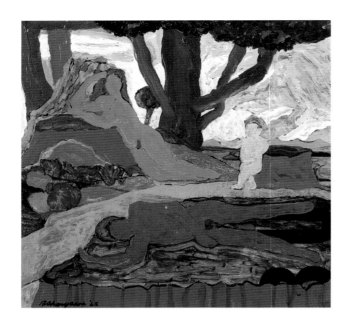

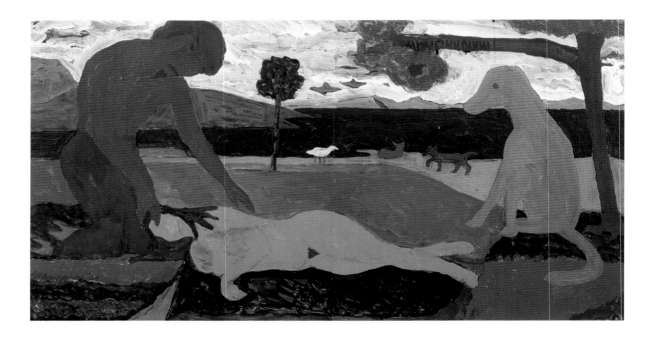

137. *ECHO AND NARCISSUS*, 1965
Acrylic on paper mounted on masonite, 10 1/2 x 11 (26.7 x 27.9)
Collection of Carol Thompson

138. *SATYR AND MAIDEN*, 1965
Oil on paper, 10 x 20 (25.4 x 50.8)
Collection of Carol Thompson

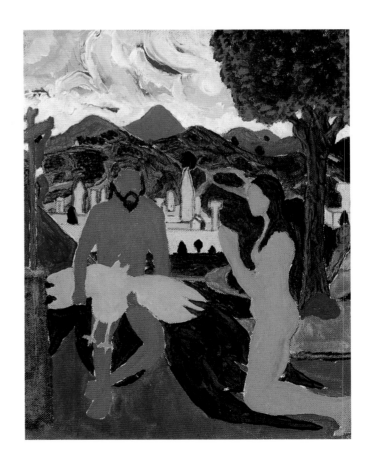

139. *ST. JEROME*, 1965
Oil on wood, 5 x 3 ¹/₄ (12.7 x 8.3)
Collection of Carol Thompson

140. *ST. JEROME AND THE DONOR*, 1964
Oil on canvas, 10 x 8 (25.4 x 20.3)
Private collection

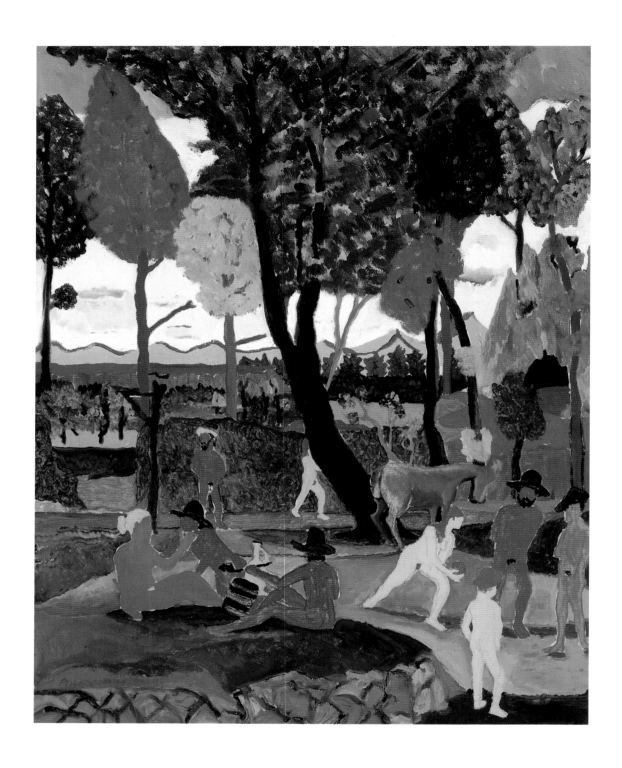

141. *LE JEU*, 1965
Oil on canvas, 30 x 24 (76.2 x 61)
Collection of Maurice Cohen

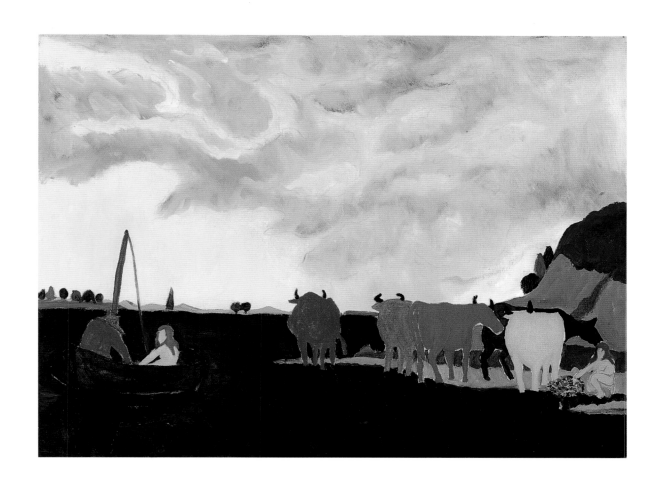

142. *FIVE COWS WITH BLUE NUDE*, 1965
Oil on canvas, 18 x 24 (45.7 x 61)
Collection of Dr. Donald and Marcia Boxman

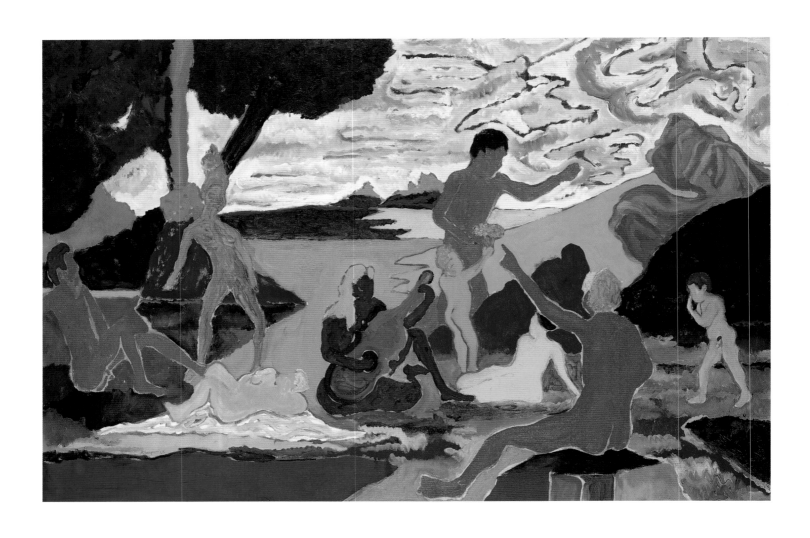

143. *HOMAGE TO NINA SIMONE*, 1965
Oil on canvas, 48 x 72 (121.9 x 183)
Minneapolis Institute of Arts; The John R. Van Derlip Fund

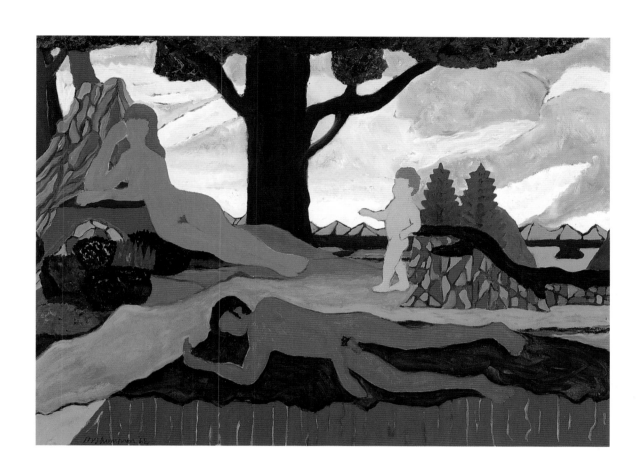

144. *ECHO AND NARCISSUS*, 1965
Oil on canvas, 36 x 48 (91.4 x 121.9)
Collection of Donald and Florence Morris

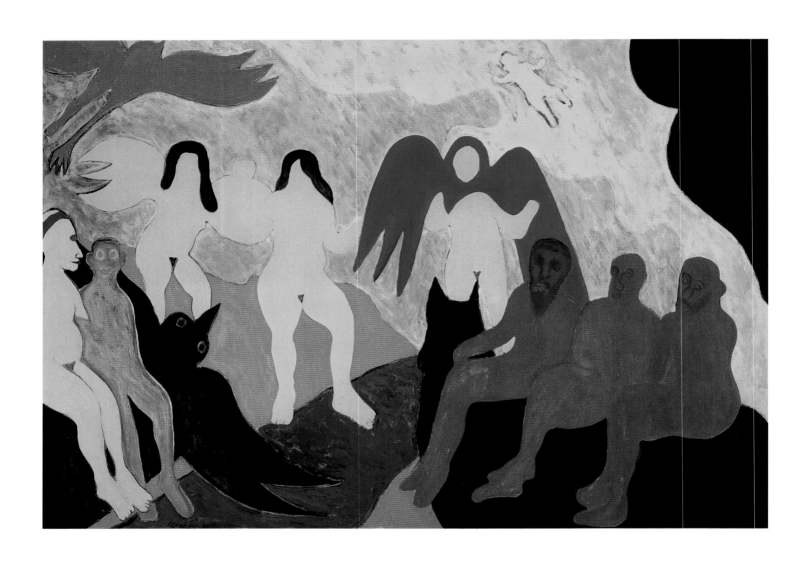

145. *THE JUDGEMENT*, 1963
Oil on canvas, 60 x 84 (152.4 x 213.4)
Brooklyn Museum of Art, New York;
A. Augustus Healy Fund

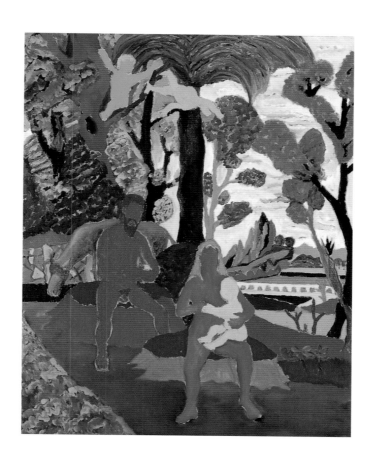

146. *LUNCH ON THE JOURNEY*, 1965
Oil on canvas, 20 x 16 (50.8 x 40.6)
Collection of Maurice Cohen

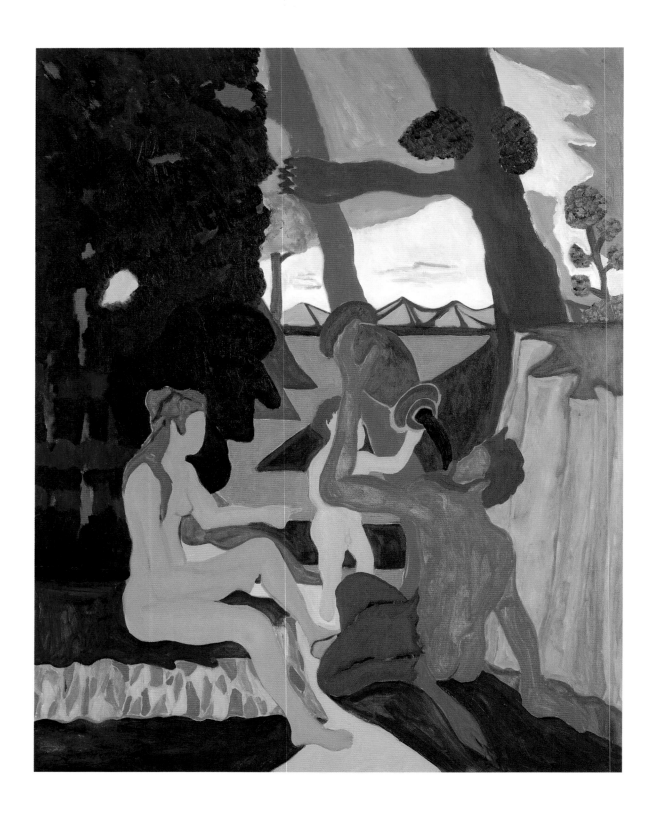

147. *SATYR AND MAIDEN*, 1965
Oil on canvas, 60 x 48 (152.4 x 121.9)
Collection of Richard and Camila Lippe;
courtesy Michael Rosenfeld Gallery, New York

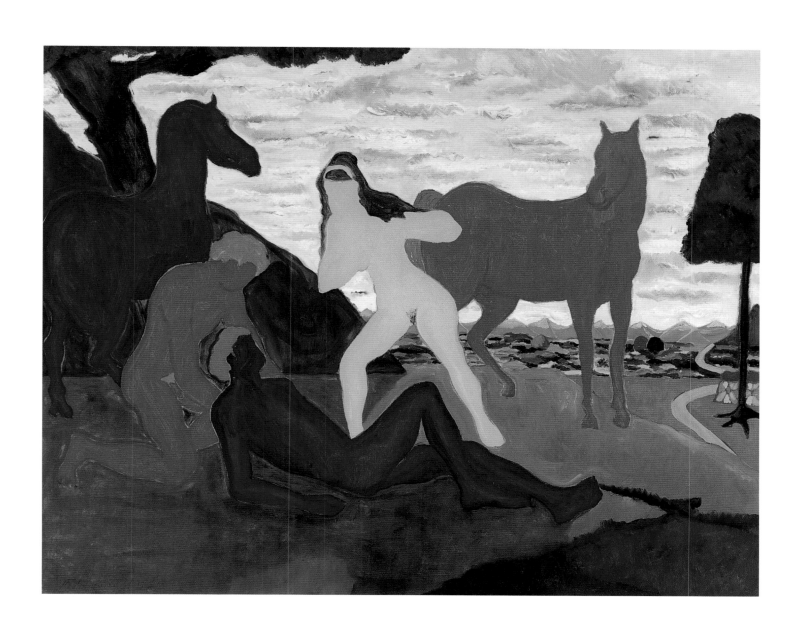

148. *TANCRED AND ERMINIA*, 1965
Oil on canvas, 48 x 60 (121.9 x 152.4)
Collection of Maurice Cohen

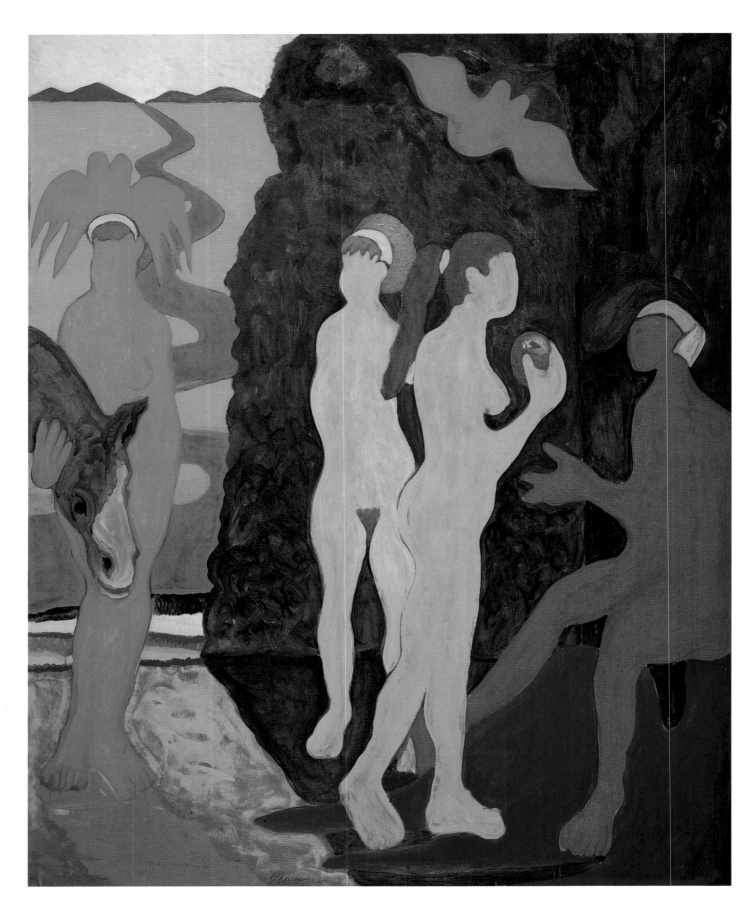

149. *JUDGMENT OF PARIS*, 1964
Oil on canvas, 75 7/16 x 60 11/16 (191.6 x 154.1)
Munson-Williams-Proctor Institute Museum of Art, Utica, New York; Purchase

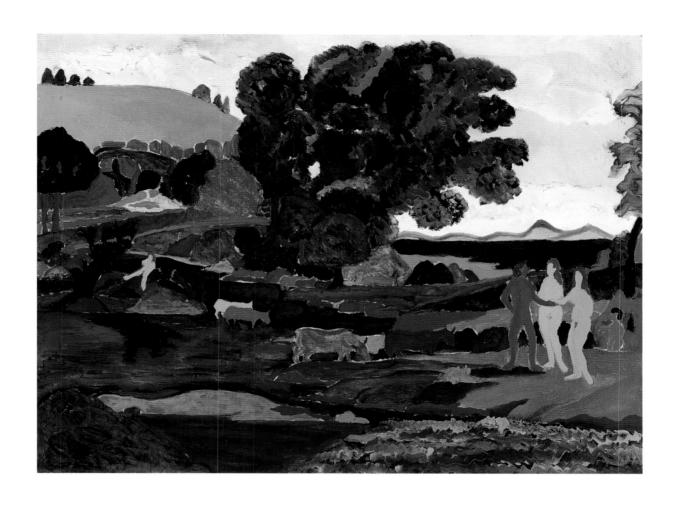

150. *RECREATION OF CEPHALUS AND PROCRIS*, 1965
Oil on canvas, 18 x 24 (45.7 x 61)
Private collection

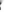

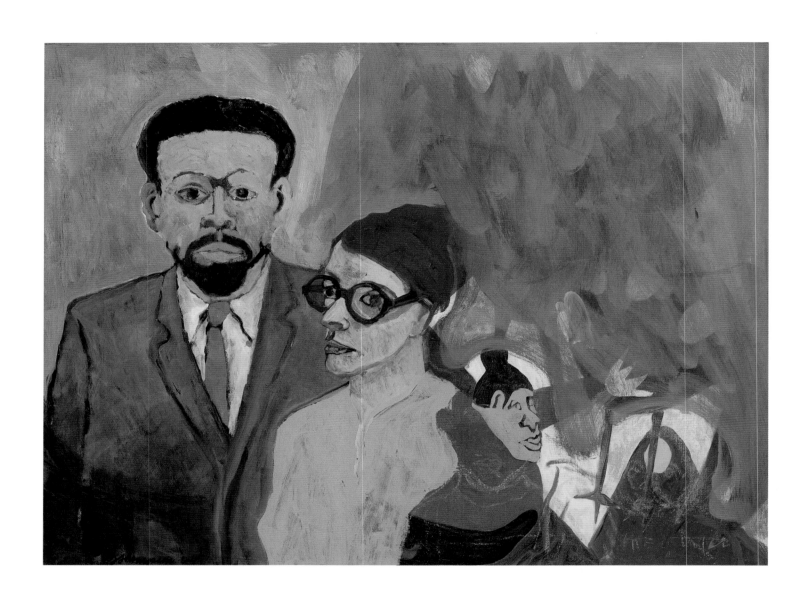

151. *LEROI JONES AND HIS FAMILY*, 1964
Oil on canvas, 36 3/8 x 48 1/2 (92.4 x 123.2)
Hirshhorn Museum and Sculpture Garden, Smithsonian Institution,
Washington, D.C.; Gift of Joseph H. Hirshhorn, 1966

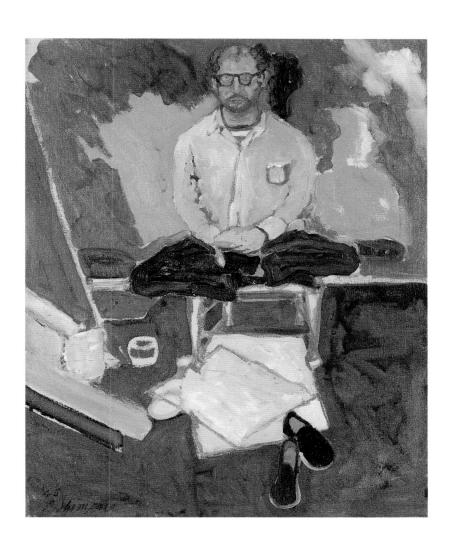

152. *PORTRAIT OF ALLEN*, 1965
Oil on canvas, 20 x 16 (50.8 x 40.6)
Collection of George Nelson Preston

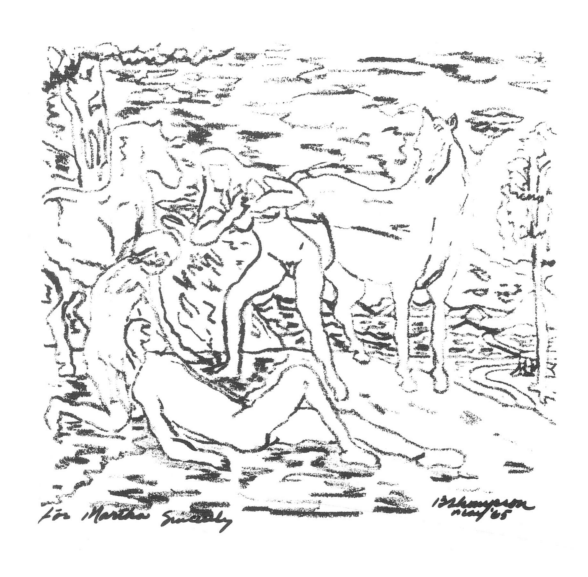

153. *FOR MARTHA, SINCERELY*, 1965
Lithograph, 22 x 23 (55.9 x 58.4)
Anderson Gallery, Buffalo, New York

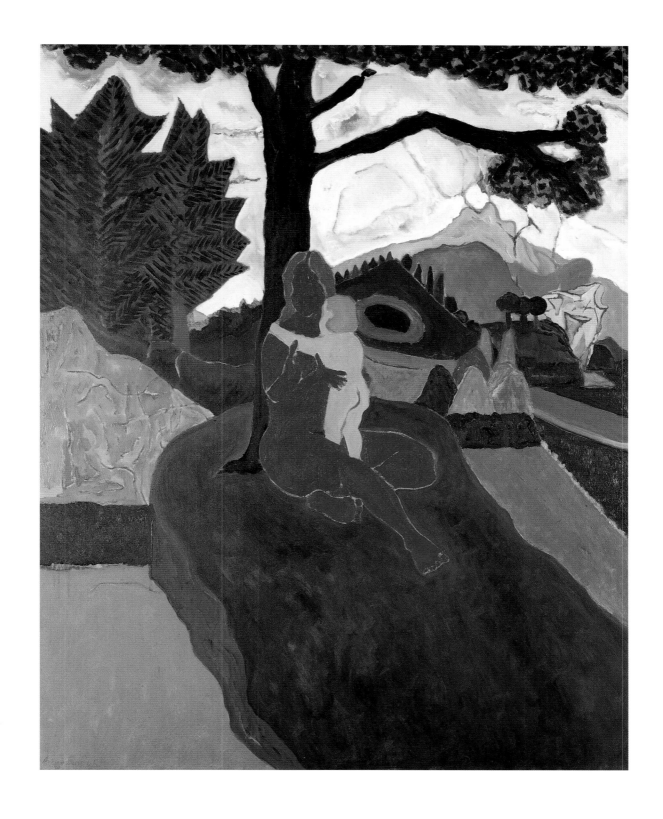

154. *MOTHER AND CHILD*, c. 1965
Oil on canvas, 60 x 48 (152.4 x 121.9)
Collection of Mr. and Mrs. Robert C. Davidson, Jr.;
courtesy Michael Rosenfeld Gallery, New York

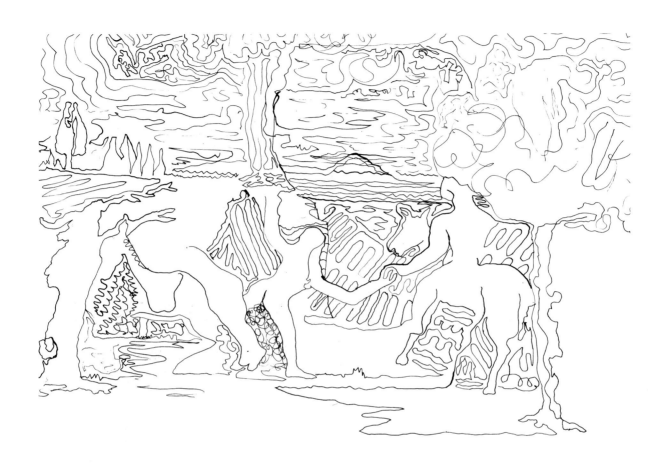

155. *UNTITLED*, 1966
Ink on paper, 13 3/4 x 19 1/4 (34.9 x 48.9)
Vanderwoude Tananbaum Gallery, New York

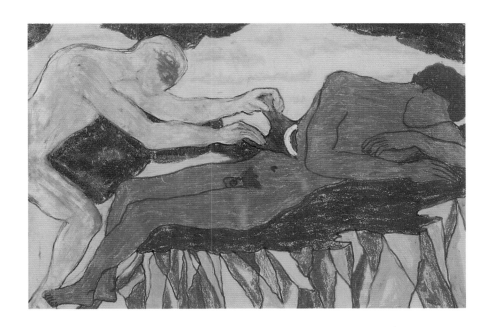

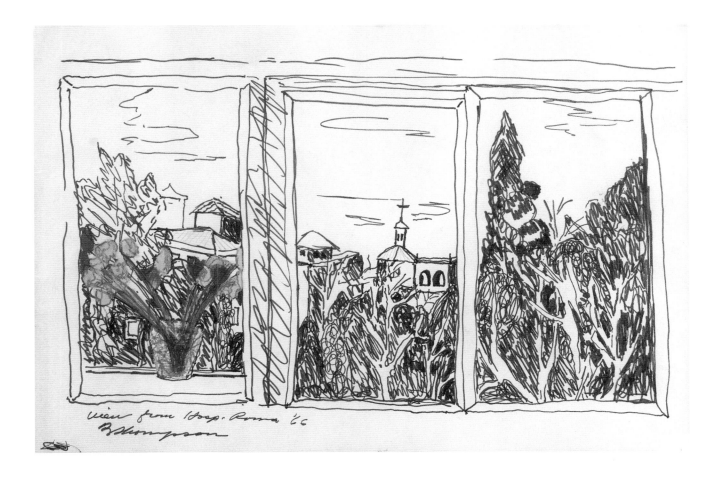

156. *UNTITLED (THE OPERATION)*, 1966
Crayon on paper, 8 1/4 x 12 (21 x 30.5)
Collection of Jim and Danielle Sotet

157. *VIEW FROM HOSPITAL*, 1966
Mixed media on paper, 16 13/16 x 20 11/16 x 1 1/8 (42.7 x 52.5 x 2.9)
Anderson Gallery, Buffalo, New York

171

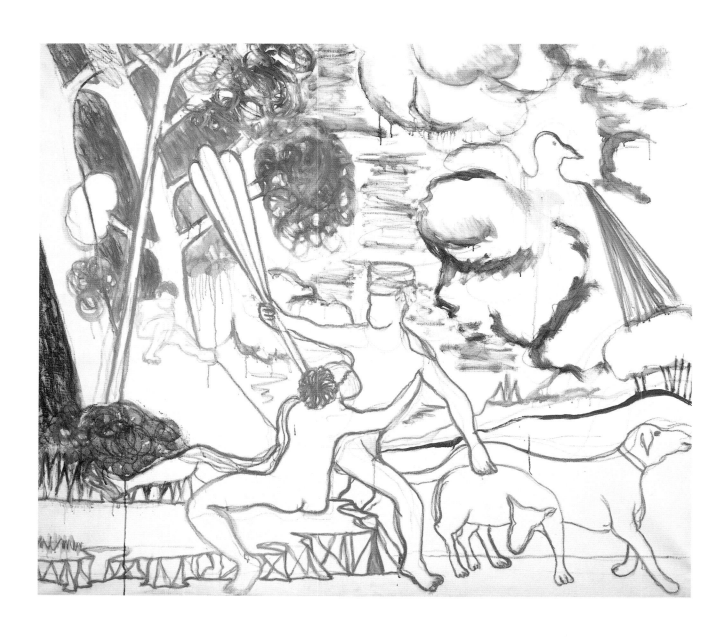

158. *LAST PAINTING*, 1966
Oil on canvas, 55 x 63 (139.7 x 160)
Collection of Carol Thompson

COMMENTARIES

SHAMIM MOMIN

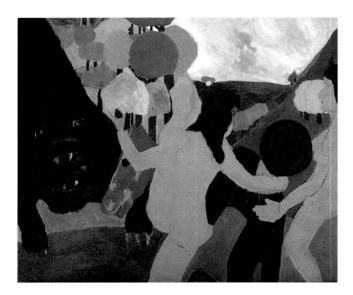

159. **BLACK MONSTER**, 1959 (see Fig. 46)

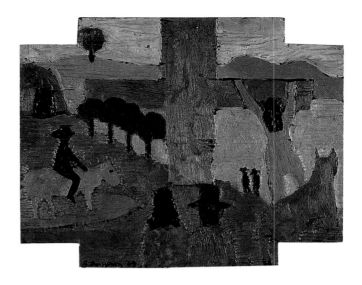

160. **RED CROSS**, 1959 (see Fig. 50)

BLACK MONSTER

In *Black Monster*, Thompson explores the ambiguous narrative style that would become characteristic of his mature work. He used the monsters, who also appear in several other early paintings, to express the violent, aggressive nature of man, and to suggest a linkage between man and beast. Women, in this system, were aligned with nature and a more passive, receptive stance. Thompson here connects the "black monster" on the left to the man in the black hat (also a recurring motif) through color; the two figures are also visually linked by the body of the horse, another "beast." The black-hatted man reaches toward one of the decidedly Caucasian women in a gesture that parallels the grasping paws of the monster. The opposition of the black beast and the "black" man with the pale pink bodies of the white women makes a wry comment on the politics of interracial relationships—on the racial clichés that placed the African-American man in the role of the sexually aggressive, bestial intruder into the white world. The women's ambiguous gestures—possibly embracing rather than pushing away the black-hatted man—put an ironic spin on the trope of the pristine, sexless, virtuous female that still has purchase in American society. This politically charged subcurrent of social commentary, unusual in Thompson's work, indicates the artist's awareness of the civil rights issues that were burgeoning in the 1950s.

RED CROSS

In 1958, Thompson spent a summer in Provincetown, Massachusetts, at the time a thriving artists' community. There he met a group of figurative expressionists who influenced his work, among them Jan Müller and Lester Johnson. Although art historical literature records an intense rivalry between the figurative expressionist and Abstract Expressionist groups in that period, Thompson in fact mixed quite amicably with the abstract artists in Provincetown. In *Red Cross*, the shaped canvas is related to the efforts of some artists in the 1950s to reject what was perceived as the tyranny of the rectangular frame. In these works, the form of the support becomes a related element of the painting itself, as opposed to a neutral frame that serves to distance the image from the space of the viewer. We also see Thompson here beginning to incorporate motifs from Old Master paintings—the composition has distinct echoes of a medieval or Renaissance Calvary setting. This intriguing combination of traditional subject matter and modern style soon became critical to the development of Thompson's work.

BACCHANAL

The choice of subject matter in *Bacchanal*, painted around 1960, illuminates Thompson's governing attitudes toward both the nature of artistic creation and the difficulties of mid-century life. In this early depiction of the scene (he painted two other *Bacchanals* later in the decade), Thompson places the figure of Bacchus, wearing his signature crown of vine leaves, in the center of the composition, possibly in reference to himself. The rites of Bacchus, the Greek god of fertility and wine, included frenzied, wine-induced orgies that, particularly in Renaissance depictions, inverted the humanist virtues of order and reason. Thompson's hedonistic and exuberant lifestyle stood opposed to these virtues, which had become the standard of socially acceptable bourgeois behavior. He believed in living freely and—as evidenced by his severe heroin use—dangerously, in order to transcend the banalities of life. This credo was translated onto canvas with a wild energy. In this early work, that energy is positive; in later paintings, it seems tinged with the darker side of chaos.

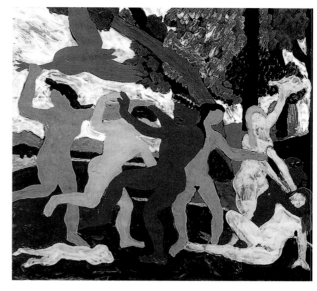

161. *BACCHANAL*, c. 1960 (see Fig. 67)

GARDEN OF MUSIC

Garden of Music is one of Thompson's most important early works. Inspired by the jazz musicians with whom Thompson felt an artistic affinity, the composition depicts such identifiable jazz greats as Ornette Coleman, John Coltrane, Sonny Rollins, Charlie Haden, and Ed Blackwell, all in an abstracted and anonymous setting. This method of combining the particular and the universal, found frequently in the artist's oeuvre, manipulates traditional portraiture by eliminating the suggestion of a specific time or place. By endowing the image with a sense of timelessness, Thompson celebrates music's essential and elemental power and the enduring genius of its creators. The allusion to the Garden of Eden suggests that the musicians play in a "paradise" generated by their music. Thompson thus heroicizes the musicians as primordial innovators. The free, expressionistic use of color and the rhythm of form, here and in many of Thompson's works, were also influenced by the improvisatory approach of jazz artists to traditional musical structure.

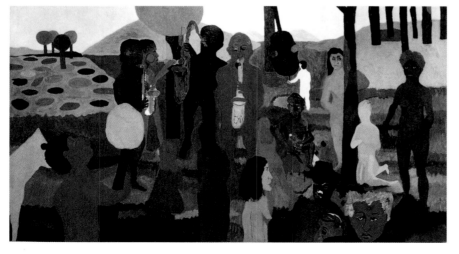

162. *GARDEN OF MUSIC*, 1960 (see Fig. 51)

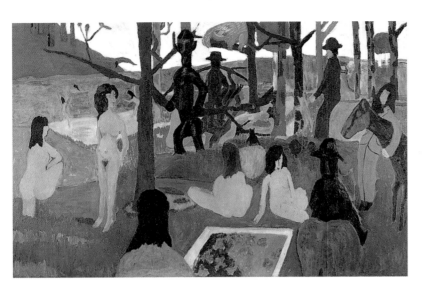

163. *UNTITLED*, 1960 (see Fig. 61)

164. *YELLOW CROUCHING FIGURE*, 1961 (see Fig. 78)

UNTITLED

As Thompson became increasingly interested in developing a new pictorial vocabulary, he experimented with borrowing segments of compositions and, later, whole compositions from canonical European masterworks. In the right foreground of this untitled work, two nude women recline on the grass in direct postural reference to Manet's famous *Déjeuner sur l'herbe*. The association is strengthened by the presence of several clothed, hatted men, who help align Thompson's work with Manet's by creating a similarly ambiguous sequence of events. As in the Manet, Thompson's women and clothed horsemen are situated in an unidentifiable wooded setting and bear no relation to a known narrative or legend. The combination of contemporary elements within the sacred syntax of classical painting marks an important stage in Thompson's maturing style, almost an announcement of his engagement with the art historical past as a means of integrating it into the present.

YELLOW CROUCHING FIGURE

During his short tenure at the University of Louisville and his summer in Provincetown in 1958, Thompson developed relationships with artists and teachers that had a marked influence on him, particularly in the years preceding his first trip to Europe in 1961. In Louisville, Thompson took several life-drawing classes that resulted in a few finished, portrait-style compositions such as *Yellow Crouching Figure*. More important, the experience determined his habit of incessantly drawing the people around him (his sketchbooks are filled with recognizable figures). Thompson seldom made full studies for paintings, but one can see in this work how sketches from life could be translated into abstract, flattened forms.

Thompson's Louisville teachers were well-versed in a range of European traditions. Ulfert Wilke's engagement with Fauvism and German Expressionism, for example, introduced Thompson to a deliberately thick, brushy application of paint, a non-naturalistic palette, and a stylized, often improbable anatomical structure. The flattened space and patterning with color rather than contour in *Yellow Crouching Figure* seem particularly related to European modernist movements. Finally, one can see a debt to painter Gandy Brodie, whom Thompson knew in Provincetown, in the large, contrasting blocks of color that form the background of this work and often appear in other Thompson paintings of the period.

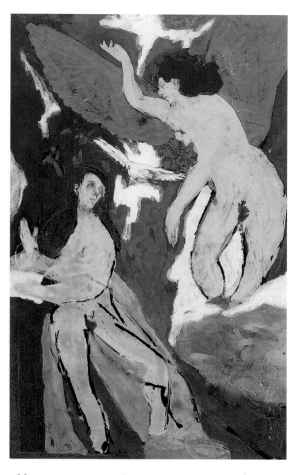

165. EL GRECO (1541–1614)
The Annunciation, 1597–1603
Oil on canvas, 50 3/8 x 33 (128 x 83.8)
Museu de Arte, São Paulo

166. *AFTER EL GRECO'S ANNUNCIATION*, c. 1960 (see Fig. 57)

AFTER EL GRECO'S ANNUNCIATION

Painted directly over a catalogue reproduction of El Greco's *Annunciation*, *After El Greco's Annunciation* illustrates most directly Thompson's interpretive strategy toward the historical sources that inspired so many of his works. He retains the central elements of the event, in which the angel Gabriel announces to the Virgin Mary that she will bear the son of God. The traditional composition represents the moment of mystic conception, evidenced by the dove and the stream of light descending from heaven, which symbolize the Holy Spirit and God the Father, respectively. Thompson also left in iconographic elements such as the lily held by Gabriel as a sign of Mary's purity. However, he painted out the robes of the Virgin and Gabriel, leaving them nude, and colored their genital areas in blotches of red. The Virgin's mantle became a long, loose cascade of red hair, possibly in reference to Mary Magdalen, the penitent prostitute. If this allusion is intentional, Thompson would be conflating the Magdalen with the mother of Christ. He underscores the sexuality of his rendering through rough brushwork and strident color, a drastic inversion of the profane and the sacred. A sensual emphasis frequently appears in Thompson's oeuvre, though it later evolves into a more complex formal language that is carried through the entire composition (as in *Venus and Adonis* of 1964).

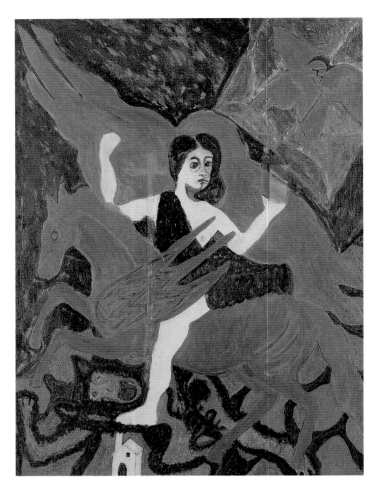

167. *ENCHANTED RIDER*, c. 1962–63 (see Fig. 90)

ENCHANTED RIDER

Enchanted Rider dates from c. 1962–63, when Thompson was in Europe, studying and working. He spent a year in a cold-water studio at Glacière, near the Montparnasse section of Paris, and then moved with his wife, Carol, to the small Spanish island of Ibiza, where this work was most likely painted. The theme of flight, which frequently appears in his work in the form of birds and winged creatures, can be understood to represent freedom. At this particular time in Thompson's life, it alluded to his self-image as the unattached, wandering, modern Individual— one who broke from bourgeois society, from respectability and tradition, in order to find true creativity. In this sense, Thompson also embodies the fundamentally American notion of the rugged, heroic loner, freely following his instincts.

Enchanted Rider, however, clearly expresses an ambiguity in the equation of flight with freedom, for the imagery echoes the myths both of Pegasus and of Icarus. The winged horse Pegasus, who became the loyal mount of the Greek hero Perseus, implies the positive side of freedom. In Thompson's painting, the winged Perseus and his Pegasus flee monsters below, hooves barely clearing the gaping mouths, but clearing them nonetheless. However, the ominous blackness that presses against them from the background, along with the hovering winged man in the top right corner, suggest that the very freedom of flight can be dangerous. The reference here is to the story of Icarus. He and his father, Daedalus, escaped from the island of Crete using wings constructed of feathers and wax. Despite his father's warnings, Icarus flew too close to the sun, which melted the wax wings, causing him to plunge to his death. Thompson's allusions to the Pegasus as well as Icarus myths, therefore, analogize flight to both freedom and death.

BIRD RITUAL

Thompson painted *Bird Ritual* either in Spain or shortly after returning to New York in late 1963. It incorporates many of the themes that dominated his art—birds and flight, ritual, women and sexuality— in a more intimate context than is found in many of his works with a recognizable narrative basis. Thompson later commented that he felt "painting should be...like the theater....I am trying to show what's happening, what's going on...in my own private way"—an attitude literally apparent in the stage-like presentation of the "ritual" and in the ambiguous depiction of a seemingly emotionally charged event. The archway in the shallow background of the canvas is inspired by the indigenous Spanish architecture of Ibiza as well as by the cavelike character of the Thompsons' rented house. The brushy, melting, fields of color within the arch combine with the hovering, holy spirit–cherubim figure to designate a doorway of passage, perhaps of enlightenment, perhaps of death. The actions of the all-female participants recall Thompson's early fascination with hedonistic rites, seen in *Bacchanal*. As is typical of his paintings, the figures are symbolic types—madonnas, clothed like nuns in mantles that reveal only their faces (one of these figures covers her mouth in horror at the proceedings), and sirens, unabashedly nude and actively involved in the ritual.

It is unclear exactly what kind of ritual this is, or what role the women and birds play. Yet their strange activity is endowed with a certain purposefulness and order that highlights the *idea* of ritual. The brooding and even menacing quality of the work, made more threatening by its narrative opacity, may have been influenced by Thompson's exposure to the late work of Francisco Goya, which he saw in Spain. In particular, one can find echoes of Goya's Black Paintings—images of nearly impenetrable darkness that reflect Goya's obsession with the forces of unreason and madness.

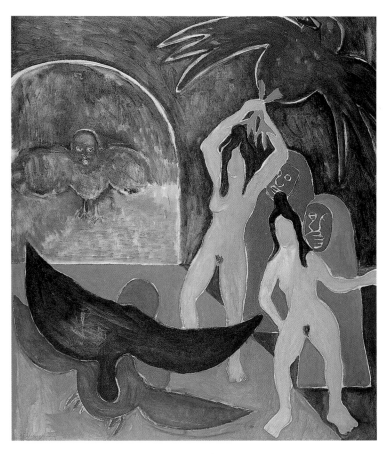

168. ***BIRD RITUAL***, 1963 (see Fig. 88)

169. PIERO DELLA FRANCESCA (C. 1420–1492)
Discovery of the Wood of the True Cross and *Meeting of Solomon and the Queen of Sheba*, from the *Legend of the True Cross*, c. 1452–57
Fresco, 132 5/16 x 294 (336.1 x 746.8)
San Francesco, Arezzo

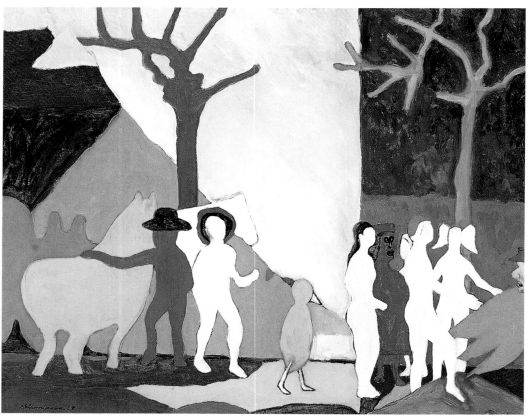

170. *QUEEN OF SHEBA'S VISIT TO KING SOLOMON*, 1963 (see Fig. 95)

QUEEN OF SHEBA'S VISIT TO
KING SOLOMON

Based on a scene in Piero della Francesca's fifteenth-century fresco cycle of the *Legend of the True Cross* in San Francesco, Arezzo, Thompson's *Queen of Sheba's Visit to King Solomon* focuses not on the actual meeting of the two rulers, but on a moment in the cycle directly preceding it. In medieval legend and in the left half of Piero's fresco, the queen kneels down to worship a plank of wood that was serving as a bridge, knowing from a vision that it would later make up the cross on which Jesus is crucified. Typically, Thompson eliminates many of the landscape details and architectural elements, abstracting the background to large geometric color sections. He retains Piero's two hatted men, presumably grooms, with their horses, who help draw the eye from the sloping mountain at left down to the right, where the main event takes place. Thompson does not depict the queen kneeling to worship the wood, but rather stepping directly into the stream, as if to forge it herself. From the other bank, a wing reaches over to lead her across the water. The wing belongs to the blue-faced man (King Solomon, one presumes), whose profile barely emerges from the edge of the canvas. By deflecting focus from the formal meeting of the two royal personages (depicted in the right half of Piero's fresco), Thompson transforms the moment into a mysterious encounter, one which the viewer understands will take place off the picture plane. Facing a story lacking in closure and clear visual clues, we are left to wonder about the nature of the curious procession and meeting.

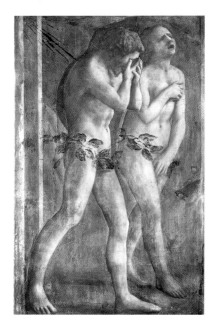

171. MASACCIO (C. 1401–1428)
Expulsion from the Garden of Eden, c. 1427
Fresco, 82 x 34 9/16 (208.3 x 87.8)
Santa Maria del Carmine, Florence

172. PIERO DELLA FRANCESCA
Nativity, c. 1480
On panel, 49 x 48 1/2 (124.5 x 123.2)
National Gallery, London

173. *EXPULSION AND NATIVITY*, 1964 (see Fig. 115)

EXPULSION AND NATIVITY

In *Expulsion and Nativity*, Thompson combines two biblical events, one from Genesis, the other from the New Testament, by reinterpreting two famous fifteenth-century paintings: Masaccio's *Expulsion from the Garden of Eden* and Piero della Francesca's *Nativity*. The left section of the Thompson work abstracts the figures of Adam and Eve as they forcibly leave Eden. Their punishment, the curse of lust and, for women, the labor of childbirth, is apposed by the birth of Jesus on the right side of the painting. The contrast expresses a fundamental Christian typology: the incarnation of Christ redeems humankind from the stain of Original Sin—the first Adam is superseded by the Second Adam (Christ), and the First Eve by the Second Eve (Mary). Although this reading of the two scenes is standard, Thompson's frequent exploration of sexuality and the role of women encourages another, more contemporary interpretation. Thompson transforms the stable in Piero's painting into the black, shadowy silhouette of a huge bird, its looming darkness suggesting Thompson's own conflicting use of bird imagery. The orange figure, distinct from the others in color, stands directly behind the kneeling figure of Mary (rather than off to her side, as in Piero's version) and reaches an arm up toward the bird. The gesture compositionally links the bird to Mary and then to Christ, who are grouped together by their similar coloring. Is Thompson interjecting a negative comment on the redemptive nature of the Nativity? The question cannot be answered definitively, but the artist is certainly asking us to reconsider the traditional resolution of Original Sin in the Christian scheme of redemption.

174. ***TRIUMPH OF BACCHUS***, 1964 (see Fig. 131)

TRIUMPH OF BACCHUS

The story of the triumph of Bacchus, a pagan theme that Thompson adopted for this image, was often depicted in the Renaissance (Thompson had earlier explored other aspects of the Bacchus story, as in the c. 1960 *Bacchanal*.) The imagery is based on Roman triumphal military processions, which fifteenth-century Italian painters revived in order to glorify the gods of antiquity. The influence of the Renaissance masters Thompson saw in Paris is evident here in the superb clarity and harmony of design as well as in composition—the placement of Bacchus seated in the center may have been inspired by Renaissance and Baroque renditions of the event. The rhythm of color, in particular, illustrates the achievement of Thompson's late

work, as the yellow, blue, and red figures trace out an interlocking pattern of energetic, almost circular dynamism that marks the movement of the procession along the wooded path. As usual, Thompson eradicates the sense of distance and compositional "breathing space" characteristic of classic art, pushing compressed space up to the picture plane. The flattened forms and linear rhythms create an abstracted, dreamlike atmosphere that also contributes to the narrative force: by making place and time indistinct, this atmosphere endows the scene with the character of allegory.

DESCENT FROM THE CROSS

Investigations of the complex nature of sexuality
and love figure prominently in Thompson's work.
Although many compositional elements are lifted
from earlier art—including Madonnas, nymphs,
harpies, and hags—Thompson adds his own percep-
tion of the relationship between physicality and emo-
tion, and of the role of women in his life. After the
early death of his father, his family was dominated by
strong women, particularly his mother, whose middle-
class aspirations for her son continued to plague him
despite his determination to follow an independent
creative path. In amorous relationships with women,
Thompson spoke of feeling a disconnection between
the emotional and the physical aspects of love. In his
work, women have either a passive but provocative
nature, as in *Black Monster*, 1959, or a powerful,
overwhelming presence, as in this 1963 painting.

In the depiction of the *Descent from the Cross*,
the event immediately following Christ's crucifixion,
Thompson eliminates Joseph of Arimathea (who
took down the body of Christ) as well as other male
characters, and concentrates on the women. The
tiny, upside-down winged body of Christ is held by
a haglike yellow woman, and by Mary Magdalen,
whose naked body is painted a passionate red that
implies a secular association with love and sex. The
elderly Madonna, identified by her blue robe, leans
her large, almost monumental body toward her son,
helpless as a toy and entirely subject to all three
women, who read as types rather than as individuals.
Though the presence of female mourners is related
to iconographic tradition, in Thompson's image the
women's relationship to the male figure (Christ?
Thompson?) seems highly personal and conflicted.

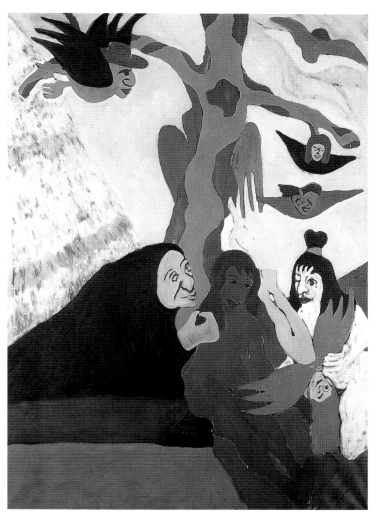

175. ***DESCENT FROM THE CROSS***, 1963 (see Fig. 93)

176. NICOLAS POUSSIN (c. 1594–1665)
Venus and Adonis, c. 1628-29
Oil on canvas, 38 3/4 x 53 (98.4 x 134.6)
Kimbell Art Museum, Fort Worth, Texas

VENUS AND ADONIS

In the 1964 *Venus and Adonis* Thompson adopts a painting by the seventeenth-century French master Nicolas Poussin. Several times in his career, Poussin turned to the theme of the mythological lovers. Here, however, rather than depict the more typical moment of Venus attempting to restrain Adonis from leaving for the hunt (where she knows he will die), or cradling the body of the dying Adonis, Poussin translated a passage from Ovid into a poetic scene of the two lovers reclining languorously during a passionate interlude from the hunt. The work emphasizes, as does Thompson, the harmonious rapport between the lovers and their pastoral setting. In Thompson's version, the quiet, simplified rhythms suggest a calmer, less troubled, understanding of emotional involvement than is seen in earlier works such as *Descent from the Cross*. The progression of linked forms across the canvas is grounded on the right by the blue bird-creature who cradles Venus' feet with its wings; the sequence continues through the joined figures of Venus reclining in Adonis' lap and on through to the bird whose feet Adonis holds in the air—a ceaseless movement of forms that unites the physical, the emotional, and the natural worlds.

177. **VENUS AND ADONIS**, 1964 (see Fig. 133)

178. *UNTITLED (THE OPERATION)*, 1966 (see Fig. 156)

UNTITLED (THE OPERATION)

In Rome in 1966, Thompson, in a state of severe physical deterioration, entered the hospital for a gall bladder operation. After the surgery, friends brought him crayons and paper, and he created this small work, *Untitled (The Operation)*, clearly appropriated from *Creation of Eve* imagery, in which God takes a rib from Adam's side to create woman. As a visual analogy, one can read Adam's "operation" as Thompson's gall bladder surgery. In a metaphorical sense, the transformation of Adam's rib into something that filled a companionless void may allude to Thompson's perception of his creative efforts.

After the surgery, and against the doctor's advice, Thompson quickly returned to his frenetically paced life, as if he were racing against the clock. Adam's rib may here signify Thompson's creative work; "removing" it from his deteriorating body would ensure that his life's effort would endure beyond his own mortality.

179. *UNTITLED (STUDY OF FIGURES AND ANIMALS IN LANDSCAPE)*, 1960
Ink on paper, 19 1/2 x 25 5/16 (49.5 x 64.3)
Whitney Museum of American Art, New York; Purchase, with funds from the
Thomas Fountain Purchase Fund and the Drawing Committee 93.105

ONE-ARTIST EXHIBITIONS

1959
Arts in Louisville Gallery, Kentucky, "Paintings and Drawings"

1960
Delancey Street Museum, New York, "Paintings and Sculpture"

1961
Superior Street Gallery, Chicago, "Recent Paintings"

1963
Martha Jackson Gallery, New York

1964
Richard Gray Gallery, Chicago, "Paintings and Drawings"

Paula Johnson [Cooper] Gallery, New York, "Gouaches"

1965
Richard Gray Gallery, Chicago, "New Paintings"

Martha Jackson Gallery, New York, "New Paintings"

Donald Morris Gallery, Detroit, "Paintings"

1968
Martha Jackson Gallery, New York, "Important Works in New York Collections, 1960–1966"

1969
New School Art Center, Wollman Hall, New School for Social Research, New York

1970
Donald Morris Gallery, Detroit, "Paintings 1959–1966"

1971
J.B. Speed Art Museum, Louisville, Kentucky, "Bob Thompson 1937–1966: Memorial Exhibit"

1974
University Gallery, Herter Hall, University of Massachusetts at Amherst

1975
Martha Jackson Gallery, New York, "Drawings"

National Collection of Fine Arts, Smithsonian Institution, Washington, D.C.

1976
Sheraton Hotel, Urban League National Convention

Martha Jackson Gallery, New York, "Bob Thompson 1937–66: A Tribute"

1978
The Studio Museum in Harlem, New York, "The World of Bob Thompson"

1983
Vanderwoude Tananbaum Gallery, New York, "Bob Thompson 1937–1966: Major Works of the 60's"

1986
Vanderwoude Tananbaum Gallery, New York

Wadsworth Atheneum, Hartford, Connecticut, "MATRIX 90"

1987
Jamaica Arts Center, Jamaica, New York

1988
Vanderwoude Tananbaum Gallery, New York

1990
Vanderwoude Tananbaum Gallery, New York

1991
Vanderwoude Tananbaum Gallery, New York, "Bob Thompson: Major Paintings of the 1960s"

1997
Michael Rosenfeld Gallery, New York, "Bob Thompson: Heroes, Martyrs & Spectres"

GROUP EXHIBITIONS

1958
City Gallery, New York, "Drawings"

J.B. Speed Art Museum, Louisville, Kentucky, "1958 Louisville Art Center Annual"

Provincetown Art Association, Massachusetts, "First 1958 Show"

Provincetown Art Association, Massachusetts, "Second 1958 Show"

Provincetown Arts Festival, Massachusetts, "American Art of Our Time"

1960
The American Federation of Arts, New York, "The Figure in Contemporary American Painting"

The Mint Museum of Art, Charlotte, North Carolina, "The Horace Richter Collection: Contemporary American Painting and Sculpture"

Zabriskie Gallery, New York, "Jay Milder and Bob Thompson"

1963
Cranbrook Academy of Art, Bloomfield Hills, Michigan, "Moods of Light"

1964
Antiquities, New York, "Cruz, Cox, Overstreet, Thompson, White, Whitten: Paintings"

Art Gallery, Fairleigh Dickinson University, Florham-Madison Campus, New Jersey, "...Some Negro Artists"

City Gallery, New York, "Exhibition of Paintings: Peter Passuntino/Bob Thompson"

The Dayton Art Institute, "International Selection 1964–1965"

The University of Arizona Art Gallery, Tucson, "The Bird in Art"

1965
J.B. Speed Art Museum, Louisville, Kentucky, "A Survey of Contemporary Art"

Provincetown Art Association, Massachusetts, "Second 1965 Show"

Temple Emanu-el, New York, "Sixth Annual Festival"

1966
The Brooklyn Center, Long Island University, "Forty-three Artists from Eighteen Nations"

Champlain Gallery, Harpur College, State University of New York, Binghamton, "New Figuration"

The Jewish Museum, New York, "The Harry N. Abrams Family Collection"

UCLA Art Galleries, Dickson Art Center, University of California, Los Angeles, "The Negro in American Art"

1967
St. Mark's Gallery, New York, "Friends of Bob Thompson Present a Group Memorial Exhibit"

1968
New School for Social Research, New York, "The Humanist Tradition in Contemporary American Painting"

The Star Turtle Gallery, New York, "The Tenants of Sam Wapnowitz"

1969
Sixth Floor Art Gallery, Brooklyn College Student Center, "Afro-American Artists: Since 1950: An Exhibition of Paintings, Sculpture and Drawings"

1970
La Jolla Museum of Art, California, "Dimensions of Black"

The Museum of the National Center of Afro-American Artists, The Museum of Fine Arts, The School of the Museum of Fine Arts, Boston, "Afro-American Artists: New York and Boston"

1971
Acts of Art Gallery, New York, "Rebuttal to Whitney Museum Exhibition"

Art Lending Service, The Museum of Modern Art, New York, "Untitled I"

Musée Rath, Geneva, "8 artistes afro-américains"

1972
Martha Jackson Gallery, New York, "Concept & Content: Cage, Thompson, Tàpies"

1977
Everson Museum of Art, Syracuse, New York, "Provincetown Painters: 1890's–1970's"

Indianapolis Museum of Art, Indiana, "Perceptions of the Spirit in Twentieth-Century American Art"

1980
Chrysler Museum, Norfolk, Virginia, "American Figurative Painting 1950–1980"

1981
Provincetown Art Association and Museum, Massachusetts, "The Sun Gallery"

1984
The Institute for Art and Urban Resources (P.S. 1), Long Island City, New York, "Underknown: Twelve Artists Re-Seen in 1984"

The Metropolitan Museum of Art, New York, and The American Federation of Arts, "The Figure in 20th Century American Art: Selections from The Metropolitan Museum of Art"

1985
National Museum of American Art, Smithsonian Institution, Washington, D.C., "The Martha Jackson Memorial Collection"

Provincetown Art Association and Museum, Massachusetts, "Expressionism: An American Beginning"

South Campus Art Gallery, Miami-Dade Community College, Florida, "Sam Gilliam & Bob Thompson"

1986
Kenkeleba Gallery, New York, "Fetishes, Figures & Fantasies"

Provincetown Art Association and Museum, Massachusetts, "Kind of Blue: Benny Andrews, Emilio Cruz, Earle Pilgrim, Bob Thompson"

1987
California Afro-American Museum, Los Angeles, "The Banks Family Collection"

Luise Ross Gallery, New York, "Image to Abstraction—The 50's"

1988
The Arkansas Arts Center, Little Rock, "Works by Artists Who Are Black"

Newport Harbor Art Museum, Newport Beach, California, "The Figurative Fifties"

1989
Philippe Briet Gallery, New York, "Don't You Know By Now"

University Art Museum, University of California, Santa Barbara, "Ruth S. Schaffner Collection"

Vanderwoude Tananbaum Gallery, New York, "Figurative Work of the Fifties and Sixties"

1990
California Afro-American Museum, Los Angeles, "Novae: William H. Johnson and Bob Thompson"

1991
Sacks Fine Art Inc., New York, "African American Artists of the Harlem Renaissance Period and Later..."

1992
The Artists' Museum, New York, "Color as a Subject"

Bomani Gallery, San Francisco, "Paris Connections"

1998
Michael Rosenfeld Gallery, New York, "African-American Art: 20th Century Masterworks, IV"

"Academic Strait Jacket: Disdainful Thompson." *Gazette of the Arts in Louisville*, February 9, 1959, p. 1.

Adrian, Dennis. "New York." *Artforum*, 4 (December 1965), p. 54.

A[nderson], L[aurie]. "Reviews and Previews: Bob Thompson." *Art News*, 70 (February 1972), p. 20B.

"Art in New York: Galleries." *Time*, October 1, 1965, p. NY1.

"Art Notes: Bob Thompson Exhibition." *The Louisville Courier-Journal & Times*, September 22, 1974, p. H16.

Ashbery, John. "Golden Oldies." *New York*, 11 (December 11, 1978), pp. 102, 105.

Banks, Marissa, Lorraine Glennon, and Jeffrey Schaire. "The 25 Most Undervalued American Artists: An *Art & Antiques* Survey of Tomorrow's Blue-Chip Art." *Art & Antiques* (October 1986), pp. 78–79.

B[arnitz], J[acqueline]. "Reviews: In the Galleries." *Arts Magazine*, 40 (November 1965), p. 64.

Barrell, Bill, et al. "Bob Thompson: His Life and Friendships." In Leo Hamalian and Judith Wilson, eds. *Artist and Influence 1985*. New York: Hatch-Billops Collection, 1985, pp. 107–42.

Bearden, Romare. "*American Negro Art* by Cedric Dover." *Leonardo*, 3 (April 1970), p. 243.

B[eck], J[ames] H. "Reviews and Previews: New Names This Month: Bob Thompson, Peter Passuntino." *Art News*, 59 (November 1960), p. 19.

Beskind, Dorothy. *Bob Thompson, Happening!* (16mm color film). 25 minutes, 1965.

Betz, Margaret. "New York Reviews." *Art News*, 78 (January 1979), p. 143.

Beveridge, Meryle. "Faithful To His Own Strange Notions." *New York Post*, December 29, 1975.

The Bird in Art (exhibition catalogue). Tucson: The University of Arizona Art Gallery, 1964.

Bob Thompson (1937-1966) (exhibition catalogue). New York: New School Art Center, Wollman Hall, New School for Social Research, 1969. Foreword by Paul Mocsanyi, statements by Meyer Schapiro and Ulfert Wilke.

Bob Thompson 1937–1966: Memorial Exhibit (exhibition catalogue). Louisville, Kentucky: J.B. Speed Art Museum, 1971. Statements by Meyer Schapiro, Margaret Bridwell, Dario Covi, et al.

["Bob Thompson, 29 [sic], Dies; Artist] Succumbs in Rome" (obituary). *The New York Times*, June 8, 1966, p. 47.

Bowling, Frank. "Discussion on Black Art." *Arts Magazine*, 43 (April 1969), pp. 16–20.

Brenson, Michael. "Art: 12 Artists Shown in 'Underknown,' at P.S. 1." *The New York Times*, October 26, 1984, p. C26.

_____. "Black Artists: A Place in the Sun." *The New York Times*, March 12, 1989, sec. 2, pp. 1, 36.

_____. "Review/Art." *The New York Times*, April 8, 1988, p. C32.

B[urckhardt], E[dith] B. "Reviews and Previews: Jay Milder and Bob Thompson." *Art News*, 59 (Summer 1960), p. 18.

B[urton], S[cott]. "Reviews and Previews: Bob Thompson." *Art News*, 67 (April 1968), p. 58.

Butterfield, Debbie. "Contemporary Black Art." In Jehanne Teilhet, ed. *Dimensions of Black* (exhibition catalogue). La Jolla, California: La Jolla Museum of Art, 1970.

C[ampbell], L[awrence]. "Reviews and Previews." *Art News*, 62 (December 1963), p. 50.

_____. "Reviews and Previews: New Names This Month." *Art News*, 58 (February 1960), p. 19.

_____. "Reviews and Previews: 'No Hard-Edges Here.'" *Art News*, 64 (May 1965), p. 14.

C[anaday], J[ohn]. "This Week Around the Galleries." *The New York Times*, December 8, 1963, sec. 2, p. 22.

Childs, Charles. "The Artist: Caught Between Two Worlds." *Tuesday Magazine* [supplement], 2 (April 1967), pp. 9–10.

Coker, Gylbert. "Bob Thompson: Honeysuckle Rose to Scrapple from the Apple." *Black American Literature Forum*, 19 (Spring 1985), pp. 18–21.

Comerford, Ellen S. "Castellani Museum Opens with Stunning 'Novae.'" *Niagara Gazette*, October 5, 1990, p. 3.

Cotter, Holland. "Heroes, Martyrs and Spectres." *The New York Times*, October 17, 1997, p. x.

_____. "Two Painters/Two Decades: Jan Müller and Bob Thompson." *The New York Times*, May 28, 1993, p. C16.

Crouch, Stanley. "Meteor in a Black Hat: The Life and Death of Painter Bob Thompson." *The Village Voice*, December 2, 1986, pp. 23–29, 60.

Cruz, Emilio. "Reflections on a Bob Thompson Painting in a Catalogue." In *Fetishes, Figures & Fantasies* (exhibition catalogue). New York: Kenkeleba Gallery, 1986, n.p.

Dillenberger, Jane, and John Dillenberger. *Perceptions of the Spirit in Twentieth-Century American Art* (exhibition catalogue). Indianapolis, Indiana: Indianapolis Museum of Art, 1977.

The Figurative Fifties: New York Figurative Expressionism (exhibition catalogue). Newport Beach, California: Newport Harbor Art Museum, 1988. Catalogue entry on Bob Thompson by Judith Wilson.

Fine, Elisa Honig. *The Afro-American Artist: A Search for Identity*. New York: Hacker Art Books, 1982.

Forgey, Benjamin. "An Artist Too Early Lost." *The Washington Star*, December 26, 1975, pp. B1–2.

F[riedlander], A[lberta] R. "2 Young Artists Impressive." *Chicago Tribune*, c. February 3–March 1, 1961.

Gaugh, Harry F. "Oakleigh Collection." *Arts Magazine*, 51 (January 1977), p. 17.

Geldzahler, Henry. *Underknown: Twelve Artists Re-Seen in 1984* (exhibition catalogue). Long Island City, New York: The Institute for Art and Urban Resources (P.S. 1), 1984.

Ghent, Henri. "Arts: Bob Thompson, Twice." *Amherst Free Valley Advocate*, October 2, 1974, pp. 15–16.

_____. *8 artistes afro-américains* (exhibition catalogue). Geneva: Musée Rath, 1971.

Giuliano, Charles. "Kind of Blue." *Provincetown Arts* (Fall 1986), pp. 8, 38, 40.

G[iuliano], C[harles]. "Reviews: In the Galleries." *Arts Magazine*, 42 (March 1968), p. 57.

Giuliano, Charles. "There Ain't Never Enough." *Avatar* [1968], n.p.

Glueck, Grace. "Exhibition in Geneva to Include Late Louisvillian's Work." *The Louisville Courier-Journal & Times*, April 18, 1971, sec. F, p. 13.

"Goings On About Town." *The New Yorker*, February 5, 1990, p. 16.

Grosvenor, Verta Mae. *Vibration Cooking, or The Travel Notes of a Geechee Girl*. Garden City, New Jersey: Doubleday & Co., 1970.

Hakanson, Joy. "One Artist Who Defies Fads." *The Detroit Sunday News*, December 6, 1970, p. E6.

H[arrison], J[ane]. "New York Exhibitions: In the Galleries: Bob Thompson." *Arts Magazine*, 38 (February 1964), pp. 24–25.

The Harry N. Abrams Family Collection (exhibition catalogue). New York: The Jewish Museum, 1966.

H[eartney], E[leanor]. "Underknown." *Art News*, 84 (January 1985), pp. 149, 139.

Heilenman, Diane. "Black Artists: Those Who Are Emerging, Acclaimed Painter Saluted." *The Louisville Courier-Journal & Times*, January 11, 1987, pp. I1, I10, I11.

H[enry], G[errit]. "New York Reviews." *Art News*, 82 (April 1983), pp. 161, 164.

The Horace Richter Collection: Contemporary American Painting and Sculpture (exhibition catalogue). Charlotte, North Carolina: The Mint Museum of Art, 1960. Foreword by Horace Richter, essay by Meyer Schapiro.

Huntington, Richard. "Review: Art: Bold Strokes." *The Buffalo News*, October 12, 1990, *Gusto* section, pp. 1, 31.

Igoe, Lynn Moody, with James Igoe. *250 Years of Afro-American Art: An Annotated Bibliography*. New York and London: R.R. Bowker, 1981.

Jay Milder: Urban Visionary, Retrospective 1958–1991 (exhibition catalogue). Brooklyn, Connecticut: New England Center for Contemporary Art, 1991. Essays by Peter Selz and Judith Stein.

J[ohnson], J[ill]. "Reviews and Previews." *Art News*, 62 (January 1964), p. 15.

_____. "Reviews and Previews: Bob Thompson." *Art News*, 61 (September 1962), p. 11.

J[udd], D[onald]. "In the Galleries: Bob Thompson, Peter Passuntino." *Arts*, 35 (December 1960), p. 58.

Kirby, Michael. *Happenings: An Illustrated Anthology*. New York: E.P. Dutton, 1965.

Lansdell, Sarah. "Art Notes: Thompson at Smithsonian." *The Louisville Courier-Journal & Times*, January 4, 1976, p. H12.

_____. "Bob Thompson's Edens." *The Louisville Courier-Journal & Times Magazine*, February 21, 1971, pp. 22–25, 27, 29–30.

_____. "Bob Thompson: Vivid Idylls from the Classics." *The Louisville Courier-Journal & Times,* January 31, 1971, p. F14.

Larson, Kay. "Worthy Victims." *New York,* November 19, 1984, p. 58.

Lerner, Abram, ed. *The Hirshhorn Museum and Sculpture Garden, Smithsonian Institution.* New York: Harry N. Abrams, 1974.

Lewis, Samella. *Art: African American.* New York: Harcourt Brace Jovanovich, 1978.

Lippard, Lucy. "New York Letter." *Art International,* 9 (November 20, 1965), p. 42.

Lorber, Richard. "Arts Reviews: Bob Thompson." *Arts Magazine,* 50 (May 1976), p. 22.

McDarrah, Fred W. *The Artist's World in Pictures.* New York: E.P. Dutton, 1961.

_____. "Portrait of a Scene." *The Village Voice,* December 12, 1963, p. 12.

McGill, Douglas C. "Bob Thompson's Dionysian Landscapes." *The New York Times,* July 18, 1968, p. C15.

McNally, Owen. "A Passion for Painting." *Hartford Courant,* June 11, 1986, pp. D1, D4.

Mellow, James R. "Chronicles: New York Letter: Some Recent Figurative Painting." *Art International,* 7 (May 15, 1968), p. 71.

N[eumann], T[homas]. "Reviews and Previews: Bob Thompson." *Art News,* 63 (December 1964), p. 57.

1958 Louisville Art Center Annual (exhibition catalogue). Louisville, Kentucky: J.B. Speed Art Museum, 1958.

Novae: William H. Johnson and Bob Thompson (exhibition catalogue). Los Angeles: California Afro-American Museum, 1990. Essays by Robert Colescott, Dr. Leslie King-Hammond, Lizetta LeFalle-Collins, and Judith Wilson.

"Obituaries." *Art News,* 65 (September 1966), p. 13.

"Obituary." *The Louisville Courier-Journal & Times,* June 6, 1966.

"Obituary." *The Village Voice,* June 9, 1966, p. 7.

P[etersen], V[alerie]. "Reviews and Previews: Robert Thompson and Terry Barrell." *Art News,* 62 (May 1963), p. 62.

Powell, Richard J. *Black Art and Culture in the 20th Century.* London: Thames and Hudson, 1997.

Powell, Rick. "Stories Come Alive Through Paintings of Late Artist." *The Howard University Hilltop,* January 23, 1976, p. 6.

Rand, Harry. *The Martha Jackson Memorial Collection* (exhibition catalogue). Washington D.C.: National Museum of American Art, Smithsonian Institution, 1985.

Ratcliff, Carter. "Review of Exhibitions: Bob Thompson at Martha Jackson." *Art in America,* 64 (May–June 1976), p. 108.

Raynor, Vivien. "Art." *The New York Times,* February 4, 1983, p. C23.

Rivers, Larry, with Carol Brightman. *Drawings and Digressions.* New York: Clarkson N. Potter, 1979.

Rivers, Larry, with Arnold Weinstein. *What Did I Do? The Unauthorized Autobiography.* New York: Harper Collins, 1992, pp. 393–94.

"Robert Thompson." *The Detroit News,* April 11, 1965.

Rose, Barbara. "Art: In Cold Duck." *New York,* March 17, 1975, pp. 72–73.

_____. "New York Letter." *Art International,* 8 (February 15, 1964), p. 41.

Russell, John. "Art View: From a Glorious Past to a Conspicuously Bright Future." *The New York Times,* August 27, 1989, p. 33.

Sanconie, Marie-Françoise. "Peintres noirs américains, 1945–1980." Ph.D. dissertation. Paris: Université de la Sorbonne Nouvelle, 1984.

Schiff, Bennett. "In the Art Galleries." *New York Post Magazine,* May 29, 1960, p. 12.

Schjeldahl, Peter. "Art: Painter's Painter." *Seven Days,* February 7, 1990, pp. 50–51.

_____. "For Thompson, a Triumph Too Late." *The New York Times,* February 23, 1969, pp. D31–32.

_____. "New York Letter." *Art International,* 13 (October 1969), p. 77.

Seckler, Dorothy Gees. *Provincetown Painters 1890's–1970's.* Syracuse, New York: Everson Museum of Art, 1977. Edited with foreword by Ronald A. Kuchta.

Siegel, Jeanne. "Robert Thompson." In "Four American Negro Painters, 1940–1965: Their Choice and Treatment of Themes." Master's thesis. New York: Columbia University, Department of Art History, 1966.

_____. "Robert Thompson and the Old Masters." *The Harvard Art Review,* 2 (Winter 1967), pp. 10–14.

Silver, Ed. "Arts: Bob Thompson, Twice." *Amherst Free Valley Advocate*, October 2, 1974, p. 15.

Sims, Lowery Stokes. *The Figure in 20th Century American Art: Selections from The Metropolitan Museum of Art* (exhibition catalogue). New York: The Metropolitan Museum of Art, in association with the American Federation of the Arts, 1984, pp. 108–09. Foreword by William S. Lieberman.

Smith, Roberta. "Review/Art: Bob Thompson's Figures and Abstractions, Religion and Myth." *The New York Times*, February 2, 1990, p. C28.

Spellman, A.B. *Black Music, Four Lives.* New York: Schocken, 1970.

Stevens, Nelson. *Bob Thompson* (exhibition catalogue). Amherst: University Art Gallery, University of Massachusetts, Amherst, 1974. Essays by Jackie McLean, Rosalind R. Jeffries, and Emilio Cruz.

The Sun Gallery (exhibition catalogue). Provincetown, Massachusetts: Provincetown Art Association and Museum, 1981. Preface by Annabelle Hebert, essay by Irving Sandler.

Tall, William. "The Black American Modigliani." *Detroit Free Press*, December 13, 1970.

Tannenbaum, Judith. "Arts Reviews." *Arts Magazine*, 49 (May 1975), p. 20.

T[illim], S[idney]. "In the Galleries: Bob Thompson, Jay Milder." *Arts*, 34 (June 1960), p. 59.

"What Might Have Been Lives On Through Art." *New York Amsterdam News*, February 8, 1969, p. 11.

Wilson, Judith. *Bob Thompson* (exhibition brochure). Jamaica, New York: Jamaica Arts Center, 1987.

_____. "Bob Thompson's *Beauty and the Beast*." In Leo Hamalian and James V. Hatch, eds. *Artist and Influence 1988: Images of Women*. Vol. 6. New York: Hatch-Billops Collection, 1988.

_____. "Myths and Memories: Bob Thompson." *Art in America*, 71 (May 1983), pp. 139–43.

The World of Bob Thompson (exhibition catalogue). New York: The Studio Museum in Harlem, 1978. Preface by Mary Schmidt Campbell, Introduction by Gylbert Coker.

Zimmer, William. "Slices of Life From Black Artists." *The New York Times*, July 20, 1986, p. C24.

_____. "Splendid Works." *The Soho Weekly News*, November 16, 1978, pp. 25, 27.

WORKS IN THE EXHIBITION*

Dimensions are in inches, followed by centimeters; height precedes width.
As of March 2, 1998

BLACK MONSTER, 1959
Oil on canvas, 56 3/4 x 66 1/4
(144.1 x 168.3)
Anderson Gallery, Buffalo, New York

EN MOUVEMENT IV, 1959
Pastel and gouache on photographic
reproduction, 7 5/8 x 5 1/2 (19.4 x 14)
Collection of Martha Henry

LE POIGNARDER (THE STAB), 1959
Oil on canvas, 50 x 60 (127 x 152.4)
Solomon R. Guggenheim Museum,
New York; Gift, Jo and Lester Johnson,
1978

LOVERS, 1959
Oil on board, 10 1/2 x 13 1/2
(26.7 x 34.3)
Collection of Raymond J. McGuire

RED CROSS, 1959
Oil on carved panel, 15 x 18 1/2
(38.1 x 47)
Collection of Meredith and
Gail Wright Sirmans

UNTITLED, 1959
Oil on canvas, 50 x 56 (127 x 142.2)
Collection of Nancy Ellison

GARDEN OF MUSIC, 1960
Oil on canvas, 79 1/2 x 143
(201.9 x 363.2)
Wadsworth Atheneum, Hartford,
Connecticut; The Ella Gallup Sumner
and Mary Catlin Sumner Collection

LADY IN BETWEEN, 1960
Oil on board, 7 x 12 (17.8 x 30.5)
Collection of Miki Benoff

THIS HOUSE IS MINE, 1960
Oil on board, 7 x 12 (17.8 x 30.5)
Collection of Miki Benoff

TO THE BENOFFS MERRY XMAS,
1960
Oil on board, 6 3/4 x 13 3/4 (17.2 x 34.9)
Collection of Miki Benoff

THE TREK, 1960
Oil on wood, 4 1/4 x 21 3/4
(10.8 x 55.2)
Collection of Martha Henry

UNTITLED, 1960
Oil on canvas, 73 1/2 x 111
(186.7 x 282)
Collection of Edward Shulak

UNTITLED, 1960
Oil on wood, 4 1/2 x 22 1/2 (11.4 x 57.2)
Collection of Harmon and
Harriet Kelley

**UNTITLED (STUDY OF FIGURES
AND ANIMALS IN LANDSCAPE)**,
1960
Ink on paper, 19 1/2 x 25 5/16
(49.5 x 64.3)
Whitney Museum of American Art,
New York; Purchase, with funds from
the Thomas Fountain Purchase Fund
and the Drawing Committee 93.105

WAGADU II, 1960
Oil on board, 60 3/4 x 40
(154.3 x 101.6)
Collection of Miki Benoff

**AFTER EL GRECO'S
ANNUNCIATION**, c. 1960
Gouache on photographic repro-
duction, 12 1/4 x 9 1/4 (31.1 x 23.5)
Collection of Cornelia McDougald;
courtesy Martha Henry, New York

ALLEGORY, c. 1960
Oil on canvas, 60 x 71 (152.4 x 180.3)
The Metropolitan Museum of Art,
New York; George A. Hearn Fund,
1981

BACCHANAL, c. 1960
Gouache on paper, 11 x 11 (27.9 x 27.9)
Collection of John Sacchi

NATIVITY, c. 1960
Gouache on paper, 11 x 11 (27.9 x 27.9)
Collection of John Sacchi

SKETCHBOOK, c. 1960
10 1/2 x 13 1/2 (26.7 x 34.3)
Collection of Sally Gross

ORNETTE, 1960–61
Oil on canvas, 81 x 77 3/16
(205.7 x 196.1)
Anderson Gallery, Buffalo, New York

UNTITLED, c. 1960–61
Oil on canvas, 25 x 36 (63.5 x 91.4)
Private collection

UNTITLED, c. 1960–61
Oil on wood, 3 parts, 37 1/2 x 6 3/4
(95.3 x 17.1) overall
Collection of Carol Thompson

BIRD PARTY, 1961
Oil on canvas, 54 x 74 (137.2 x 188)
Collection of Elisabeth and
William M. Landes; courtesy
Michael Rosenfeld Gallery, New York

BLUE MADONNA, 1961
Oil on canvas, 51 1/2 x 74 3/4
(130.8 x 189.9)
The Detroit Institute of Arts; Gift of
Edward Levine in memory of a friend,
Bob Thompson

CHRIST, 1961
Oil on canvas, 4 3/4 x 7 (12.1 x 17.8)
Collection of Martha Henry

THE DRYING AFTER, 1961
Oil on wood, 19 7/8 x 23 9/16
(50.5 x 59.8)
The Art Institute of Chicago;
Gift of Mr. and Mrs.
Joseph Randall Shapiro

L'EXÉCUTION, 1961
Oil on linen, 7 x 10 1/2 (17.8 x 26.7)
Collection of Ellen Phelan and
Joel Shapiro

LA FEMME DANS LA PEINTURE,
1961
Oil on paper, 17 13/16 x 16 1/8
(45.2 x 41)
Anderson Gallery, Buffalo, New York

THE FOETUS, 1961
Oil on canvas, 31 1/2 x 38 1/2
(80 x 97.8)
Private collection; courtesy
Michael Rosenfeld Gallery, New York

YELLOW CROUCHING FIGURE, 1961
Oil on paper mounted on board, 41 1/2
x 28 1/2 (105.4 x 72.4)
Anderson Gallery, Buffalo, New York

UNTITLED, 1961
Oil on canvas, 26 x 21 (66 x 53.3)
Collection of the Hudgins Family

UNTITLED, c. 1961
Oil on wood, 4 1/2 x 12
(11.4 x 30.5)
Collection of Carol Thompson

FOUR BATHERS, c. 1961–62
Oil on wood, 82 1/2 x 90 1/2
(209.6 x 229.9)
The Metropolitan Museum of Art,
New York; Gift of Patricia and
Francis Mason, 1986

ST. GEORGE AND THE DRAGON,
c. 1961–62
Oil on canvas, 89 1/2 x 81 1/2
(227.3 x 207)
The Newark Museum, New Jersey;
Purchase 1982, The Members' Fund

THE JOURNEY, 1962
Oil on wood, 8 x 11 (20.3 x 27.9)
Collection of Maren and
Günter Hensler

REFLECTIONS, 1962
Gouache on paper, 21 1/2 x 17 1/2
(54.6 x 44.5)
The Walter O. Evans Collection of
African-American Art

TREE, 1962
Oil on canvas, 78 x 108 (198.1 x 274.3)
Michael Rosenfeld Gallery, New York

UNTITLED, 1962
Oil on canvas, 36 1/4 x 25 5/8
(92.1 x 65.1)
Hirshhorn Museum and Sculpture
Garden, Smithsonian Institution,
Washington, D.C.; Gift of
Joseph H. Hirshhorn, 1966

ZÜCKLER, 1962
Gouache on paper, 21 x 17 3/4
(53.3 x 45.1)
University Art Museum, University
of California, Santa Barbara;
Ruth S. Schaffner Collection

UNTITLED, c. 1962–63
Oil on wood, two sides: 17 1/2 x 14 1/4
(44.5 x 36.2); 16 7/8 x 12 1/4
(42.9 x 31.1)
Collection of Paula Cooper

BIRD RITUAL, 1963
Oil on canvas, 72 x 60 (182.9 x 152.4)
Collection of Jacqueline Bradley and
Clarence Otis

CALEDONIA FLIGHT, 1963
Oil on canvas, 77 x 57 (195.6 x 144.8)
George R. N'Namdi Gallery,
Birmingham, Michigan

CATHEDRAL, 1963
Oil on canvas, 86 x 63 (218.4 x 160)
Collection of Andy Williams

DESCENT FROM THE CROSS, 1963
Oil on canvas, 84 x 60 1/8
(213.4 x 152.7)
National Museum of American Art,
Smithsonian Institution, Washington,
D.C.; Gift of Mr. and Mrs. David K.
Anderson, Martha Jackson Memorial
Collection

GARDEN OF EDEN, 1963
Oil on canvas, 10 x 8 (25.4 x 20.3)
The Oakleigh Collection

INFERNO, 1963
Oil on canvas, 24 x 20 (61 x 50.8)
The Oakleigh Collection

THE JUDGEMENT, 1963
Oil on canvas, 60 x 84 (152.4 x 213.4)
Brooklyn Museum of Art, New York;
A. Augustus Healy Fund

THE PROCESSION, 1963
Oil on canvas, 65 3/4 x 58 1/2
(167 x 148.6)
The Denver Art Museum; Gift of
Kimiko and John Powers

**QUEEN OF SHEBA'S VISIT TO
KING SOLOMON**, 1963
Oil on canvas, 16 x 20 (40.6 x 50.8)
Collection of Robert L. Shapiro

THE SEARCH, 1963
Oil on canvas, 8 x 10 (20.3 x 25.4)
Collection of Emily Fisher Landau

SOLOMON AND SHEBA, 1963
Oil on canvas, 14 x 10 (35.6 x 25.4)
The Oakleigh Collection

**THE SPINNING, SPINNING,
TURNING, DIRECTING**, 1963
Oil on canvas, 62 7/8 x 82 7/8
(159.7 x 210.5)
National Museum of American Art,
Smithsonian Institution, Washington,
D.C.; Gift of Mr. and Mrs. David K.
Anderson, Martha Jackson Memorial
Collection

TEN PLAGUES, 1963
Oil on canvas, 8 x 10 (20.3 x 25.4)
The Oakleigh Collection

THREE NUDES, 1963
Pastel and gouache on photographic
reproduction, 10 5/16 x 12 (26.2 x 30.5)
Collection of Martha Henry

UNTITLED, 1963
Oil on canvas, 14 x 10 (35.6 x 25.4)
Collection of June Kelly

UNTITLED, 1963
Oil on canvas on board,
12 3/16 x 14 3/16 (31 x 36)
Anderson Gallery, Buffalo, New York

UNTITLED (SKETCHBOOK), 1963
Sketchbook, 9 $1/2$ x 6 $1/4$ (24.1 x 15.9)
Vanderwoude Tananbaum Gallery,
New York

LA CAPRICE, c. 1963
Oil on canvas, 62 $1/4$ x 51 $1/2$
(158.1 x 130.8)
Michael Rosenfeld Gallery, New York

UNTITLED, c. 1963
Mixed media on paper, 2 $1/2$ x 23
(6.4 x 58.4)
Private collection

UNTITLED, c. 1963
Gouache on paper, 10 $3/8$ x 10 $7/8$
(26.4 x 27.6)
Collection of Paula Cooper

THE PROCESSION, 1963–64
Oil on canvas, 48 x 36 (121.9 x 91.4)
Collection of Mr. and Mrs.
Stanley M. Freehling

*ABUNDANCE AND THE FOUR
ELEMENTS*, 1964
Oil on canvas, 8 x 10 (20.3 x 25.4)
Sheldon Ross Gallery, Birmingham,
Michigan

*ABUNDANCE AND THE FOUR
ELEMENTS*, 1964
Oil on canvas, 48 x 60 (121.9 x 152.4)
The Oakleigh Collection

*ADORATION OF THE MAGI (AFTER
POUSSIN)*, 1964
Oil on canvas, 8 x 10 (20.3 x 25.4)
Collection of halley k. harrisburg and
Michael Rosenfeld

AN ALLEGORY, 1964
Oil on canvas, 48 x 48 (121.9 x 121.9)
Whitney Museum of American Art,
New York; Gift of Thomas Bellinger
72.137

AURORA LEAVING CEPHALUS II,
1964
Oil on canvas, 24 $1/8$ x 30 $1/8$
(61.3 x 76.5)
Hirshhorn Museum and Sculpture
Garden, Smithsonian Institution,
Washington, D.C.; Gift of
Joseph H. Hirshhorn, 1966

BIRD BACCHANAL, 1964
Oil on canvas, 12 x 16 (30.5 x 40.6)
Private collection; courtesy
Vanderwoude Tananbaum Gallery,
New York

CONVERSION OF ST. PAUL, 1964
Oil on canvas, 24 $5/8$ x 36 $5/8$
(62.6 x 93)
Hirshhorn Museum and Sculpture
Garden, Smithsonian Institution,
Washington, D.C.; Gift of
Joseph H. Hirshhorn, 1966

THE DEATH OF CAMILLA, 1964
Oil on canvas, 18 x 24 $1/8$ (45.7 x 61.3)
The Detroit Institute of Arts

THE DEATH OF CAMILLA, 1964
Oil on canvas, 24 $1/8$ x 30 $1/8$
(61.3 x 76.5)
Hirshhorn Museum and Sculpture
Garden, Smithsonian Institution,
Washington, D.C.; Gift of
Joseph H. Hirshhorn, 1966

EXPULSION AND NATIVITY, 1964
Oil on canvas, 63 x 83 $1/2$ (160 x 212.1)
Private collection

JUDGMENT OF PARIS, 1964
Oil on canvas, 75 $7/16$ x 60 $11/16$
(191.6 x 154.1)
Munson-Williams-Proctor Institute
Museum of Art, Utica, New York;
Purchase

LeROI JONES AND HIS FAMILY,
1964
Oil on canvas, 36 $3/8$ x 48 $1/2$
(92.4 x 123.2)
Hirshhorn Museum and Sculpture
Garden, Smithsonian Institution,
Washington, D.C.; Gift of
Joseph H. Hirshhorn, 1966

MARS AND VENUS, 1964
Oil on canvas, 12 $1/8$ x 16 $1/8$
(30.8 x 40.9)
Hirshhorn Museum and Sculpture
Garden, Smithsonian Institution,
Washington, D.C.; Gift of
Joseph H. Hirshhorn, 1966

MASSACRE OF THE INNOCENTS,
1964
Oil on canvas, 12 x 16 $1/8$ (30.5 x 41)
Hirshhorn Museum and Sculpture
Garden, Smithsonian Institution,
Washington, D.C.; Gift of
Joseph H. Hirshhorn, 1966

*LA MORT DES ENFANTS DE
BÉTHEL*, 1964
Gouache on paper, 19 $1/2$ x 20 $1/2$
(49.5 x 52.1)
Collection of Ed and Diane Levine

THE OFFERING, 1964
Oil on canvas, 9 x 12 (22.9 x 30.5)
Collection of Janice and Mickey Cartin

PARNASSUS, 1964
Oil and graphite on canvas, 20 x 30
(50.8 x 76.2)
The Metropolitan Museum of Art,
New York; Gift of Dr. and Mrs.
Irwin R. Berman, 1977

POLYPHEMUS, ACIS AND GALATEA,
1964
Oil on canvas, 9 x 12 (22.9 x 30.5)
Curtis Galleries, Minneapolis

*SACRAMENT OF BAPTISM
(POUSSIN)*, 1964
Felt-tip pen, ink, and graphite on
canvas, 12 x 16 $1/8$ (30.5 x 41)
Hirshhorn Museum and Sculpture
Garden, Smithsonian Institution,
Washington, D.C.; Gift of
Joseph H. Hirshhorn, 1966

ST. JEROME AND THE DONOR,
1964
Oil on canvas, 10 x 8 (25.4 x 20.3)
Private collection

*ST. MATTHEW'S DESCRIPTION OF
THE END OF THE WORLD*, 1964
Oil on canvas, 72 x 60 $1/8$
(182.9 x 152.7)
The Museum of Modern Art, New
York; Blanchette Rockefeller Fund

SAVING OF PYRRHUS (POUSSIN),
1964
Felt-tip pen, ink, and graphite on
canvas, 18 x 24 1/8 (45.7 x 61.3)
Hirshhorn Museum and Sculpture
Garden, Smithsonian Institution,
Washington, D.C.; Gift of
Joseph H. Hirshhorn, 1966

TRIUMPH OF BACCHUS, 1964
Oil on canvas, 60 x 72 1/16 (152.4 x 183)
Whitney Museum of American Art,
New York; Purchase, with funds from
the Painting and Sculpture Committee
98.19

UNTITLED, 1964
Ink on wax paper, 14 1/8 x 21
(35.9 x 53.3)
Anderson Gallery, Buffalo, New York

UNTITLED, 1964
Oil on canvas, 8 x 10 (20.3 x 25.4)
Collection of Paula Cooper

UNTITLED (AFTER POUSSIN), 1964
Oil on printed gallery announcement,
10 7/8 x 18 1/8 (27.6 x 46.1)
The Museum of Modern Art, New
York; Gift of Lillian L. and Jack I. Poses

**UNTITLED (PERSEUS AND
ANDROMEDA)**, 1964
Gouache on paper, 10 x 10 1/2
(25.4 x 26.7)
Collection of Rachelle and Steven Morris

VENUS AND ADONIS, 1964
Oil on canvas, 8 x 10 (20.3 x 25.4)
Hirshhorn Museum and Sculpture
Garden, Smithsonian Institution,
Washington, D.C.; Gift of
Joseph H. Hirshhorn, 1966

VENUS AND ADONIS, 1964
Oil on canvas, 60 x 48 (152.4 x 121.9)
Collection of Elizabeth and Eliot Bank

BACCHANAL II, 1965
Oil on canvas, 60 x 84 (152.4 x 213.4)
Collection of Dr. and Mrs.
Paul Todd Makler

**DEATH OF THE INFANTS OF
BETHEL**, 1965
Oil on canvas, 60 x 84 (152.4 x 213.4)
The Art Institute of Chicago; Walter
Aitken Endowment

DIANA, THE HUNTRESS, 1965
Oil on canvas, 48 x 36 (121.9 x 91.4)
Collection of Janice and Mickey Cartin

ECHO AND NARCISSUS, 1965
Oil on canvas, 36 x 48 (91.4 x 121.9)
Collection of Donald and
Florence Morris

ECHO AND NARCISSUS, 1965
Acrylic on paper mounted on masonite,
10 1/2 x 11 (26.7 x 27.9)
Collection of Carol Thompson

FIVE COWS WITH BLUE NUDE, 1965
Oil on canvas, 18 x 24 (45.7 x 61)
Collection of Dr. Donald and
Marcia Boxman

FOR MARTHA, SINCERELY, 1965
Lithograph, 22 x 23 (55.9 x 58.4)
Anderson Gallery, Buffalo, New York

HOMAGE TO NINA SIMONE, 1965
Oil on canvas, 48 x 72 (121.9 x 183)
Minneapolis Institute of Arts; The
John R. Van Derlip Fund

LE JEU, 1965
Oil on canvas, 30 x 24 (76.2 x 61)
Collection of Maurice Cohen

LUNCH ON THE JOURNEY, 1965
Oil on canvas, 20 x 16 (50.8 x 40.6)
Collection of Maurice Cohen

PORTRAIT OF ALLEN, 1965
Oil on canvas, 20 x 16 (50.8 x 40.6)
Collection of George Nelson Preston

**RECREATION OF CEPHALUS AND
PROCRIS**, 1965
Oil on canvas, 18 x 24 (45.7 x 61)
Private collection

ST. JEROME, 1965
Oil on wood, 5 x 3 1/4 (12.7 x 8.3)
Collection of Carol Thompson

SATYR AND MAIDEN, 1965
Oil on canvas, 60 x 48 (152.4 x 121.9)
Collection of Richard and Camila
Lippe; courtesy Michael Rosenfeld
Gallery, New York

SATYR AND MAIDEN, 1965
Oil on paper, 10 x 20 (25.4 x 50.8)
Collection of Carol Thompson

TANCRED AND ERMINIA, 1965
Oil on canvas, 48 x 60 (121.9 x 152.4)
Collection of Maurice Cohen

MOTHER AND CHILD, c. 1965
Oil on canvas, 60 x 48 (152.4 x 121.9)
Collection of Mr. and Mrs. Robert C.
Davidson, Jr.; courtesy Michael
Rosenfeld Gallery, New York

LAST PAINTING, 1966
Oil on canvas, 55 x 63 (139.7 x 160)
Collection of Carol Thompson

UNTITLED, 1966
Ink on paper, 13 3/4 x 19 1/4
(34.9 x 48.9)
Vanderwoude Tananbaum Gallery,
New York

UNTITLED (THE OPERATION),
1966
Crayon on paper, 8 1/4 x 12
(21 x 30.5)
Collection of Jim and Danielle Sotet

VIEW FROM HOSPITAL, 1966
Mixed media on paper, 16 13/16 x
20 11/16 x 1 1/8 (42.7 x 52.5 x 2.9)
Anderson Gallery, Buffalo, New York

ASSISTANCES FOR THE JOURNEY,
n.d.
Oil on wood, 6 3/4 x 10 1/8 (17 x 25.7)
Collection of Katherine Kahan

STAIRWAY TO THE STARS, n.d.
Paper, oil, and photograph on canvas,
40 x 60 (101.6 x 152.4)
Collection of George and Joyce Wein

PHOTOGRAPH AND REPRODUCTION CREDITS
Alinari/Art Resource, NY: 65 (left), 180 (top), 182 (top left); Dirk Bakker: 132 (bottom), 152, 155 (bottom), 156, 159, 161, 163; Dorothy Beskind: 66, 67 (left), 80; Ricardo Blanc: 64 (right), 135, 142 (bottom), 147 (top), 150 (bottom); Del Bogart: 118; Margaret M. Bridwell Art Library, University of Louisville: 29, 59 (bottom); The Brooklyn Museum of Art: 160; © 1997 The Art Institute of Chicago: 99 (bottom); Geoffrey Clements: 34 (left), 34 (right), 39, 188; Curtis Galleries, Inc., Minneapolis: 144 (top); Elizabeth Davis: 82, 94 (top), 98, 105, 123 (top), 164, 168, 171 (bottom), 174 (left), 176 (right); © The Detroit Institute of Arts: 100, 138 (top); Foto Marburg/Art Resource, NY: 182 (top right); Giraudon/Art Resource, NY: 64 (left), 177 (left); Paula Goldman: 88 (top), 88 (bottom), 89 (top), 93; David Heald © The Solomon R. Guggenheim Foundation, New York: 83; Jack Kaufman: 131; Robert E. Mates: 133; copyright © by Fred W. McDarrah: 6-7, 8, 26, 44-45, 48, 51, 53, 54, 55, 57, 75; © The Metropolitan Museum of Art: 96, 106, 143; The Minneapolis Institute of Arts: 69 (left), 158; © The Museum of Modern Art, New York: 145, 147 (bottom); Reproduced courtesy of the Trustees, The National Gallery, London: 68 (right), 70 (right); National Museum of American Art, Smithsonian Institution, Washington, D.C.: 114, 117, 130, 178, 185; Josh Nefsky: 103, 121 (top), 121 (bottom); William O'Connor: 141; Philipp Scholz Rittermann: 119, 180 (bottom); © Photo RMN/Arnaudet: 69 (right); Raymond Ross: 11; Charles Rotmil: 2; Manu Sassoonian: 123 (bottom); Lee Stalsworth: 110 (left), 134, 138 (bottom), 166; Jerry L. Thompson: 72, 84, 89 (bottom), 90 (left), 90 (right), 91 (top), 91 (bottom), 95 (top), 97 (left), 97 (right), 101 (top), 101 (bottom), 104, 108 (right), 113 (left), 113 (right), 120 (top), 120 (bottom), 122 (top), 128 (top), 129, 144 (bottom), 150 (top), 154 (top), 154 (bottom), 155 (top), 157, 162, 171 (top), 172, 175 (top), 177 (right), 187; Michael Tropea: 61, 140; University Art Museum, University of California, Santa Barbara: 110 (right); Wendy Vail: 142 (top), 146 (top); Wadsworth Atheneum, Hartford: 86, 87, 175 (bottom); Sarah Wells: 68 (left), 107

This publication was produced by the Publications Department at the Whitney Museum.
Mary E. DelMonico, Head, Publications
Production: Nerissa Dominguez Vales, Production Manager; Christina Grillo, Publications Assistant; Sarah Newman, Production Assistant
Editorial: Sheila Schwartz, Editor; Dale Tucker, Copy Editor
Graphic Design: Deborah Littlejohn, Senior Graphic Designer; Roy Brooks, Graphic Designer

"Bob Thompson" was organized by Thelma Golden, curator, with the assistance of Shamim Momin, research assistant, and Erika Muhammad, curatorial assistant.

Catalogue Design: Bethany Johns Design
Printing: South China Printing
Printed in Hong Kong

Judith Wilson is an assistant professor of African-American studies and art history at the University of California at Irvine. She was a curatorial consultant to this exhibition.

Unless otherwise indicated, all documentary photographs are from the collection of Carol Thompson.

Thompson habitually inscribed the titles of his works on the backs of the canvases. The titles of all works cited or reproduced here generally follow his indications, including orthographic or thematic irregularities. Some works designated as untitled are either lost, destroyed, or have had their original backings obscured through restoration.